The Camera

Other Publications:

PLANET EARTH

COLLECTOR'S LIBRARY OF THE CIVIL WAR

LIBRARY OF HEALTH

CLASSICS OF THE OLD WEST

THE EPIC OF FLIGHT

THE GOOD COOK

THE SEAFARERS

THE ENCYCLOPEDIA OF COLLECTIBLES

WORLD WAR II

THE GREAT CITIES

HOME REPAIR AND IMPROVEMENT

THE WORLD'S WILD PLACES

THE TIME-LIFE LIBRARY OF BOATING

HUMAN BEHAVIOR

THE ART OF SEWING

THE OLD WEST

THE EMERGENCE OF MAN

THE AMERICAN WILDERNESS

THE TIME-LIFE ENCYCLOPEDIA OF GARDENING

THIS FABULOUS CENTURY

FOODS OF THE WORLD

TIME-LIFE LIBRARY OF AMERICA

TIME-LIFE LIBRARY OF ART

GREAT AGES OF MAN

LIFE SCIENCE LIBRARY

THE LIFE HISTORY OF THE UNITED STATES

TIME READING PROGRAM

LIFE NATURE LIBRARY

LIFE WORLD LIBRARY

FAMILY LIBRARY:

HOW THINGS WORK IN YOUR HOME THE TIME-LIFE BOOK OF THE FAMILY CAR THE TIME-LIFE FAMILY LEGAL GUIDE THE TIME-LIFE BOOK OF FAMILY FINANCE

This volume is one of a series devoted to the art and technology of photography. The books present pictures by outstanding photographers of today and the past, relate the history of photography and provide practical instruction in the use of equipment and materials.

LIFE LIBRARY OF PHOTOGRAPHY

The Camera Revised Edition

BY THE EDITORS OF TIME-LIFE BOOKS

₱ 1981 Time-Life Books Inc.

All rights reserved.

No part of this book may be reproduced in any form or by any electronic or mechanical means, including information storage and retrieval devices or systems, without prior written permission from the publisher, except that brief passages may be quoted for reviews. Revised Edition. Second printing, 1982.

Printed in U.S.A.

Published simultaneously in Canada.

School and library distribution by Silver Burdett Company, Morristown, New Jersey 07960.

For information about any Time-Life book, please write: Reader Information Time-Life Books 541 North Fairbanks Court Chicago, Illinois 60611

TIME-LIFE is a trademark of Time Incorporated U.S.A.

Library of Congress Cataloguing in Publication Data Main entry under title: The Camera. (Life library of photography) Bibliography: p. Includes index. 1. Cameras. 2. Photography. I. Time-Life Books. II. Series. TR250.C34 1981 770 81-1028 ISBN 0-8094-4156-X AACR2 ISBN 0-8094-4155-1 (lib. bdg.) ISBN 0-8094-4154-3 (retail ed.)

ON THE COVER: This montage - a turn-of-the-century view camera visible in the focusing screen of a modern SLR - represents nearly a century of progress in camera design. The 8 x 10-inch view camera, fitted with a leather bellows, brass lens and shutter mechanism, and with a frame of mahogany, is nearly a foot long when its bellows is entirely extended; it required numerous manual adjustments and had to be set on a tripod for use. The electronically controlled SLR, on the other hand, is small enough to fit in the hand and rugged enough to be sent into space.

Introduction Photography: An Art for Everyman 9 The Camera 59 The Lens 99 The Little Black Box 133 Photography versus Painting 167 On Making Better Pictures 201 233 Bibliography 234 Acknowledgments **Picture Credits** 235 Index 236

Time-Life Books Inc. is a wholly owned subsidiary of TIME INCORPORATED

FOUNDER: Henry R. Luce 1898-1967

Editor-in-Chief: Henry Anatole Grunwald President: J. Richard Munro Chairman of the Board: Ralph P. Davidson Executive Vice President: Clifford J. Grum Chairman, Executive Committee: James R. Shepley Editorial Director: Ralph Graves Group Vice President, Books: Joan D. Manley Vice Chairman: Arthur Temple

TIME-LIFE BOOKS INC. EDITOR: George Constable

Executive Editor: George Daniels
Board of Editors: Dale M. Brown,
Thomas H. Flaherty Jr., William Frankel,
Thomas A. Lewis, Martin Mann, Philip W. Payne,
John Paul Porter, Gerry Schremp, Gerald Simons,
Nakanori Tashiro, Kit van Tulleken
Art Director: Tom Suzuki
Assistant: Arnold C. Holeywell
Director of Administration: David L. Harrison
Director of Operations: Gennaro C. Esposito
Director of Research: Carolyn L. Sackett
Assistant: Phyllis K. Wise

Director of Photography: Dolores Allen Littles

President: Carl G. Jaeger
Executive Vice Presidents: John Steven Maxwell,
David J. Walsh
Vice Presidents: George Artandi, Stephen L. Bair,
Peter G. Barnes, Nicholas Benton, John L. Canova,
Beatrice T. Dobie, Carol Flaumenhaft,
James L. Mercer, Herbert Sorkin, Paul R. Stewart

LIFE LIBRARY OF PHOTOGRAPHY EDITORIAL STAFF FOR

EDITORIAL SOITTON OF THE CAMERA:
EDITORS:Robert G. Mason, Norman Snyder
Assistant to the Editors: Simone Daro Gossner
Text Editor: Peter Chaitin
Designer: Raymond Ripper
Staff Writers: Lee Greene, Jeffrey Tarter, Peter Wood
Picture Associates: Erik Amfitheatrof, Anne Ferebee
Researchers: Maureen Benziger,
Rosemarie Conefrey, Susan Gordon,
Monica O. Horne, Shirley Miller, Don Nelson,
Kathryn Ritchell
Art Assistant: Jean Held

EDITORIAL STAFF FOR THE REVISED EDITION OF THE CAMERA:

EDITOR:Edward Brash
Designer/Picture Editor: Sally Collins
Chief Researcher: W. Mark Hamilton
Text Editor: John Manners
Researchers: Cathy Gregory, Jeremy N. P. Ross,
Marilyn Murphy
Copy Coordinator: Anne T. Connell
Art Assistant: Carol Pommer
Picture Coordinator: Charlotte Marine
Editorial Assistant: Jane Cody

Special Contributors:
Don Earnest, Gene Thornton (text)
Mel Ingber (technical research)

EDITORIAL OPERATIONS

Production Director: Feliciano Madrid
Assistants: Peter A. Inchauteguiz,
Karen A. Meyerson
Copy Processing: Gordon E. Buck
Quality Control Director: Robert L. Young
Assistant: James J. Cox
Associates: Daniel J. McSweeney,
Michael G. Wight
Art Coordinator: Anne B. Landry
Copy Room Director: Susan Galloway Goldberg
Assistants: Celia Beattie, Ricki Tarlow

CORRESPONDENTS

Elisabeth Kraemer (Bonn); Margot Hapgood, Dorothy Bacon (London); Susan Jonas, Lucy T. Voulgaris (New York); Maria Vincenza Aloisi, Josephine du Brusle (Paris); Ann Natanson (Rome). Valuable assistance was also provided by: Judy Aspinall, Lesley Coleman, Karin B. Pearce (London); Jane Walker (Madrid); Miriam Hsia (New York); Mimi Murphy (Rome); Katsuko Yamazaki (Tokyo); Traudl Lessing (Vienna).

Portions of this book were written by Paul Trachtman. The editors are indebted to the following individuals of Time Inc.: George Karas, Chief, TIME-LIFE Photo Lab, New York City; Herbert Orth, Deputy Chief, TIME-LIFE Photo Lab, New York City; Melvin L. Scott, Assistant Picture Editor, Life, New York City; Photo Equipment Supervisor, Albert Schneider; Equipment Technician, Mike Miller; Color Lab Supervisor, Peter Christopoulos; Black and White Supervisor, Carmine Ercolano; Color Lab Technician, Ron Trimarchi.

Introduction

There is a paradox in photography. It seems an artless art—point the camera, press the button and you have a picture (in a minute, if you like). A child can do it. And yet photography is also a distinctive, uniquely modern medium of expression recognized as an art. People take pictures at all levels, from the child's to the artist's, and this book is planned to serve everyone who uses a camera—whether to record family activities, to pursue a serious hobby, to advance a profession or to communicate an inner vision.

The Camera assumes no previous understanding of photography, no familiarity with technical terminology. Like other volumes in the LIFE Library of Photography, it concerns itself not just with basics, but also with the newest developments in photographic science and the foremost expressions of photographic art.

To keep pace with advances in both the science and art of photography that

have taken place since the volume was first published in 1970, this revised edition contains 150 pages that have been updated or completely redone. For example, there is a complete explanation of the computerized controls that in many 35mm cameras control shutter and aperture to set exposure automatically—and even inform the operator of the computer's decisions by flashing lights.

To meet the needs of the novice as well as those of the advanced photographer, this book is multilayered. It begins with the basic parts of a camera and the relative merits of different types, and goes on to explain the scientific underpinnings of photography—why some lenses focus sharply over a wider range of distances than others, why distortion occurs with one kind of shutter and not with another.

This volume also offers directly useful information—how to decide what camera to buy; how a lens's focal length can

effect depth of field; how to make creative use of new accessories such as a motorized camera advance (pages 96-98). And an unforgettable interview with the staff photographers of Life (pages 204-211), reproduced from the original volume, gives expert advice about how to take good pictures of almost any subject from houses, sports and animals to children and world leaders.

This and other volumes are layered in another way as well. We feel that history and esthetics bear strongly on the taking of pictures at all levels of competence; in this book these elements are mixed with practical and technical matters. But esthetics changes as inexorably as technology, and 32 new picture pages have been required to show new visions by new artists; thus, an entire section devoted to the fast-growing field of color photography has been added to this revision, and appears on pages 42-49.

The Editors

Photography: An Art for Everyman

The Many Levels of Photography 12

A Moment Preserved 18

The Flavor of the Times 20
Faces in the Crowd 22
A Sense of Place 24
Suffering and Joy 26
The Historical Event 28
The Shocking Instant 30

A Search for Beauty 32

An Emphasis on Composition 34
The Sensual Shapes of Nature 36
Personality in Portraits 38
The Manipulated Print 40

The Impact of Color 42

Glamorizing Fashions 44 Capturing the Exotic 46 Transforming Landscapes 48

An Extension of Vision 50

Crystallized Motion, Visible Time 52
Probing the Infinitesimal 54
The Body's Wonders 56
Scenes of a Distant Planet 58

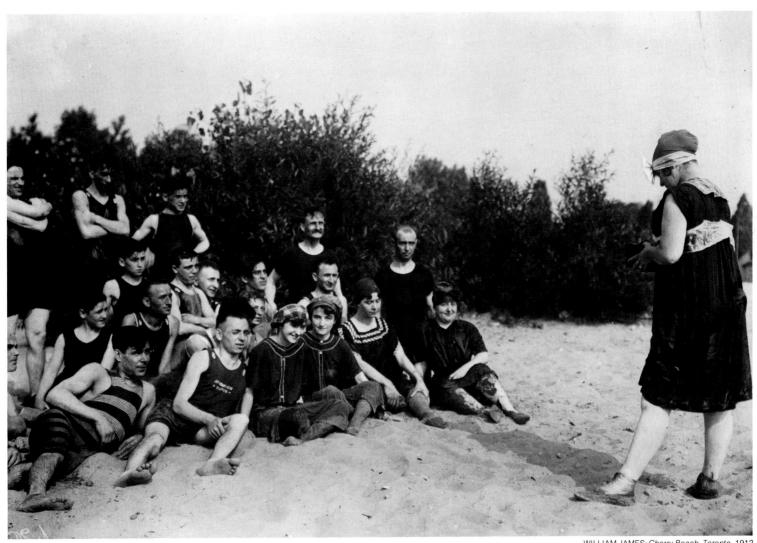

WILLIAM JAMES: Cherry Beach, Toronto, 1912

The Many Levels of Photography

Photography is a magic act—a little black box that can trap people and wild animals, strange places and well-loved ones, and bring them all back home. It is a trick that never ceases to delight the audience, the magician most of all. After seeing it done for the first time in 1839, the English chemist and astronomer Sir John Herschel could barely believe his eyes. "It is a miracle," he said.

Photography is indeed a miracle, an invention that allows us to make instant images of anything we see. It has become the peculiar art form of our technological age—fast, accurate, largely automatic; an efficient and powerful way of communicating information; an unmatched way of spanning time and space. No medium of expression has ever appealed so immediately to so many people, nor has any medium but spoken language been so universally used. It was first embraced by artists and entrepreneurs as a means of making portraits more than a century ago, but it quickly broadened to provide new miracles: views of foreign lands, glimpses of great wars and beautiful women— and countless snapshots of Sunday at the beach.

Today we live in a world in which photography is so commonplace we rarely give it a second thought. Yet as individuals we are not only daily consumers of vast numbers of pictures, but prolific producers as well. In the United States, the number of photographs taken each year by amateurs increased from four billion to 12 billion within a decade, while the number of cameras they owned more than doubled. Picture taking has been made so sophisticated — and at the same time so easy — that even a 10-year-old can pop a cartridge of "instant-loading" film into the back of a camera and snap away with reasonable success. On more and more cameras the controls are so automatic and reliable that sharp, properly exposed pictures are almost guaranteed. Some cameras even focus themselves automatically. The processing of film has also been short-cut in cameras designed to produce a fullcolor print a moment after the picture is taken. And for the more advanced photographer the market offers an ever-expanding array of cameras, lenses, accessories and films that allows him to search out and capture the most exotic subjects and effects.

Most people ask no more of a camera than that it preserve the treasured moments of their lives: the expressions of children, the look of a new house; graduations, marriages, family reunions; the trip to the Grand Canyon or Mexico or France. Some of the pictures may be fuzzy, the Eiffel Tower may seem to stick out of Father's head; yet every time the album or slide projector is brought from the closet, the moments miraculously live again.

They live much more enjoyably for those who devote even a little attention to the equipment and techniques of photography. Its magic is not arcane. As the succeeding chapters in this book show, cameras and lenses, for all their

technological gleam, operate on logical, and essentially simple, principles. The application of these principles over the years has led to the development of a variety of ingenious equipment—and more important, to an instructive variety of ways of taking pictures.

Photography is an art that can be pursued at many levels, each offering its own rewards. Sometimes, moreover, the rewards are at first unsuspected; many of the greatest photographers got started by accident. Landscape master Ansel Adams, for example, began his professional life as a classical pianist; Gordon Parks had been a busboy, a musician and a professional basketball player before he bought his first camera in a Seattle pawnshop; Aaron Siskind was an elementary schoolteacher; Alfred Eisenstaedt was a wholesale belt and button salesman when he sold his first pictures to a newspaper.

The careers of five photographers in particular are illuminating: Each was introduced to serious photography in a different fashion, each became a world-famous artist while preserving the unquenchable enthusiasm of the amateur, each mastered different facets of the craft.

The first of these is Jacques-Henri Lartigue, a Frenchman who all his life has taken a rare delight in recording the people and things that have passed before his eyes, and doing it with great skill (pages 20 and 164-165). At the age of seven he tried out his first camera, a wooden box on a tripod so tall he had to climb up on a stool to look at its viewing screen; pictures were taken by removing a cork that covered the lens, counting the proper number of seconds and then replacing the cork. After trying it out for the first time the boy wrote to a friend: "It's marvelous, marvelous! Nothing will ever be as much fun. I'm going to photograph everything, everything!"

And that is just what Lartigue did. With this heavy instrument, and with smaller cameras he owned later, he took pictures of his family and friends, of portly gentlemen in linen suits strolling along the beach, of ladies in big floppy hats, of the automobiles that were just beginning to stutter along the streets of Paris, of the flimsy airplanes that were struggling into the air. Over the years he accumulated an extraordinary record not only of his own life but of a whole era in the midst of exciting change. In 1979 Lartigue donated this collection—including 100,000 negatives—to the government of France, which housed it in a huge wing of a Paris exhibition hall. Photography stirs deep feelings in Lartigue. "Picture taking," he once said, "is a trap of images—serious, fleeting, funny, tragic, fanciful, rare, human, irreplaceable." Every family album, to some degree, or other, reaffirms his words.

Lartigue transformed into an art the very first level of photography, the recording of homely scenes of everyday life. Quite a different level was achieved by Crawford Greenewalt, a former president of the Du Pont company in Wil-

mington, Delaware. Greenewalt was an enthusiastic amateur photographer and on a summer afternoon in the 1950s, he tried to take a picture of a ruby-throated hummingbird to add to his collection of photographs of Delaware birds. It was a tricky matter to catch the little bird on film, for its wings beat the air dozens of times a second as it darted about near the bird feeder outside his window. The picture turned out fairly well, but Greenewalt was determined to do still better and began to experiment with various kinds of equipment. After some puttering around, he worked out an arrangement of a small but versatile camera, a Hasselblad, and three electronic flashes whose rapid bursts of light were triggered when the tiny birds flew through the beam of a photoelectric cell. With this rig he photographed his fill of hummingbirds near home, then began taking his vacations all over North and South America in search of other species, carrying his 250 pounds of equipment wherever he went. He eventually traveled some 100,000 miles, produced an unparalleled collection of photographs and, in the process, became a world authority on hummingbirds. Later he admitted, "Perhaps if I had known what the intervening years were to bring. I would not have had the courage to begin. [Yet] in retrospect, I wouldn't have missed a mile, or an hour, anywhere along the way."

Such an application of photography to special interest led the great Swedish photographer Lennart Nilsson to still another level, that of the professional, for he converted his fascination with the natural world into a brilliant photographic career. He began early in life. By the time he was five he was already a knowing collector of plant and flower specimens. At the age of 12 he had started to photograph them in the wild; at 15 he produced a series of pictures he called "The Nature of the Farm," which was published by a leading Swedish magazine. Encouraged, Nilsson later went on as a full-time professional to do classic picture studies of everything from ant colonies to Arctic polar bears.

Not content with photographing nature from the outside, he then devised ways to record its workings from within. In one picture essay for *Life* he attached his camera to a special miniature lens by means of a long, light-conducting cable and managed to photograph the inside of a human artery, cholesterol deposits and all. Later he made a celebrated close-up survey of the body's interior (page 56).

Nilsson's pictures command attention not only because they reveal what had been hidden but because they are strangely beautiful. In this respect they are examples of photography at its highest level, that of the search for beauty in any form film can record.

Lennart Nilsson discovers beauty in unusual subjects, but the most ordinary subject matter can serve the artist as well.

It does for one photographer who, for 50 years, has worked consistently at the artist's level, Henri Cartier-Bresson of France (pages 126-127, 203 and 216-217). He set only one goal for himself: that he lift "decisive moments" out of the broad spectrum of people's lives. In pursuit of that goal as a professional photojournalist, he has spent his own life quite literally wandering around the world, walking along out-of-the-way streets, patiently watching people and their surroundings until they fell into compositions that he felt had both beauty and meaning.

He uses only one kind of camera, a Leica, and usually only a 50mm lens, yet despite his simple equipment and his quiet, seemingly aimless approach, his skills are every bit as disciplined as those of photographers with a trunkful of gear. And, like many seasoned photographers, his appetite for pictures still knows no bounds. "Photography," he says, "is an intuitive way to express oneself, here and now—an opportunity of plunging into the reality of today. It is one's guess of what life is.... With me the camera is a kind of magnet. You want to catch the whole world in that little box, all the significant details that add up to life."

Perhaps this is the greatest gift the camera can offer the serious photographer: a means of seeing and, through seeing, understanding a little bit more about the "significant details" of life and the world around him. It is almost axiomatic among professionals that a photographer sees a subject more clearly every time he attempts to photograph it, just as a painter opens up a richer visual world for himself as he works or a writer understands more deeply what he is writing about the more he writes.

This attraction—the lure of experiencing more of the world by catching it "in that little box"—inexorably pulls the photographer upward and onward, level by level. Perhaps the most striking example of this progression from level to level of his art is found in the career of one man, Edward Steichen. During a lifetime that spanned eight decades, Steichen was an amateur, a professional portraitist, a combat and reconnaissance photographer in two wars, a leader in magazine photography and a distinguished museum curator. But above all he was a restless explorer of his medium, of nature and of man.

Steichen was a 16-year-old lithographer's apprentice in Milwaukee in 1895 when he bought his first camera, a second-hand Kodak. The dealer loaded it with a 50-exposure roll of film, gave him a few pointers and sent him on his way. "My first exposure," Steichen wrote in his autobiography *A Life in Photography*, "was of our cat sleeping in the show window of my mother's millinery shop. I used up the rest of the roll on various subjects about the house. . . . When the film came back I had a real shock. Only one picture in the lot had been considered clear enough to print." That one picture, how-

ever, was a charming, sensitive portrait of his little sister playing the piano.

The young photographer was hooked. He bought another, larger camera and set up a darkroom in the cellar, after his mother had worriedly removed her jars of preserves a safe distance from the "dangerous, poisonous chemicals," as she called them. "My only reliable information about developing," Steichen recalled, "came from the printed instructions in the box of plates. A few moments after I had put the first plate in the tray of developer and begun to rock it vigorously the image commenced to appear. And when I could identify it as the building I had photographed, I let out a terrific war whoop. My mother came rushing downstairs and called through the door to me, "Is everything all right?" I said, 'You bet it's all right!' She thought I had been poisoned and was in agony."

In his spare time, Steichen began to explore the basic levels of photography by taking pictures of all sorts of things: friends, relatives and group picnics (for 25 or 50 cents a print); pigs, hopvines and wheatfields for advertisements his firm prepared for clients; soft, misty woodlots he loved to walk in at the edge of town. When he discovered that raindrops falling on his lens transformed one of those woodland scenes into a more evocative picture, he wet his lens for other pictures; when he accidentally knocked his tripod or had the lens out of focus and found it gave him an impressionistic effect of light or movement, he used the technique again on purpose. "I knew, of course," said Steichen, "that trees and plants had roots, stems, bark, branches, and foliage that reached up toward the light. But I was coming to realize that the real magician was light itself...."

During his early twenties Steichen progressed to a new level. After a stint in Paris studying painting, but mostly taking pictures, he hung out his shingle as a portrait photographer in New York and joined Alfred Stieglitz in his pioneering efforts to establish photography as a unique art. It was in those years that he made his first commercial success as a professional and discovered ways of getting beneath the self-conscious poses people assume when sitting for a photograph; among his many portraits from this period is a classic one of the financier J. P. Morgan glowering at the camera, irritated with Steichen for suggesting an uncomfortable pose.

In World War I, Steichen became chief of the Army Air Service's aerial photography unit and served on the staff of General Billy Mitchell. In addition to an abiding horror of war, he gained a new respect for the technical powers of his medium, including the sharp, brilliant detail that was needed in pictures on whose proper interpretation soldiers' lives depended. In the 1920s and 1930s he moved to still another level, that of a skilled magazine photographer, capturing for the pages of *Vogue* and *Vanity Fair* the personalities of the famous people of the day—Greta Garbo, Charlie Chaplin, Mau-

rice Chevalier, Carl Sandburg (who had become his brother-in-law), George Gershwin, Franklin Roosevelt. He also developed studio lighting and posing techniques that helped turn fashion and advertising photography from artificialities toward a fresh, realistic approach. During this spectacularly successful period of his life Steichen became the most highly paid photographer in the world.

When World War II came, Steichen volunteered once more, at the age of 62, and became head of combat photography for the United States Navy. In addition to some famous battle photographs of his own aboard the carrier Lexington, he supervised a later film about carriers (The Fighting Lady) and two exhibits at New York's Museum of Modern Art ("Road to Victory," "Power in the Pacific"). Then, as the Museum's first Director of Photography, he turned the sum of his experience to a new role as curator, editor and teacher. creating some 40 more exhibitions, many of them introducing the work of talented younger photographers to the public. In 1952 he embarked on a project that was to become his eloquent answer to war: an exhibit he called "The Family of Man." With it he achieved for photography a level of communication that no one had before. In pictures of poor people and rich people, white people and black people, old people and young people around the world, he stunningly conveyed the oneness of life in all its aspects: birth, death, work, love, children, suffering, joy. The show was the most widely seen and probably the most widely felt exhibit in history, traveling in six editions to 37 countries. One American visitor to Guatemala reported that thousands of Indians came down from the hills, barefoot and on muleback, to see it, standing transfixed in front of photograph after photograph. Steichen was satisfied: "The people in the audience looked at the pictures, and the people in the pictures looked back at them. They recognized each other."

As he approached 90, Steichen retired with a lifetime of honors—and an "itch to photograph again." He began a whole new career at the highest level of photography, a pure search for meaning in nature, form and light. Increasingly, his efforts focused on a single subject that he could see from the windows of his Connecticut home: a tree he had planted himself some years earlier, a slender, lovely shadblow by a pond. An ardent amateur once more, he photographed his tree in all lights of day and moonlight, in all seasons, in snow and rain, with still and movie cameras, in color and black and white until shortly before his death in 1973 at age 94. "Here was something in nature," he said, "that repeated everything that happened in life." Capturing its beauty, its moods, its growth and progress was for Steichen the ultimate challenge, one that never ceased to renew itself. Each picture showed him something different about the subject: "Each time I get closer to what I want to say about that tree. There is an excitement about using the camera that never gets used up."

A Moment Preserved

In the hands of a perceptive person, the camera possesses a unique power: It is a matchless recorder of moments, of people and of place; it can reproduce the past with a fidelity no other medium can match. The classic photograph at right by Alfred Stieglitz demonstrates this power. For even the most casual viewer, the picture revives at once the look and feel of life in lower Manhattan during the 1890s. For a moment we are made part of a world of horse-drawn streetcars, antique street lamps and gentlemen in bowler hats—a world that time and change have now erased in almost every detail. Not only does the genius of Stieglitz permit us a glimpse of the dress, architecture and city transit of a departed era, but it enables us to share a precise and personal moment in the photographer's own life.

Stieglitz made the picture during his first lonely months back in New York after nine years of living and studying abroad. He later recalled the circum-

stances: "There was snow on the ground. A driver in a rubber coat was watering his steaming horses. There seemed to be something closely related to my deepest feeling in what I saw, and I decided to photograph what was within me. The steaming horses, and their driver watering them on a cold winter day; my feeling of aloneness in my own country, amongst my own people...." Today all these things still are contained in a moment marvellously preserved three quarters of a century ago.

Like the Stieglitz print, every photograph ever made freezes an image of something as it appeared at one instant in time. The pictures on the following pages demonstrate the power of the photograph to capture such fleeting moments—fragments of history, human faces and emotions, the look of an industrial town in New Jersey or a lonely hotel room in Maine—and to retain them virtually forever.

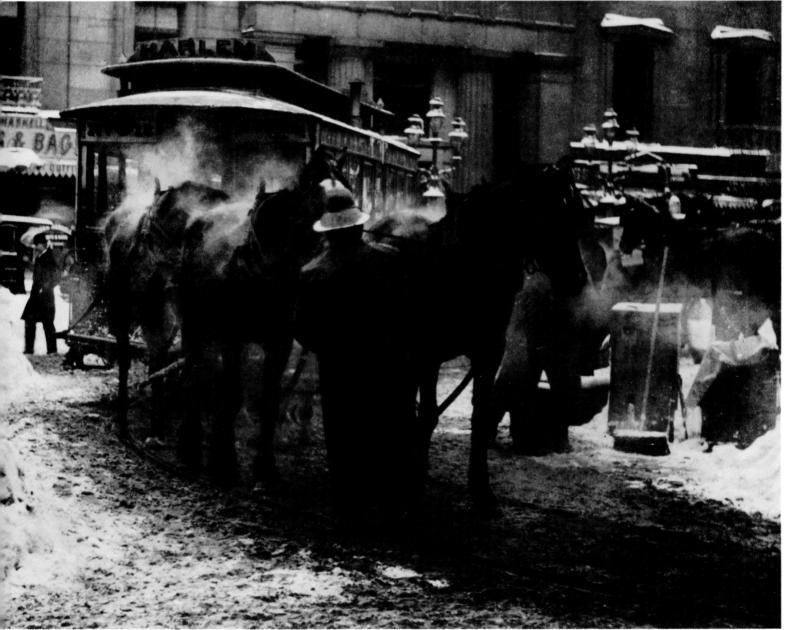

ALFRED STIEGLITZ: The Terminal, 1893

The Flavor of the Times

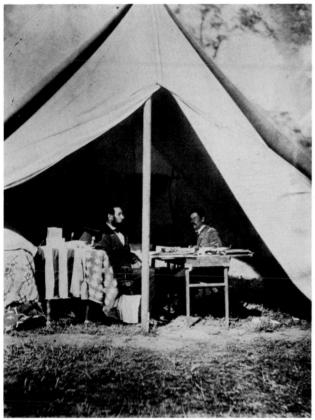

ALEXANDER GARDNER: President Lincoln and General McClellan at Antietam, 1862

JACQUES-HENRI LARTIGUE: Paris, Avenue des Acacias, 1912

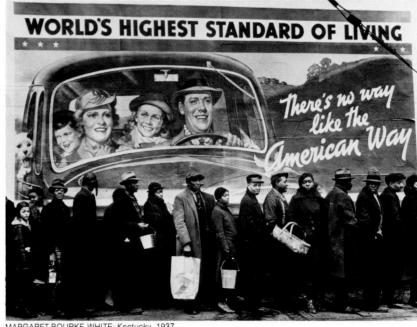

MARGARET BOURKE-WHITE: Kentucky, 1937

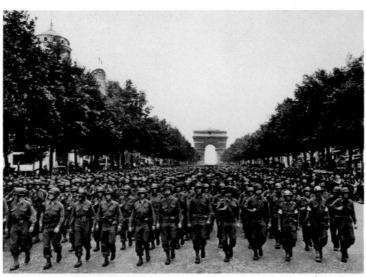

BOB LANDRY: The U.S. 28th Division Marching Down the Champs-Élysées, 1944

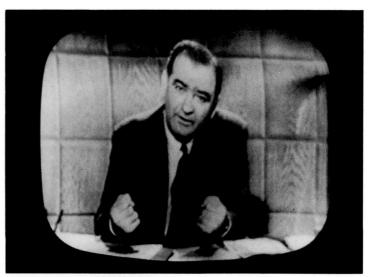

UNITED PRESS INTERNATIONAL: Senator Joseph McCarthy on Television, 1954

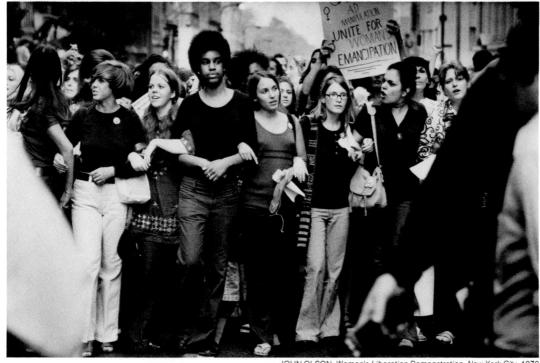

JOHN OLSON: Women's Liberation Demonstration, New York City, 1970

Faces in the Crowd

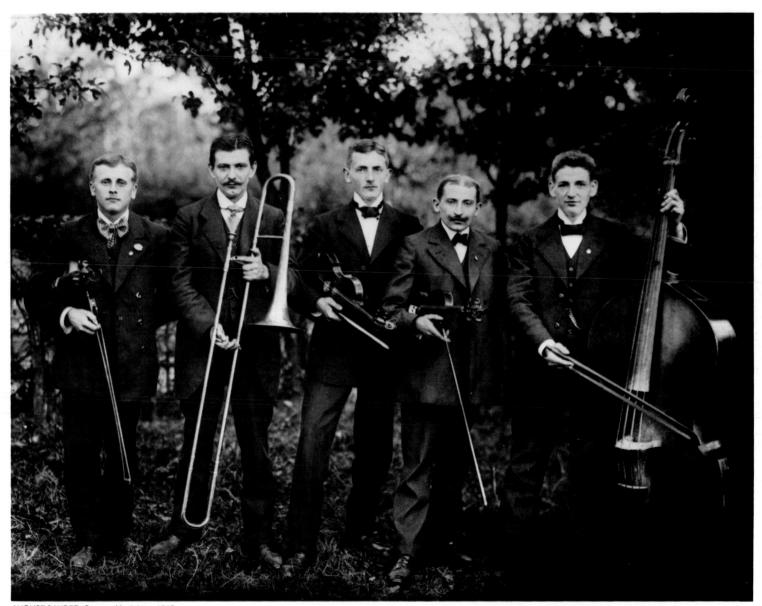

AUGUST SANDER: German Musicians, 1918

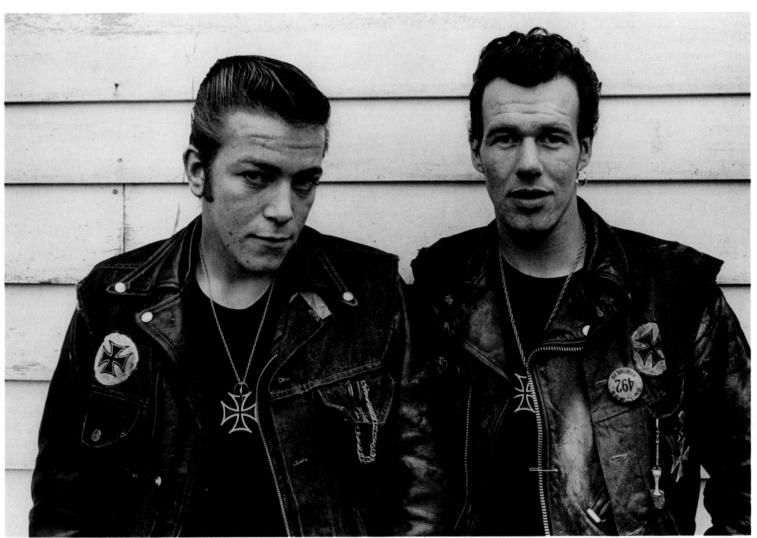

DANNY LYON: Sparky and Cowboy (Gary Rogues), 1965

A Sense of Place

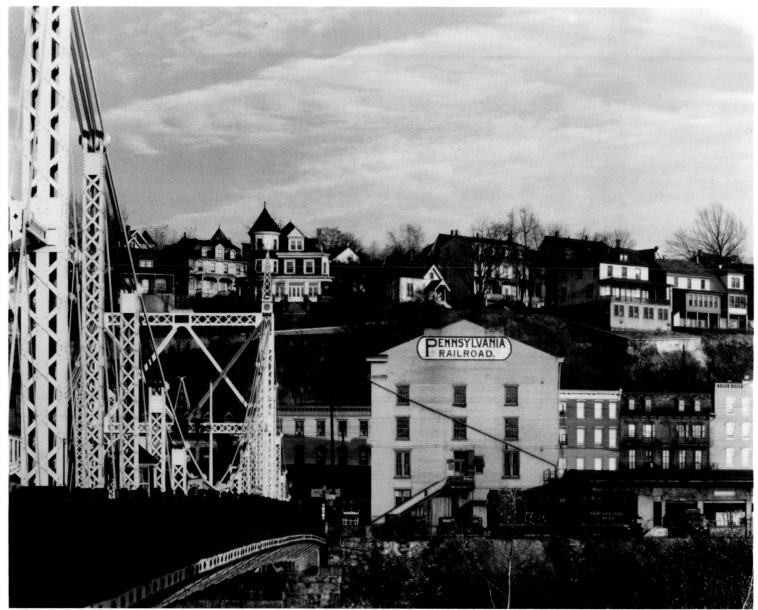

WALKER EVANS: Phillipsburg, New Jersey, 1936

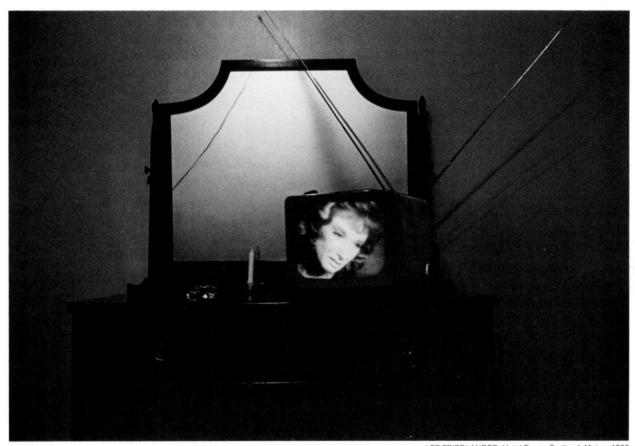

LEE FRIEDLANDER: Hotel Room, Portland, Maine, 1962

An Art for Everyman: A Moment Preserved **Suffering and Joy**

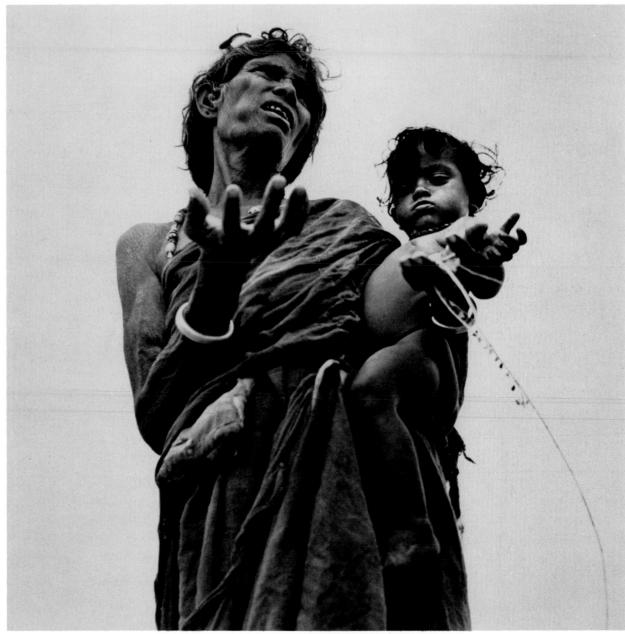

WERNER BISCHOF: Famine in India, 1951

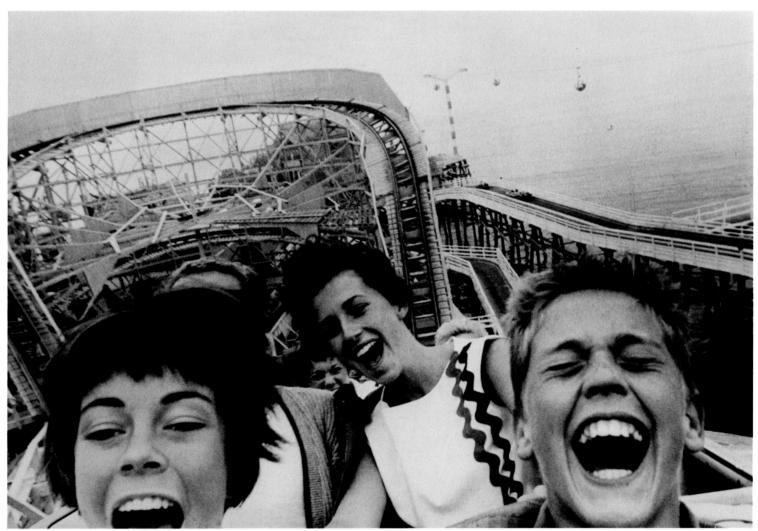

C. ROBERT LEE: Pacific Ocean Park, Santa Monica, 1960

The Historical Event

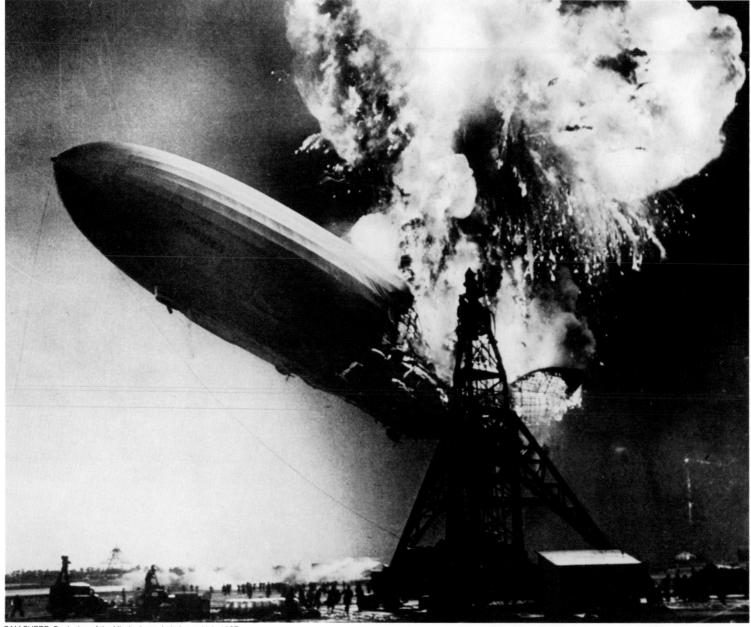

SAM SHERE: Explosion of the Hindenburg, Lakehurst, N.J., 1937

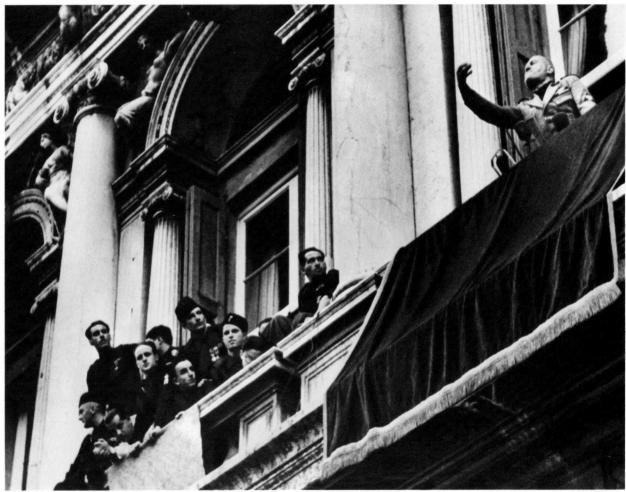

ALFRED EISENSTAEDT: Mussolini Addressing the Crowd in Venice's Piazza San Marco, 1934

Only the photograph can freeze for all time the unique moment, the event that stands out in history. Some such pictures are the result of careful planning; some just happen. In June 1934, *Life* photographer Alfred Eisenstaedt, then working for the Associated Press, went to Venice to cover the first meeting between Adolf Hitler and Benito Mussoli-

ni. He stationed himself at midday in front of a crowd in the Piazza San Marco and waited. When II Duce at last stepped onto a balcony to address the throng, Eisenstaedt snapped the memorable photograph above.

By contrast, when the German Zeppelin *Hindenburg* arrived at Lakehurst, New Jersey, on May 6, 1937, complet-

ing its 37th Atlantic crossing, Sam Shere of International News Photos had no inkling that he would be taking anything more than routine shots for the Sunday supplements. Then the huge airship suddenly exploded over his head, completely destroying itself in less than a minute. In an instant of tragedy, he shot the picture of a lifetime.

The Shocking Instant

Some pictures are so highly charged with emotion that they become unforgettable events in themselves. The United States Marines raising the flag on Iwo Jima was one such photograph; the living skeletons who survived the Nazi concentration camps were others.

One of the most shockingly memorable pictures from the war in Vietnam is the one at right, which, like that of the Iwo flag-raising, won a Pulitzer Prize. Edward Adams, an Associated Press photographer, snapped it at the very instant when Brigadier General Nguyen Ngoc Loan, South Vietnam's national police chief, put a pistol bullet through the head of a suspected Viet Cong terrorist, whose hands were tied behind his back.

During a bloody conflict so thoroughly recorded by the camera that the sight of one more death might hardly have been expected to stir a ripple, Adams' photograph was such a terrifying summation of war, death and man's timeless brutality to man that it immediately became a photojournalistic classic.

EDWARD T. ADAMS: Execution of a Suspected Viet Cong Terrorist, 1968

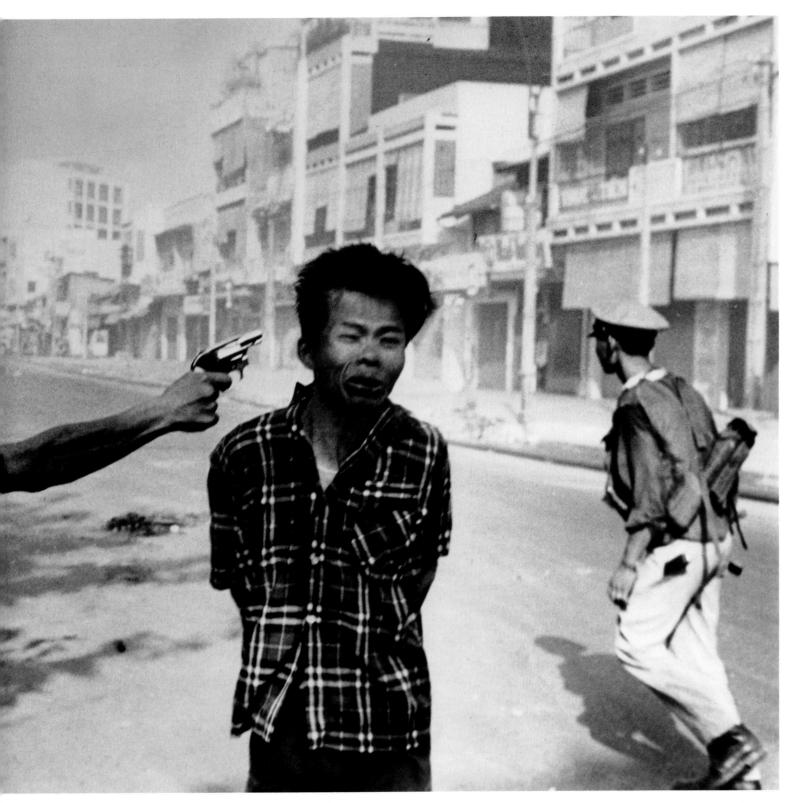

A Search for Beauty

From the moment it was invented, photography was accepted by most people for what it is: an unparalleled recording medium. But some photographers soon realized that if it were to win a place among the arts, its images had to go beyond mere record keeping—that photographs had to be beautiful and expressive in themselves.

In the beginning there were no rules for this new art form, no established body of artists or traditions to say what it should do. Inevitably many photographers relied heavily on what was going on in painting or sculpture at the time. This frequently led to amusing—even disastrous—results (Chapter 5). In a few cases it produced remarkably good pictures.

One example, from the so-called "pictorial" school of photography that was popular around the turn of the century, is the lovely study of a girl shown on the opposite page, made by the American photographer Gertrude Käsebier in 1903. Its

romantic pose, soft focus and moody lighting are remarkably similar to many paintings then in voque.

But even such graceful attempts to parallel painting slighted the unique power of the camera. Photographers began to recognize their medium as a virtually limitless means of showing others the world the way they saw it.

Photography, they found, could evoke the serenity of lakes and clouds or the rushing, hemmed-in quality of the city. It could celebrate sensuous natural forms in the female figure or even in a common vegetable; it could express people's personalities more convincingly by framing them in bold compositions of line and tone; it could arrest action at revealing moments. And finally, they discovered that by employing all the tricks of the darkroom, they could make photographs that altered the world of reality and fashioned it anew, creating a reality that exists only in the artist's mind.

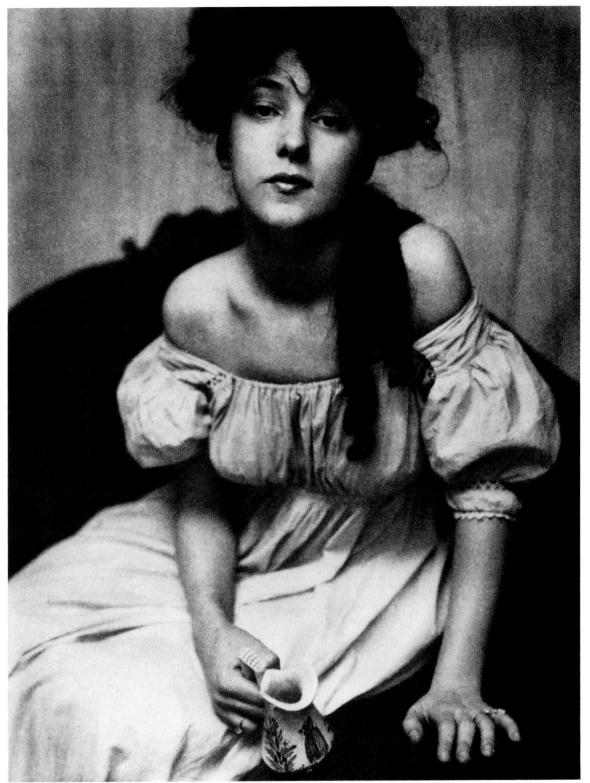

GERTRUDE KÄSEBIER: Portrait (Miss N.), c. 1903

An Emphasis on Composition

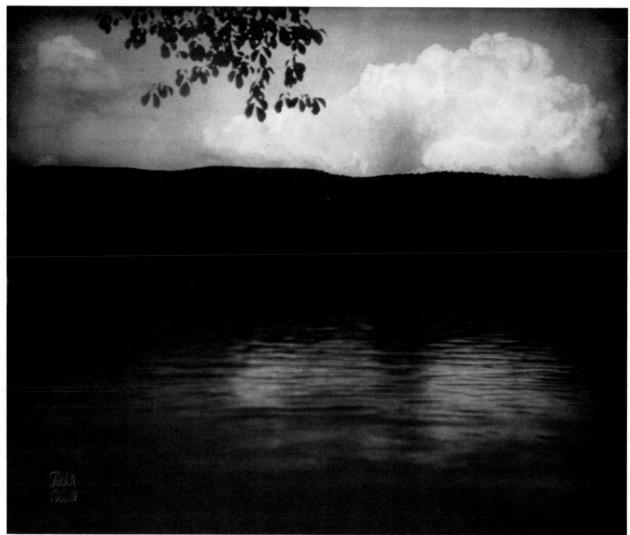

EDWARD STEICHEN: The Big White Cloud, Lake George, 1903

During the first decades of this century, the idea of using the camera to extract beauty from the surrounding world had already been well advanced by such men as Edward Steichen and Paul Strand. In the two examples of their

work shown here—the landscape above by Steichen, the cityscape opposite by Strand—documentary detail is almost nonexistent, the locations and other specifics are irrelevant. There are only the broadest generalities: water,

earth and sky; a building, a street, faceless pedestrians. The emphasis is on design; these are essentially compositions of contrasting masses and light and dark tones.

In the Strand photograph, the ele-

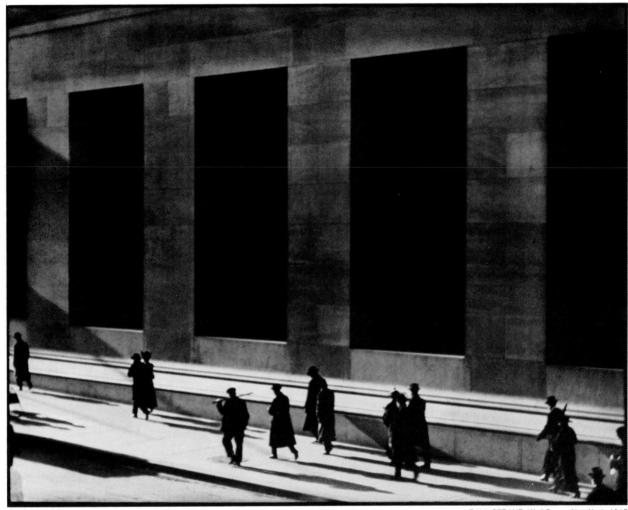

PAUL STRAND: Wall Street, New York, 1915

ments are the monolithic, almost ominous base of a Wall Street building with its heavy, rectangular window recesses looming over the fleeting black silhouettes of passersby. The Steichen picture of Lake George shows the ran-

dom curves found in nature rather than the straight, man-made lines of the city, but the artistic effect is similar; in both pictures the same kind of dark and light areas are balanced against one another.

The Sensual Shapes of Nature

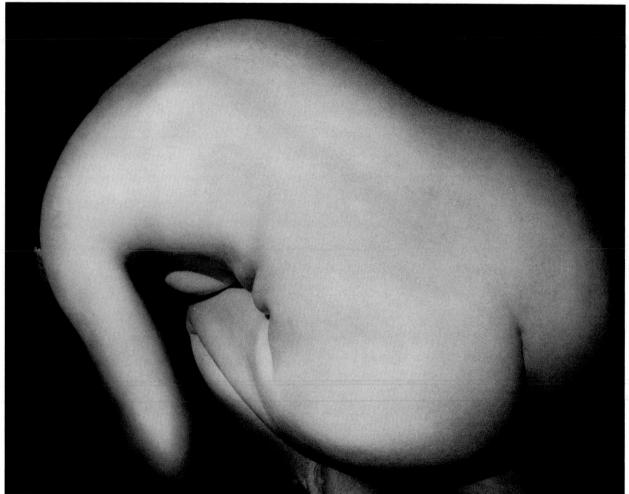

IMOGEN CUNNINGHAM: Nude, 1934

The ability of photography to celebrate the shapes of nature is strikingly shown in these two strangely similar photographs. In contrast to the voluptuous, faintly lustful approach of some 19th Century photographers to the subject of the nude, the view of the human body sought by many photographers of the

modern era, like Imogen Cunningham, is an expression of pure plastic form (above). In the same manner, men like Edward Weston went beyond conventional still life to find in a common pepper (opposite) the same kind of sensual, organic shape. Weston, who made hundreds of such studies of vegetables,

believed that with this picture he had succeeded. "It is classic," he wrote in his diary, "completely satisfying—a pepper—but more than a pepper: abstract, in that it is completely outside subject matter; . . . This new pepper takes one beyond the world we know in the conscious mind."

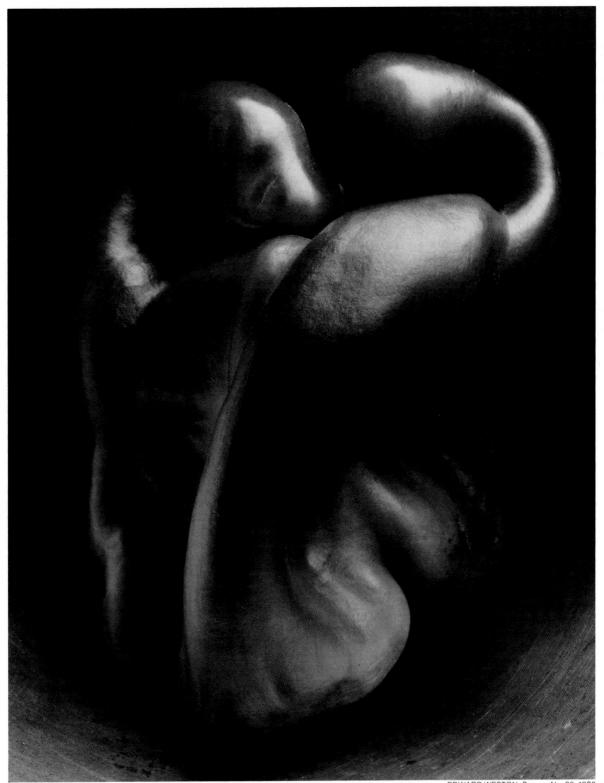

EDWARD WESTON: Pepper No. 30, 1930

Personality in Portraits

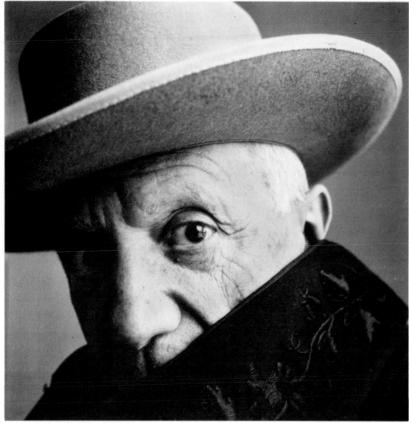

IRVING PENN: Picasso, 1957

A photographer making a portrait is driven by two powerful forces: his own creative approach and the personality of his subject. The results often vary widely but ultimately depend on bold selection and framing of what he sees.

"A great presence, deeply aware of his own image," observed Irving Penn of Pablo Picasso (above), who had dressed up for this picture in bullfighter's cloak and stiff-brimmed Cordoban hat. Penn, on assignment from Vogue magazine, let

the great painter pose himself, while he focused on the essence of the man, his "eye—round, quick, intensely black."

For a portrait of singer Carly Simon, freelance photographer Norman Seeff wanted to convey the sensuous, spirited mood of her songs. So he had the singer dress in a lacy camisole and high-topped boots, then made scores of shots as she assumed a variety of poses. His favorite frame (opposite) ended up on the jacket of Simon's album, Playing Possum.

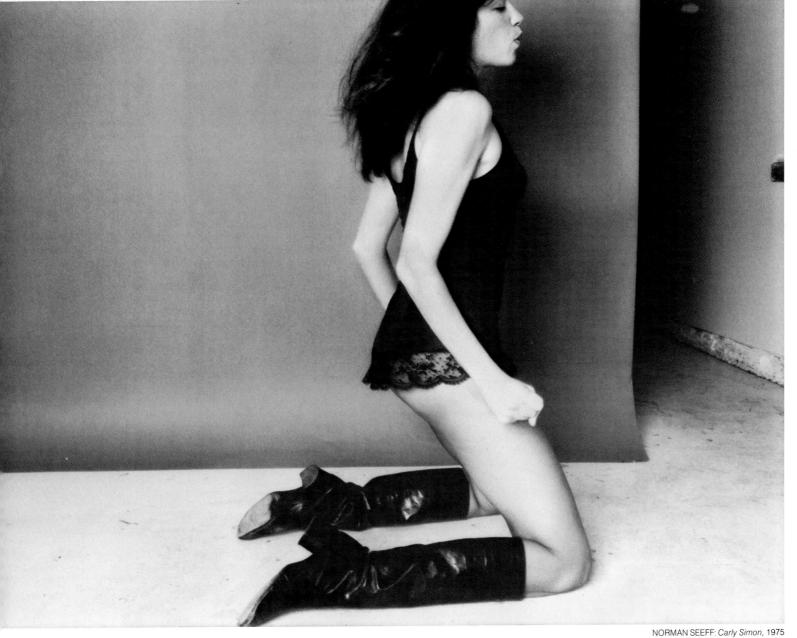

The Manipulated Print

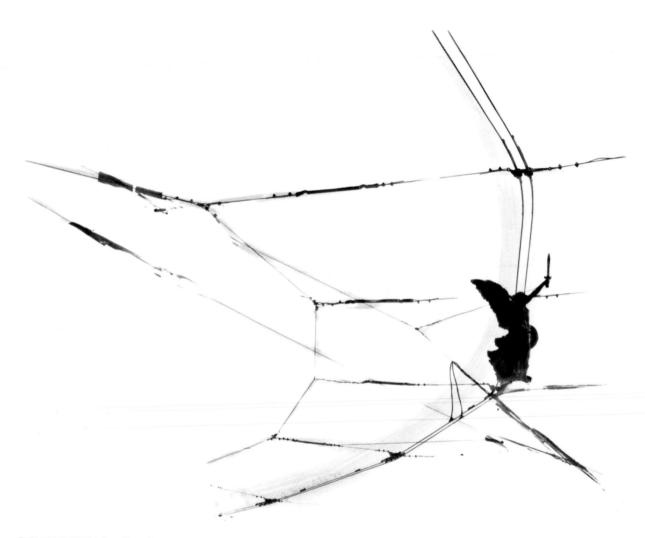

GERALD INCANDELA: Tram Lines, Rome, 1977

Discovery in photography can also take place after the shutter is snapped. To make the picture above, Gerald Incandela enlarged a negative of a Roman street scene on photographic paper in normal fashion. But then instead of immersing it in a tray of developing solution

as usual, he brushed the developer only on those areas of the printing paper where he wished an image to appear. Thus, only overhead tram wires and the figure atop a nearby statue are visible in the final print: the rest of the scene, untouched by the developer, is blank.

To create the photomontage at right, Jerry Uelsmann took three shots; he placed each negative in a separate enlarger, blended images by moving a single piece of printing paper from one to the other, then reversed some of the images and produced halo effects.

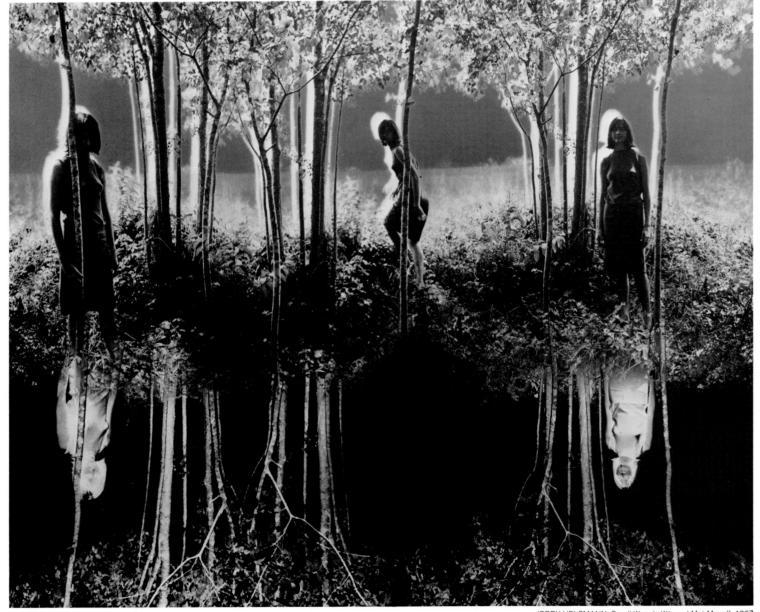

JERRY UELSMANN: Small Woods Where I Met Myself, 1967

The Impact of Color

The reality recorded by the earliest photographers was an illusory realm of black and white subtly shaded in gray. Shapes, patterns, lines, the interplay of light and dark are conveyed beautifully by black-and-white photography, as the pictures on the preceding 24 pages demonstrate. But there was one aspect of reality that the pioneers could not capture: color.

Although experiments in color photography were made even with daguerreotypes, practical methods for recording color did not come into use until after the turn of the century. Over the decades since, several processes of varying effectiveness—culminating in the simple-to-use films of present times—were introduced, and photographers began to explore the added dimension that color brings to photography.

The first color process to achieve wide popularity was Autochrome, which was invented toward the end of the 19th Century by two French brothers, Auguste and Louis Lumière. Autochromes are glass plates bearing a black-and-white emulsion that is coated with minute particles of dyed potato starch; after a plate is processed, the particles produce a delicately hued positive transparency.

Just two years after the Lumière brothers had created the Autochrome process— and six years after the Wright brothers had achieved the first manned flight—a photographic experimenter named Léon Gimpel used the process to

make the picture at right, showing the first major international aeronautical exhibition in the Grand Palais in Paris. Only because he employed color was he able to capture the splendor of the occasion. The predominant golden tones convey a richness of setting that could never have been recorded in black and white.

Color photography, by portraying the hues that the eye sees, heightens the realism of a picture. For certain kinds of photographs, the appeal of that extra realism is so strong that early color techniques, awkward as most of them were, found application in special fields. Some determined amateurs even took family snapshots with Autochromes, although they required uncomfortably long exposures in a view camera capable of using glass plates. But color was most appreciated in advertising and fashion pictures. to reveal the hues of commercial products, and in travel photographs, to convey the full impact of exotic scenes.

Understandably, the professionals who earned their livings photographing far-off places, fashion and advertising were among the first to make extensive use of color. Not until the years following World War II, after the advent of modern color slide and print films provided easy ways to make good color pictures in any type of camera, did color begin to dominate snapshot photography and find an increasingly important role in photojournalism and art photography.

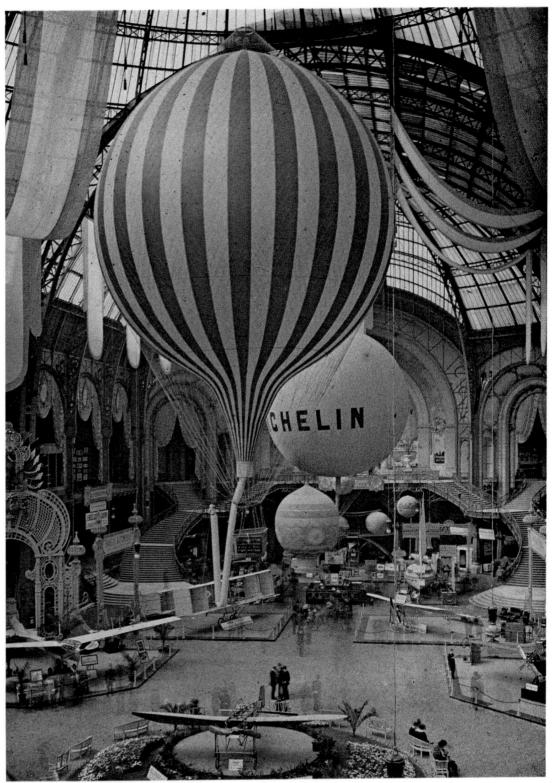

LÉON GIMPEL: Exposition Aeronautique, Paris, 1909

Glamorizing Fashions

Even before the introduction of practical modern color films brought color to millions, readers of fashion magazines saw full-color pictures reproduced from photographs made with a special camera that could take three black-and-white negatives, each through a primary-color filter. These "separation negatives" could then be used to create full-color prints by any of several methods.

Among the most beautiful of such color positives were those called carbro prints. They were produced by making three black-and-white prints, one from each separation negative. When each print was then pressed against a pigment-impregnated sheet, the sheet reacted chemically with the image in the print so that, after processing, the image was transferred to the sheet—but in shades of a primary color rather than shades of gray. The pigment images were superimposed on a paper backing to make a full-color picture.

One of the masters of carbro printing was Paul Outerbridge, a noted advertising and fashion photographer from the 1920s to the early 1940s. In the picture at right, Outerbridge used the carbro process not only to make vivid renderings of flesh tones but also to capture the subtle hues of planks, ropes and fabric.

More than three decades later Helmut Newton, working on a similar swimsuit theme but employing modern color film, took a more startling approach. When he photographed the poolside scene shown on the opposite page for a fashion magazine, Newton interjected dominant blackand-white elements that contrast with, and draw attention to, the sun-washed colors of the models and the pool.

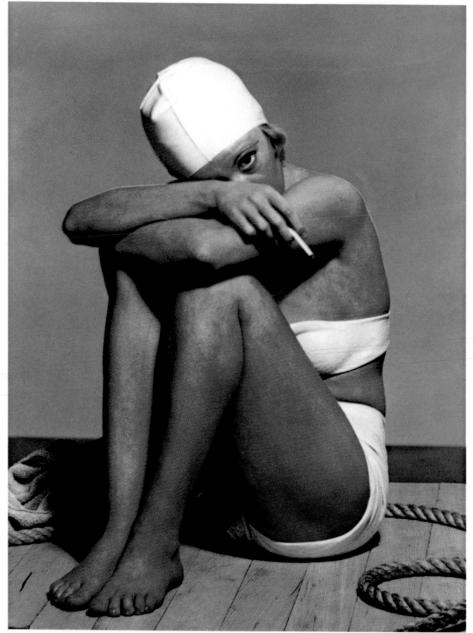

PAUL OUTERBRIDGE: Woman in Bathing Suit, 1936

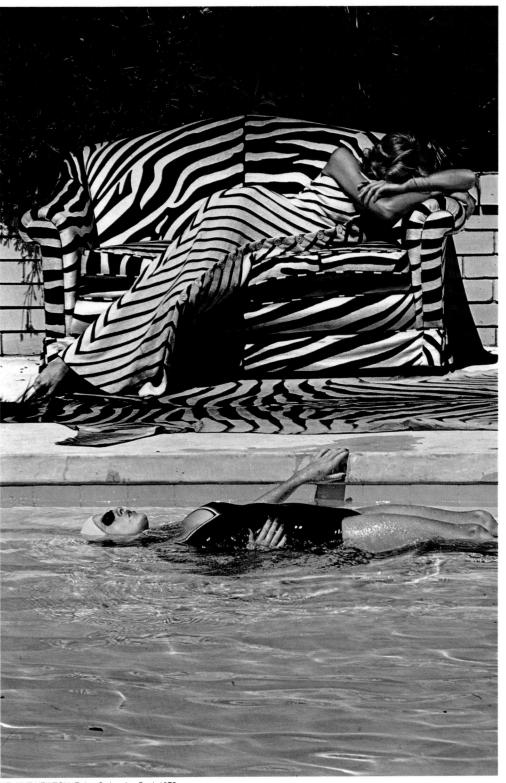

HELMUT NEWTON: Zebra Swimming Pool, 1973

Capturing the Exotic

An expanded understanding of the world and its peoples has been one result of the popularity of color photography. David Douglas Duncan, a noted veteran of Life's staff of photographers, took this dramatic picture of Egyptian women at prayer for a series of articles on the Islamic world. The occasion was the beginning of Ramadan, the sacred month in the Moslem calendar that is observed with dawn-to-dusk fasting. The setting was the plaza in front of Cairo's Abdin Palace, where the faithful gather at daybreak to worship on ceremonial canvas tarpaulins, hand-painted with bright designs, in early morning light.

Duncan's eye was caught by the striking contrast between the silhouetted figures of the women in traditional black hoods and robes, and the rich colors of the canvases. "I'm primarily a black-and-white enthusiast," says Duncan, "but color in a foreign country tells you a lot more than black and white—about the dress, the way of life. Here, the tarpaulin makes the difference."

DAVID DOUGLAS DUNCAN: The Dawn of Ramadan, 1954

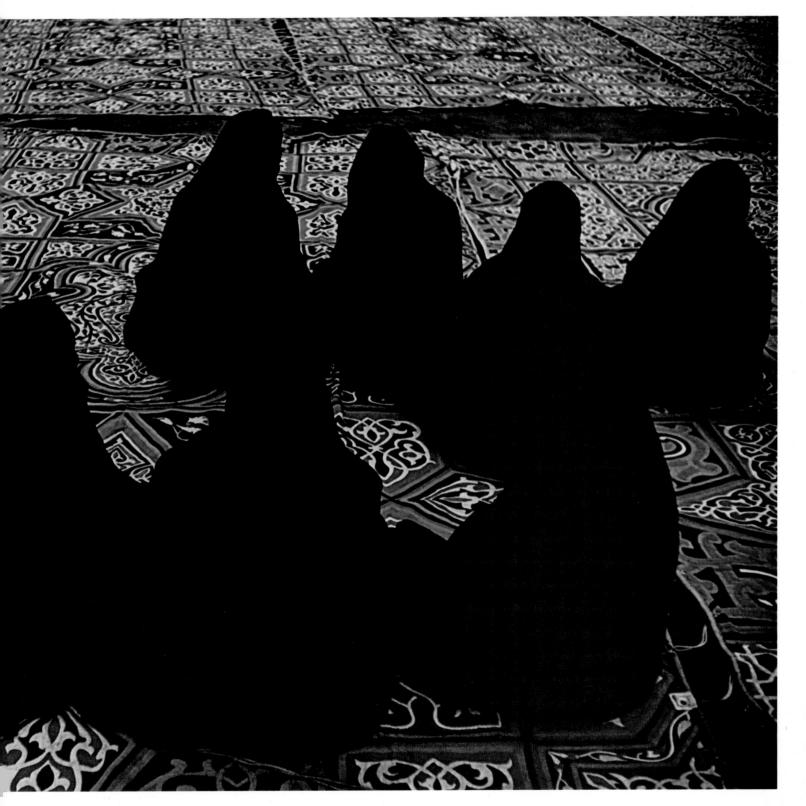

Transforming Landscapes

The exotic scenery of remote lands has long been a favorite subject for color photography. But some artists of today have discovered that it is possible to use color not only to record the reality of distant places but also to convey a more personal vision of nature closer to home.

One photographer who has provided an unusual view of his native landscape is Franco Fontana. By carefully selecting his camera angle and by shooting in the late afternoon when the sun's low rays tend to flatten out irregularities, he reduced a series of undulating hills in the Basilicata region of southern Italy to intersecting layers of lines and angles (*right*). Even the rich blue band at top is not immediately recognizable as the sky. "The landscape I choose becomes a reflection of my inner horizons," said Fontana.

A scene that seems remote to most viewers was also Richard Misrach's subject. But he took an even more unusual approach (opposite). Instead of standing back to encompass a broad, well-lit vista, he shot at dusk from the midst of tangled Hawaiian jungle foliage.

During a hand-held exposure of about 15 seconds he fired a powerful electronic flash, making vegetation within 15 yards of the flash appear sharply detailed but strangely drained of color. As he triggered the flash he deliberately jerked the camera slightly to the left. This separated what the camera recorded during the flash burst—details of foliage, the true colors of leaves and tree trunks—from what it recorded during the rest of the exposure, leaving dark, featureless silhouettes seen against the twilight sky.

FRANCO FONTANA: Italian Landscape, 1978

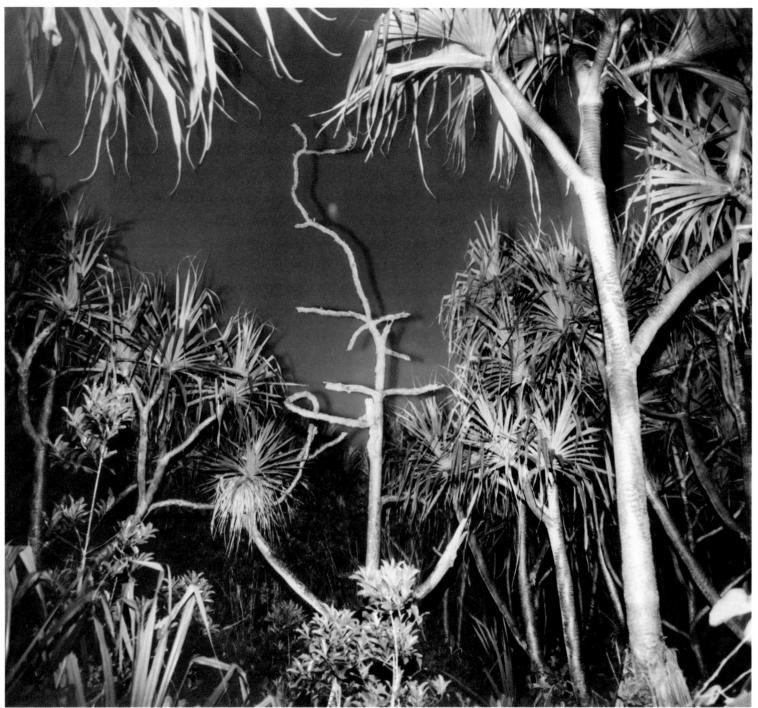

RICHARD MISRACH: Hawaii XV, 1978

An Extension of Vision

The human eye is a superb instrument, able at a glance to differentiate between subtle shades of color, to function in seashore glare or murky darkness, to focus on fine print or on distant mountains, to judge size, to register movement, to measure depth. But the eye has its limits. It can perceive only the form of electromagnetic energy that we call visible light: to other almost identical forms, such as heat and X-rays, it is blind. The eye is quick enough to follow the beat of a swan's wing, but not that of a hummingbird's. At 20 feet it can distinguish an object as small as 7/100 inch across, but nothing smaller. Most limiting of all is the eye's attachment to man himself; it goes where man goes - and nowhere else.

The camera frees man from such limitations on his ability to see. No one photographic process can do all the things that the eye can, and yet many can do things the eye cannot. There is almost nothing that one form or another of the mechanical eye and sensitized film fails to see. To register the effects of a nuclear explosion, for instance, scientists have snapped pictures showing what occurs in 1/200,000,000 second. Photographic plates are used to record the movements of the smallest things known—the minuscule particles that are produced by an atom smasher - and of the largest things known, stars that glimmer so distantly they too are invisible to the human eye.

Astronomers were among the first to put photography to work seeing the unseen. By the end of the last century they had already used the camera extensively to explore space. The photograph at the right, made by two French astronomers in 1894, shows the moon as it appeared

through the large telescope at the Observatory of Paris. It is one of a series of plates comprising the first systematic photographic survey of the moon and in its time it was a revelation. Today our concept of outer space is far more detailed and comprehensive primarily because of photographs. Men have carried cameras to the surface of the moon. Unmanned space robots have taken them farther still for a first look at parts of the solar system that are invisible from Earth. Even more important are detailed closeups of planets and moons radioed to Earth to give scientists information about the composition, weather - even the topography - of worlds millions of miles from our own.

The camera peers inward, too, revealing the infinitely fine warp and woof of matter. With the aid of X-rays, computers and radioactive materials it peels back the very tissues of life, laying bare the structure and ills of the human body; teamed with the microscope, it has recorded the moment of conception when an egg and spermatozoon meet.

By going where the eye cannot go and sensing what the eye cannot see, the camera has become an indispensable tool for investigating the natural world. At the same time it has provided an unexpected bonus. It is remarkable how many photographs taken purely for scientific purposes are truly beautiful simply as pictures to look at. "Beauty is truth, truth beauty," the poet John Keats wrote. The camera, whether focused on the atom or the stars, on a dancer's movements or a fly's eye, reveals much truth—and as the pictures on the following pages show, much beauty too.

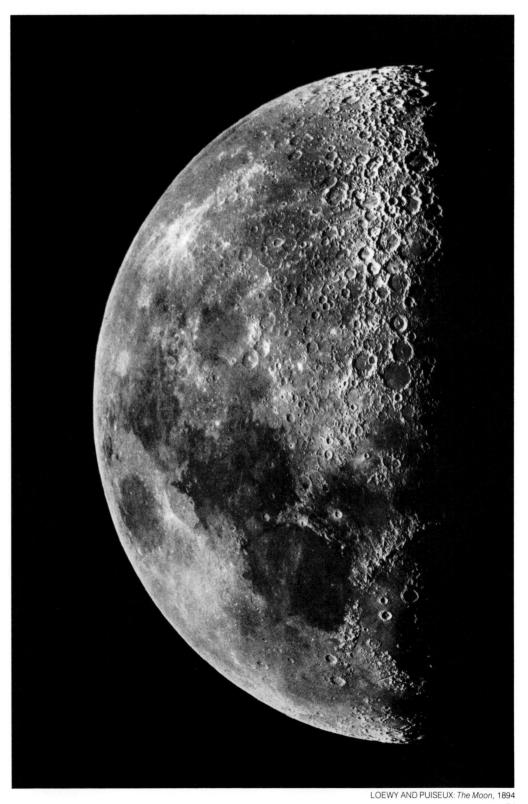

Crystallized Motion, Visible Time

A drop of milk falls into a saucer; a delicate coronet of liquid erupts and is gone. It happens too quickly for the eye to catch - but not too quickly for a camera equipped with an electronic flash. Harold E. Edgerton, who took this picture, pioneered ultra-high-speed photography at the Massachusetts Institute of Technology in the early 1930s. He developed an electronic flash of such high intensity and brief duration that it could make pictures at a speed of one millionth of a second - fast enough to stop a bullet in flight. Multiple exposures made with a rapid succession of these flashes produced an image of motion in progress across the film. Edgerton's strobe light provided scientists with a valuable tool with which to study everything from the movement of high-speed machinery to the strike of a rattlesnake. And in the hands of an artist like Gjon Mili it can capture the beauty of motion in the graceful sweep of a ballet dancer (opposite).

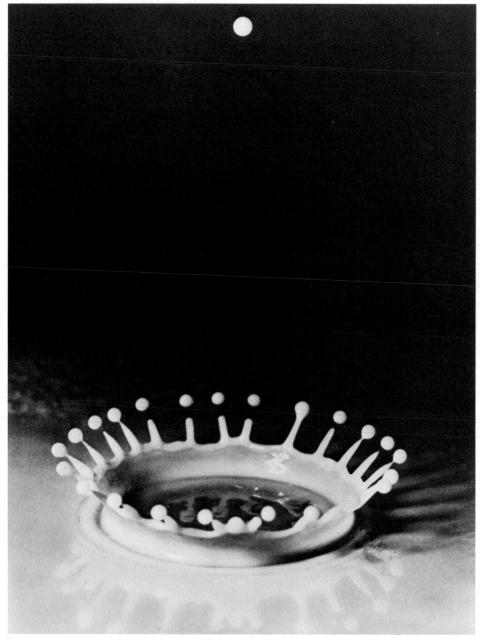

H. E. EDGERTON: Splash of a Milk Drop, c. 1936

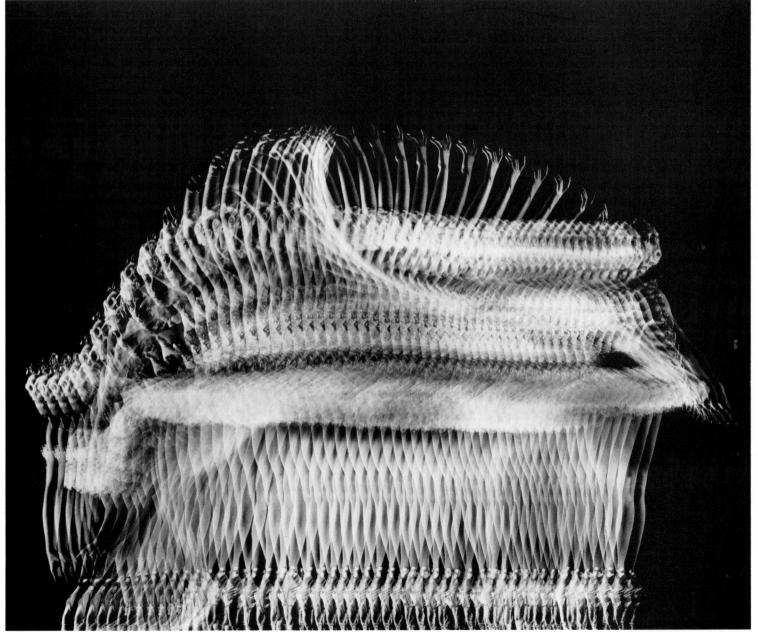

GJON MILI: Nora Kaye, 1947

Probing the Infinitesimal

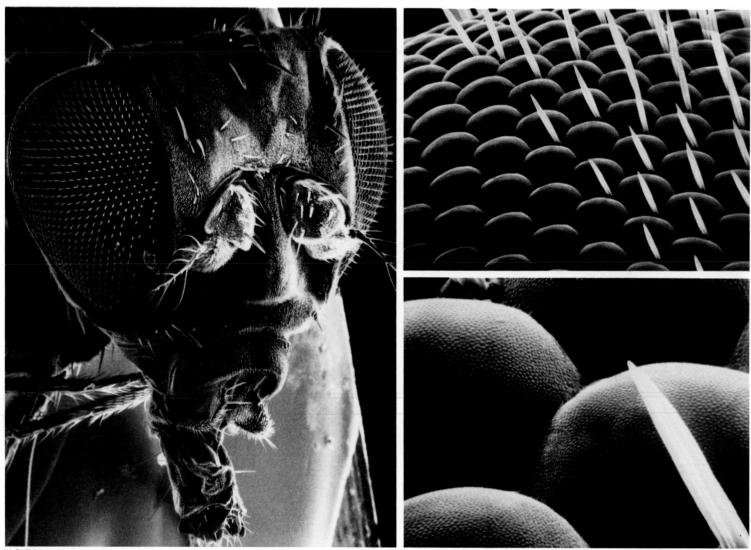

LLOYD BEIDLER: Eye of a Fruit Fly, magnified 250, 2,000 and 10,000 times, 1968

Teamed with the microscope, the camera uncovers a world most people never see. Above, a fruit fly reveals the eerie details of its multiple-lens eyes under successively more powerful magnifica-

tions. All three pictures were made with a scanning electron microscope—a device that can enlarge its subject as much as two million times by using a beam of electrically charged particles instead of

light rays. Opposite, a crystallized drop of horse urine, magnified 80 times, was photographed with two polarizing filters to turn its angled surfaces into a vivid geometric abstraction.

PHILLIP HARRINGTON: Crystal of Hippuric Acid, magnified 80 times, 1975

The Body's Wonders

Photographers, using special equipment and techniques, have been able to make visible many marvels of the human body. Swedish photographer Lennart Nilsson is one; he worked closely with doctors for years to create an extraordinary series of photographs that reveal the systems inside the human body. The picture at right is a greatly magnified detail of the female reproductive system. The flowerlike folds are the upper end of the fallopian tube, which catches eggs released by the ovary and conveys them to the womb.

Nilsson makes pictures for their beauty and their value in informing the public. "Somehow it's that which lies closest to people," says Nilsson, "that is the hardest to see and the most important."

Photography is also a medical tool. The photograph opposite is of an image on a TV screen showing a cross section of a patient's head. Ringed by a section of the skull, two brain tumors stand out in red on each side of the membrane separating the brain's hemispheres.

The image was made by a variant of the X-ray machine called a CAT (computerized axial tomography) scanner. The scanner has a doughnut-shaped device with an X-ray source on one side and an electronic detector opposite. They rotate around the patient's head, shooting an X-ray beam through a section of the brain. The detector measures the beam's intensity as it leaves the brain, and a computer converts the measurements into a cross-sectional image on a TV screen.

Extra computer programs make the image reproduced here more informative. Colors were added to distinguish brain tissues of different densities. Several cross-sectional slices were combined to give the image depth; the image also can be rotated for viewing from any angle.

LENNART NILSSON: Upper End of the Fallopian Tube, 1969

DAN McCOY: Brain Tumors, 1980

Scenes of a Distant Planet

After speeding through space for a year and a half and covering 595 million miles, the *Voyager 1* spacecraft swept past Jupiter in March 1979 and sent back spectacular pictures of the giant planet—the largest in the solar system. The photographs included not only the first sharply detailed, color views of Jupiter itself but also the first close-ups of its moons. The composite at right was assembled by scientists to indicate the position of the cloud-ringed planet (upper right) relative to four of its largest moons.

The pictures were taken with a special television camera equipped with a shutter to make individual still photographs. For each color picture, three separate exposures were required—one each through orange, green and blue filters. The signals generated by the TV-camera tube were not sent directly, as they are in ordinary television, but were converted into numbers and transmitted by radio back to Earth. The numbers, picked up by giant antennas in Australia, California and Spain, and then relayed to the Jet Propulsion Laboratory in Pasadena, California, were turned back into their original light intensities and reassembled by a computer into images.

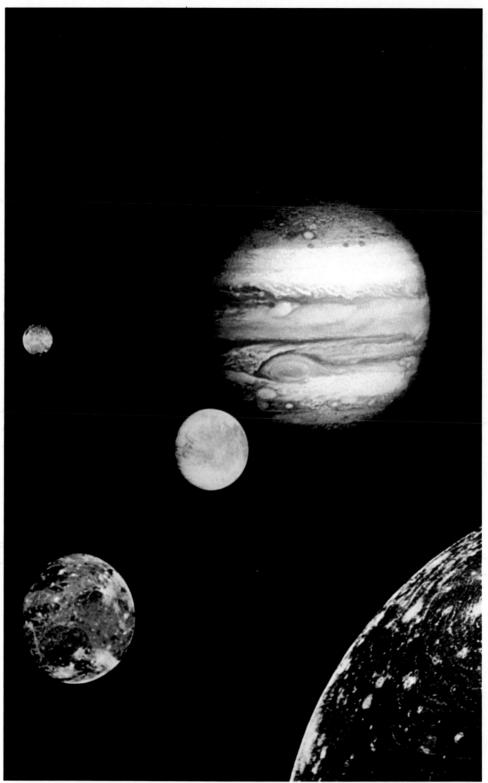

NASA: Jupiter and Four Moons as Seen from Voyager 1, 1979

The Anatomy of a Camera Explained 62

The Four Major Types 64

Viewfinder 64
Single-Lens Reflex 65
Twin-Lens Reflex 66
View Camera 67

On Choosing The Right Type 68

Understanding the Controls 72

Focusing Systems: Ground Glass 72
Focusing Systems: Rangefinder 73
The Shutter as a Controller of Light 74
The Shutter as a Controller of Motion 76
The Aperture as a Controller of Light 78
The Aperture as a Controller of Depth of Field 80
Using Shutter and Aperture Together 82
Setting Exposure Automatically 84

Using the Controls Creatively 87

Focusing for Essentials 88
Long Exposures to Span Time 90
Two Ways to Capture Action 92
Selective Blurring to Emphasize Movement 94
Multiple Exposures with a Motor 97

ANDREAS FEININGER: Photojournalist, c. 1955

The Anatomy of a Camera Explained

All cameras are basically alike. Each is simply a box with a piece of film in one end and a hole in the other. The hole is there so that light can enter the box, strike the chemically sensitized surface of the film and make a picture. Every camera, from the old box Brownie to a sophisticated model costing \$2,000, works this way. The differences are in how well and how easily they do the job, but the job is always the same: getting light onto film to form an image.

To do the job properly, certain things are needed; these are shown in the cutaway drawing at right. To begin with, there must be a viewing system, a sighting device that enables the user to aim his camera accurately at his subject. The hole that admits light to the camera -the aperture-must be made adjustable, by a device called a diaphragm, to control the amount of light entering. There must be a lens to collect the light and project an image on the film. There must be a movable screen—the shutter - to keep all light out of the camera until the moment arrives for taking a picture. Then a button is pressed, the shutter opens for an instant, just long enough to admit enough light to make a satisfactory image on the film. There must be a device for moving the exposed film out of the way and replacing it with an unexposed piece. Finally, there should be a focusing mechanism to move the lens back and forth so that it can project sharp images of both near and far objects.

All cameras except the very cheapest have all these features in some form. If that is so, then why are there so many different kinds of cameras? The reason is that cameras are asked to do so many different things, under such a

wide variety of conditions, that they have had to become specialized. A bulky studio camera has features that make it ideal for making portraits indoors; but for unposed pictures of children at a picnic it is not as good as a pocket-sized candid camera.

The next few pages constitute a short cram course in cameras, explaining which does what best and why. First, cameras will be divided into four basic types and the advantages and disadvantages of each system described. Following that, each type will be evaluated according to what it does best so that the reader, thinking over the kinds of pictures he wants to take, can decide which type is best for him—and seek out the particular model that suits his own skills and pocketbook.

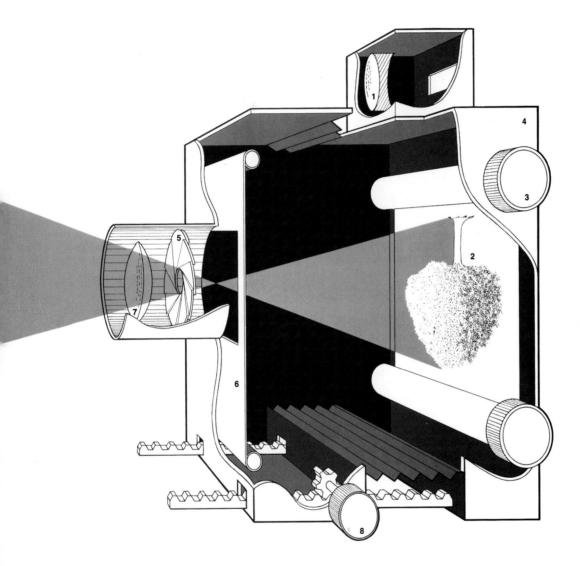

- 1 The Viewing System shows the scene the picture will cover, usually through a set of lenses (left) or the picture-taking lens itself.
- 2 The Film receives the image of the object being photographed and records this image on its light-sensitive surface.
- 3 The Film Advance winds film from one spool to another in cameras using film rolls or cartridges. In other cameras, which use sheets of film, there is a slot admitting one sheet at a time.
- 4 The Camera Body, a box that houses the various parts of the camera, protects the film from all light except that which enters through the lens when a picture is taken.
- 5 The Diaphragm, a light-control device usually made of overlapping metal leaves, forms an adjustable hole, or aperture. It can be opened to let more light pass through the lens or partially closed "stopped down" to restrict the passage of light.
- 6 The Shutter, the second light control, is a movable, protective shield that opens and closes to permit a measured amount of light to strike the film. The shutter mechanism, a complicated one on adjustable cameras, is represented here schematically as a lightproof curtain with an opening that admits light as it passes by the lens.
- 7 The Lens focuses the light rays from a subject and creates a reversed, upside-down image on the film at the back of the camera.
- 8 The Focusing Control moves the lens back or forth to create a sharp image on the film. The gear-wheel-and-track system shown here shifts the whole camera front; more commonly the lens alone moves by turning like a screw.

The Four Major Types

1 Viewfinder

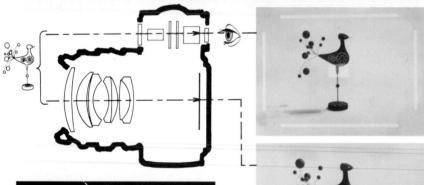

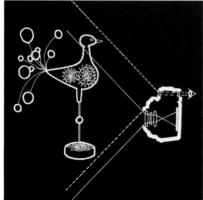

In viewfinder cameras light from the subject goes through the viewfinder to the eye and through another lens to the film (cutaway, center). The difference between these two viewpoints is called parallax error. Thus, even though the viewfinder covers the whole bird (broken lines in diagram at left), the lens does not (solid lines) and the bird's head will be cut off in the picture. Better viewfinder cameras automatically correct for parallax to match the views (above).

There are hundreds of different models of cameras, but all of them can be classified under four main types according to the viewing system they use. Of the four, the smallest and the simplest to operate are the viewfinder and small single-lens reflex cameras. They are basically eye-level cameras; you put them up to your eye and use them as a direct extension of your vision into the scene in front of you, making quick, candid pictures relatively easy to take.

The viewfinder in a viewfinder camera is a small peephole, usually equipped with a simple lens system that gives you an image approximating what the picture will be. In cameras with fully adjustable focusing, like the one shown, the viewfinder frames the subject more precisely and is linked to the lens by a device called a coupled rangefinder (page 73) so that the user can tell when his picture is in focus.

Advantages of the viewfinder: In its cruder forms it is inexpensive and has no moving parts to break down. In the more sophisticated rangefinder models it provides excellent focusing, particularly at low light levels and with wide-angle lenses, situations in which some other viewing systems do not function as well. Disadvantages: A simple viewfinder suffers from an inherent defect called parallax error (left) that prevents it from seeing exactly what the lens sees. Unless parallax error is automatically compensated for (as it is in high-quality cameras like the one shown here), it makes the viewfinder camera almost useless for carefully composed close-up work, such as portraits or pictures of flowers. Also, when a long-focal-length lens is used, images seen through the viewfinder are inconveniently small.

Obviously, the best way to see what the camera sees is to look right through the camera lens itself. This way you can frame the subject precisely and tell how much every part of the scene, from foreground objects to distant backgrounds, will be sharp or out of focus—something that cannot be done with the viewfinder, whose lens produces a sharp image of everything it sees.

The single-lens reflex camera can do this. With a mirror and prism (diagram, right) it enables the photographer to use the camera lens for composing and focusing pictures.

Advantages of the single-lens reflex: It eliminates parallax. It is easily and quickly focused, which makes it good for candid photography. Since the viewing system uses the camera lens itself, it obviously works equally well with all lenses—whatever the lens sees, the photographer sees, unlike the viewfinder camera, which cannot vary the viewfinder image to suit the picture-taking lens.

Disadvantages: The single-lens reflex is heavier and less compact than the viewfinder. It is also more complex and hence more liable to break down. Because it has a moving mirror, it is noisy; it makes a loud click when a picture is taken, compared to the almost inaudible click of a good viewfinder camera. If you are stalking wild animals or selfconscious people, this is a drawback. And because of the path the light travels to get to the user's eye—through lenses, off a mirror, then through a viewing screen and a prism—finding the critical point of focus under poor lighting conditions is often difficult. In this respect the viewfinder with rangefinder focusing is superior.

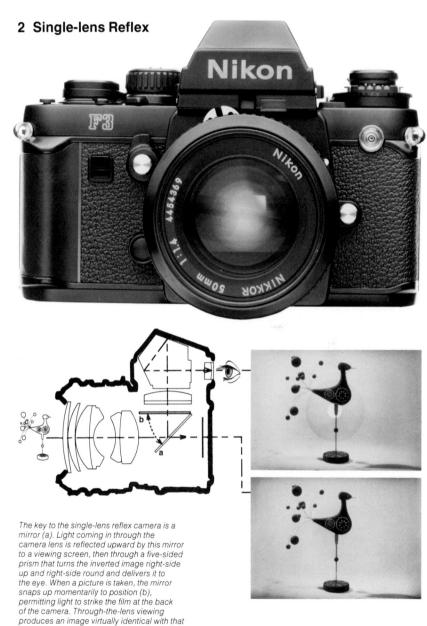

produced on the film (bird pictures at right).

3 Twin-lens Reflex

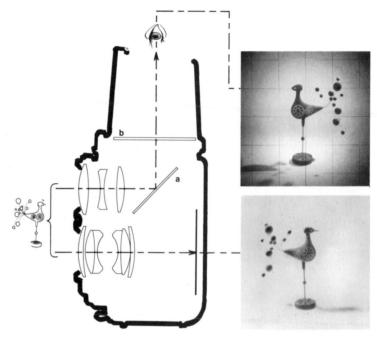

The twin-lens reflex, like the viewfinder camera, has separate viewing and picture-taking systems. Here they are stacked one over the other. The lower lens conducts light to the film. The upper one, coupled to the lower for focusing, conducts light to a mirror (a) set at a 45° angle, whence it is reflected upward to a viewing screen (b). Like all mirror reflections, the image appears reversed left to right, as shown by the top photo. The top photo also shows a grid of hairlines etched on the viewing screen to help compose the picture more accurately.

Many photographers prefer that the image they see be projected onto a flat surface rather than seen from eye level. In this way the photographer can turn a three-dimensional scene into a two-dimensional picture, something that he can study and compose carefully.

The twin-lens reflex camera does this. Like the single-lens reflex camera, it also uses a mirror that reflects an image of the scene upward onto a viewing screen. But its mirror is fixed, which means that there must be one lens for

the camera and a second one for viewing. These are coupled mechanically, so that when one is in focus, the other is also.

Advantages of the twin-lens reflex: The fixed mirror means simple, rugged construction and quiet operation, and the viewing screen permits convenient accurate composition. Because the photographer looks into this camera from the top, he can lower it to waist level or even place it on the ground—an awkward angle for an eye-level viewfinder

—for photographing babies or pets. Disadvantages: The principal problem is parallax error, although the best twin-lens reflexes have automatic parallax correction. Another drawback is that the image projected on the viewing screen is reversed left to right, which takes some getting used to. The larger size of the twin-lens reflex, while permitting larger film, does make the camera somewhat more cumbersome for candid work. On most twin-lens reflexes, lenses are not interchangeable.

4 View Camera

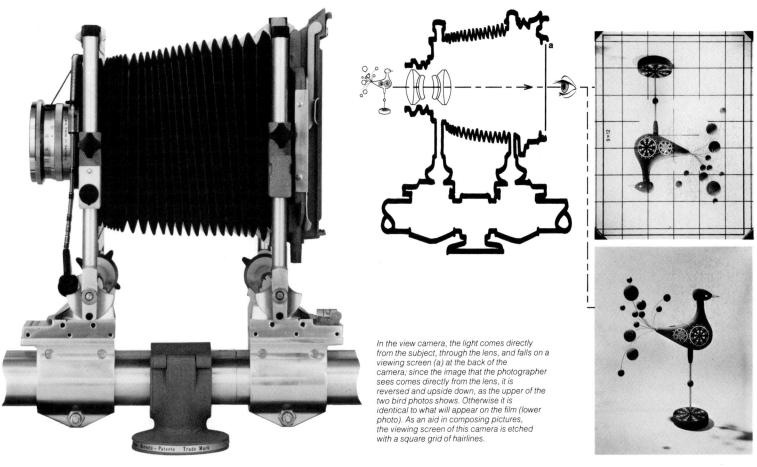

Can one get the benefits of throughthe-lens viewing and a large, picturelike image on a glass viewing screen — all in one camera? Indeed one can. In fact that is the oldest and most direct kind of viewing system that exists. The modern cameras that use this system, called view cameras, are generally built like an accordion, with a lens at the front and a viewing screen at the back. Focusing is achieved by moving the lens end forward or back until a sharp image is seen on the viewing screen. Advantages of the view camera: The image on the viewing screen is projected directly there by the picture-taking lens, so what the photographer sees is exactly what will be on his negative; there can be no parallax error. Furthermore, the viewing screen is very large, permitting detailed examination by magnifying glass to check sharpness of focus in all parts of the picture. The film size is also large, giving sharp detail in large pictures. The camera itself is adjustable, permitting the photographer

to tilt and twist it to correct problems of focus, perspective or distortion.

Disadvantages: The most serious is the bulkiness of the camera; you must use a tripod. Second most serious is that the image projected on the viewing screen is not very bright, and the photographer, to see it better, must put a cloth over his head and the back of the camera. Finally, the image appears reversed and upside down on the viewing screen. Photographers get used to this, but it is disconcerting at first.

On Choosing the Right Type

Since each of the four viewing systems just described has certain advantages over the other three, it follows that the cameras that they are built into will also tend to be different, in order to exploit whatever it is that the viewing system is best at. Therefore, in choosing a camera, the would-be photographer should have a clear idea of what he wants a camera for—what kind of pictures he wants to take—and then think about what kind he should buy.

Described below are characteristics of the four main types, although it should be borne in mind that there is actually a good deal of overlapping between types. Considerations of size, weight, ease of handling, picture quality—and, above all, price—are not absolutes. Nevertheless the types do stand out; once a photographer knows what he wants to do, he should have no difficulty in deciding which is the type for him.

1 Simple viewfinder cameras

Since the viewfinder is the simplest and usually the least expensive of all viewing systems, it is found on most of the cheapest cameras. Such cameras also lack some of the controls found on other cameras. These descendants of the old-time "box Brownie," simple as they are, are still the best choice if the only pictures required are occasional snapshots of family life, sightseeing views and groups of friends or relatives. Most take instant-loading film cartridges—including the tiny, economical 110 size—which make it easier than ever to insert film and remove film after it has been used. Some are designed for instant film. Most have built-in or attachment flash units to provide properly exposed pictures even in dim light. When the camera is loaded and the shutter cocked, the user simply aims it at his subject by looking through a simple viewfinder window that is little more than a peephole. Click—he has a picture. A reliable camera that will do this can be bought for the price of the shirt whose pocket it fits.

Why, then, pay more? Because the very simplicity of this camera puts severe limits on what can be accomplished with it. In the first place, the photographs it takes may be sharp enough to be displayed in the family album, but if they are enlarged greatly they will turn out to be unacceptably fuzzy. Second, the subject has to be standing relatively still or his image will be blurred. Finally, there is a rather awkward limit on how close the subject can be; anything closer than four or five feet again becomes blurred.

These are all handicaps and a camera buyer can overcome them simply by spending money. He can get a camera with a sharper lens and controls over focusing and exposure. At greater expense, he can get one with a rangefinder-focusing system. For more money there are other devices that focus the lens and set the aperture (or shutter) automatically, and signal to him when the light is so dim he cannot take a picture at all—or even automatically fire a built-in

flash. For still more money there are cameras with fast-moving shutters that permit taking pictures of fast-moving objects.

It is possible to go a step further and, at even more expense, purchase a viewfinder camera that not only has fully adjustable controls but also can be fitted with interchangeable lenses. Such a camera fills many of the same requirements as the cameras described below, for it shares many of their advantages and disadvantages.

2 Single-lens reflex cameras

If the photographer wants more flexibility than a box camera can provide he should look for a camera that has controls that allow him to adjust at will the sharpness of focus, the amount of light reaching the film and the speed with which the picture is snapped. If he is also looking for compact size, lightweight, inexpensive film and the kind of handiness that enables him to make photographs quickly and unobtrusively, then a single-lens reflex (or a high-quality rangefinder-focusing viewfinder camera) will probably be the best camera for him.

The single-lens reflex camera, or SLR as it is commonly called, is distinguished by extraordinary versatility. This is a result of the viewing system: The photographer looks through the picture-taking lens at the very image that will be recorded on film. He thus can fit his camera with any lens or filter and still see exactly what the camera sees. He can frame and focus precisely, whatever the lens or filter being used. Manufacturers produce a vast array of lenses and other accessories that can be fitted to their cameras for this or that special function. If he can afford the hardware, an SLR owner can turn his camera from a photographic microscope into a photographic telescope in a few seconds by uncoupling one lens or attachment and substituting another.

Practically every SLR also measures light directly through the lens with a built-in light meter. The meter thus compensates automatically for changes in lenses or filters, and gives an exact reading of the light that will actually strike the film. This reading either enables the photographer to adjust aperture and shutter speed for correct exposures or allows the camera to make the adjustments automatically. Some SLRs accommodate automatic electronic flash units that couple with the camera's electronic controls to coordinate their light output and the camera's shutter speed with the aperture and film being used.

With or without automatic exposure control, the functions of SLRs are more and more being governed by the camera's electronic circuitry rather than by mechanical (and breakable) moving parts. With a fully automatic SLR, a photographer just focuses and shoots; other automatics oblige him to set either the aperture or the shutter speed (pages 84-85). A few expensive models offer a choice of aperture or shutter automation, and nearly all have a means of over-

riding or shutting off the automatic system to cope with tricky situations.

Most SLRs take 35mm film but all of them are somewhat bulkier than 35mm viewfinder cameras. There are a few very compact SLRs that take 110 film, and a growing number of larger, generally more expensive SLRs that use 120 roll film and produce square or rectangular pictures that are substantially larger than those made on 35mm film.

3 Twin-lens reflex camera

The twin-lens reflex camera is really a compromise, a sort of halfway station between the compact viewfinders and SLRs and the fourth general type, the true view camera. For the photographer who wishes larger pictures than 35mm and is willing to give up a little in the way of compactness and ease of handling to get it, this type (page 66) should be considered. Like the larger SLR, the twin-lens reflex has a large ground-glass screen that aids careful composition. It can be viewed from above, or used at eye-level with an accessory prism.

All twin-lens reflex cameras offer a full range of exposure and focus settings, but in other respects they are less versatile than SLRs. The twin-lens reflex viewing system requires that lenses come in pairs, with the result that most models do not accept interchangeable lenses and those that do can accept only a few. There is no twin-lens reflex that is equipped with automatic exposure control or motorized film advance.

On the other hand, the twin-lens system offers some distinct advantages over SLRs. Because there is no mirror behind the picture-taking lens that must be shifted out of the way every time the shutter is clicked, the twin-lens reflex is quieter and sturdier than the SLR. It also keeps the subject visible on the viewing screen even while the shutter is open. Thus the photographer can keep an eye on what the camera is recording during long exposures or observe the subject during the instant when the shutter is released.

The shutter itself on a twin-lens reflex presents another advantage. A leaf shutter (page 75), it synchronizes with electronic flash at any shutter speed, while the focal-plane shutters on almost all SLRs can be used with flash only at a speed of 1/60 of a second or slower. Using flash with his twin-lens reflex set at motion-stopping shutter speed, the photographer can freeze subjects that are already partially illuminated—a particular advantage when shooting at weddings or parties.

4 View cameras

The largest and most cumbersome of the four main types of cameras, the view camera is practically useless for candid or action photography. But for architectural studies, studio nudes, landscapes, still lifes, portraits—anything that demands a large, high-quality picture arranged as the photographer likes—

the view camera is superb. Its versatility is almost unlimited, for it can be fitted not only with any type of lens but also with various shutters and film-holding backs among other accessories. It comes in a variety of sizes that produce negatives ranging from 2½ x 3½ inches to 20 x 24 inches; the large pictures have a fineness of detail and subtlety of tone that cannot be equaled by those made with smaller cameras. Nor can a small, rigid-bodied SLR or viewfinder camera accomplish the swings and tilts a view camera's lens and film plane perform to control distortion, focus and perspective.

The most popular view cameras are 4 x 5-inch models. Some of these, called field cameras, are designed for use outside the studio. Their controls are more limited than those of studio view cameras, but field cameras are lighter and more compact and can be neatly folded for carrying. Practically all view cameras must be mounted on tripods.

In short, starting with the lightest and simplest kinds of cameras, and moving toward the largest, the photographer will find something along the line that fits what he thinks he wants to do. But before he buys, he should learn as much as he can about the differences among the various types of cameras. One of the commonest mistakes amateurs make is buying too expensive a camera for their purposes. A \$600 instrument will *not* give pictures that are six times as good as those taken by a \$100 camera. The important factor in getting good pictures is not the fancy price tag or the prestige name, but the photographer. If he is skilled he can get good pictures with a snapshot camera. There will be many shots that he cannot take with that limiting instrument, but those that he does get will—if he is an artist—be works of art.

There is a temptation to splurge on equipment and the professional often must. He is willing to lay out hundreds or thousands of dollars on lenses and special camera bodies because he expects every piece, every feature, to enable him to do something specific. Unless you know what to do with such special features, how to exploit them, you do not need them. Get a modestly priced camera of proved make and learn to use it. When its limitations really begin to bother you, then is the time to move up. There are altogether too many top-of-the-line Hasselblads, Nikons and Leicas that are gathering dust on closet shelves right now, owned by people who shoot no more than half a dozen rolls of film a year, who have never learned to exploit the special features they have paid big money for and who probably never will.

Understanding the Controls

1 Ground Glass

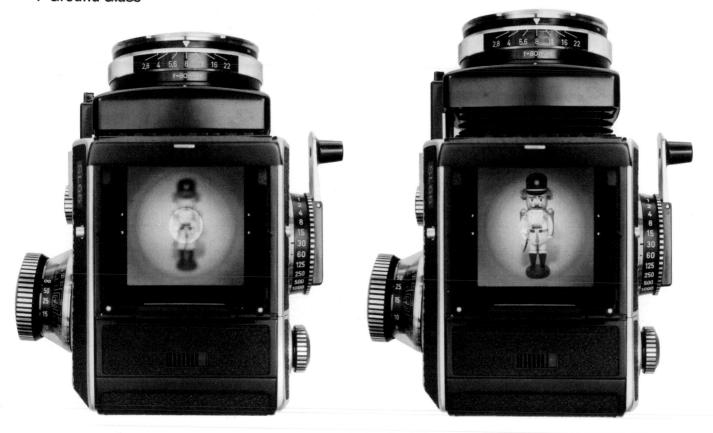

There is no more important control on a camera than the focusing control; competent photography begins with a sharp picture. Most cameras focus with a viewing screen or a rangefinder; a few have automatic focusing systems.

A rangefinder is easier to use for some photographers, particularly in dim light; the photographer adjusts focus until a double or split image appears as one (opposite) in a bright viewfinder. The lens is mechanically linked to the rangefinder so that when the finder image is aligned, the lens is focused.

In reflex and view cameras, light from

the lens hits an etched or "ground" piece of glass or plastic. Its semiopaque surface displays an image that can be focused by adjusting the lens (above). To facilitate focusing in dim light, a ground glass generally has a central spot, created by prisms, that seems to shimmer or shift until precise focus is achieved.

One automatic focusing system that is based on the rangefinder uses electronic controls to align images and focus the lens. Other systems emit waves of sound or infrared light and gauge distance by measuring the time it takes for the waves to bounce back from the subject.

In this reflex camera a mirror reflects the image from the lens upward onto a ground-glass screen. Since the ground glass at the top and the film at the back of the camera are the same distance from the lens, the image that falls on the screen will be sharp only when the lens is properly in focus. At left, above, the focusing knob on the left side of the camera is incorrectly set at 25 feet, producing a fuzzy image of a toy soldier 15 feet away. But when the knob is set for 15 feet (above, right) the image the photographer sees is sharply defined.

2 Rangefinder

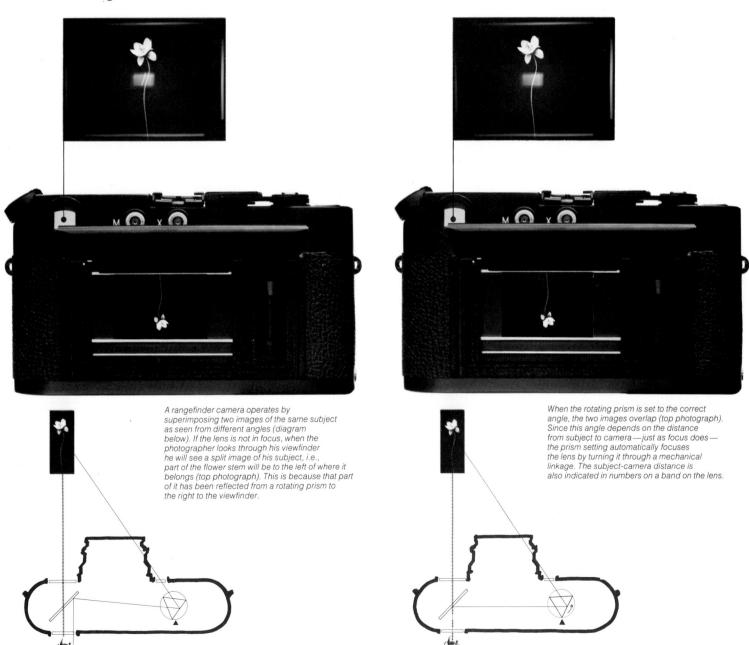

The Shutter as a Controller of Light

1 Leaf Shutter

One of the greatest advantages of an adjustable camera is that it can take pictures in blazing sunlight and in semi-darkness, and under any light condition in between. There are two controls that make this possible: the shutter, described here, and the aperture (pages 78-79). Both have the same function: to control the flow of light into the camera.

The shutter controls light flow by the amount of time it remains open: for a second, half a second, a quarter second—all the way down to 1/2000 second in some models. Each shutter setting is approximately half that of the previous one, so the photographer has an orderly choice of speeds available to him. Most cameras also provide for "time exposures" that allow the photographer to keep the shutter open for minutes or hours, as long as he wants.

There are two principal types of shutter on adjustable cameras, the leaf shutter, shown on this page, and the focal-plane shutter, shown opposite.

The leaf shutter consists of a number of small, overlapping metal blades powered by a spring; when the shutter release is pushed, these blades open up and then shut again, in a preset amount of time. In the examples at right, the blades are just beginning to swing open at (1) and no perceptible light is hitting the film. At (2), with the shutter farther open, the blades are almost completely withdrawn and at (3) light pours in. Then the blades begin to close again, admitting less and less light (4, 5). The total amount of light admitted during this cycle produces the fully exposed photograph (6). The leaf shutter is often located in the lens itself at (a) above.

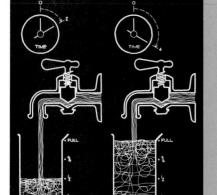

The amount of light that enters a camera, like the amount of water that pours from an open faucet into a glass, depends on how long the flow of light continues. If a glass is filled halfway in two seconds, it will be filled to the top in four seconds. In the same way, if the shutter is left open twice as long, twice as much light will be available to expose the film.

2 Focal-Plane Shutter

The focal-plane shutter is located in the camera itself—just in front of the film, or focal, plane—rather than in the lens. This is one advantage over the leaf shutter, since the focal-plane type serves for any lens used on the camera. But more importantly, because there is no shutter in the lens, you can look directly through the lens while focusing without exposing the film. There is another advantage also. Since the leaf shutter has to open, stop and then reverse direction to close again, most shutters of this type are limited to speeds of 1/500 second or slower.

The focal-plane shutter has a simpler mechanism that permits speeds of up to 1/2000 second. It is two overlapping curtains that form an adjustable slit or window. Driven by a spring, this window moves across the film, exposing the various sections of the film as it moves. The shutter can be adjusted—fast or slow, narrow slit or wide, depending on the desired exposure.

There are several drawbacks to the focal-plane shutter. It is slightly noisier than a leaf shutter; objects moving rapidly across the film plane may be distorted (pages 164-165); and it cannot be used with electronic flash at speeds faster than 1/125 second—a disadvantage for some stop-action pictures.

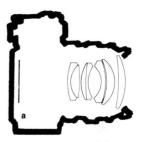

The position of the focal-plane shutter is not in the lens, but directly in front of the film, at (a) in the diagram above. The series at left shows how the slit in the shutter curtain sweeps across the face of the film, exposing different sections as it moves. Picture (6), below, shows the effect of the entire exposure, with all sections of the film having received the proper amount of light. Each section must get all the light it needs during the instant that the slit is passing in front of it. In this way the focal-plane shutter differs fundamentally from the leaf shutter. With the latter, there is a buildup of light over the entire film surface until the desired level is reached. But the end results are the same.

The Shutter as a Controller of Motion

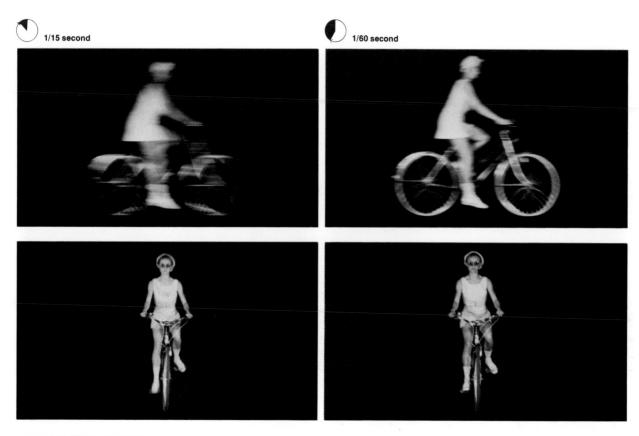

Whenever an object moves in front of a camera, the image projected on the film by the lens will also move. If the object moves swiftly or if the shutter is open for a relatively long time, this moving image will register as a blurred, indistinct picture. But if the shutter is speeded up, the blur can be reduced or eliminated. The photographer can, in fact, control this effect - and even use it to advantage. A fast shutter speed can virtually "freeze" a moving object, showing its position at any given instant, whether it be a football player jumping for a pass or a bird in flight. A slow shutter speed, on the other hand, can be used deliberately to accentuate the

blurring and suggest the feeling of motion in the photograph.

The range of effects that can be obtained by varying shutter speed is shown in the four side views of a girl riding a bicycle (top row above). To produce these photographs, four cameras were set at different shutter speeds and synchronized to go off simultaneously. In the picture at far left the girl rode far enough during the relatively long 1/15 second exposure to leave a broad white blur on the film. At the faster shutter speeds of the next two frames the rider is more distinct, but there is still enough blurring to indicate that she was in motion. In the

final photograph (far right) a shutter speed of 1/500 second stopped the motion so effectively it is hard to tell whether the bicycle was moving at all.

The amount of blurring that occurs in a photograph, however, is not determined simply by how fast the object itself moves. What matters is how far its image actually travels across the film during the exposure. In the lower set of photographs, with the girl riding directly toward the camera, her image remains in virtually the same position on the film. Consequently there is far less difference in blurring in the four lower pictures, though they were taken at the same shutter speeds as the top strip.

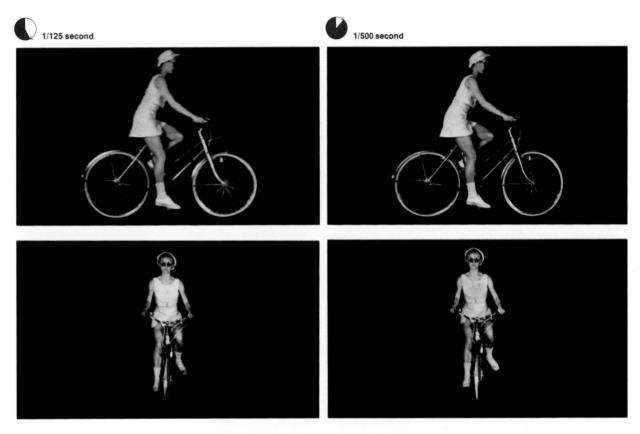

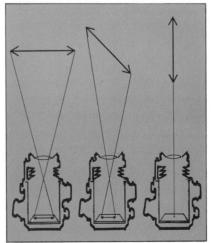

The diagram at left shows how the direction of a moving object affects the amount of blur that will result. When the object is traveling parallel to the plane of the film (first arrow) all this movement is recorded on the film. If it is moving at an angle to the film (second arrow), less left-to-right movement will be recorded and, as a result, less blur. When the object moves directly toward the camera (right arrow), there is no left-to-right movement at all and hence a minimum of blur.

The Aperture as a Controller of Light

If a photographer cannot or does not want to change his shutter speed to adjust the light that reaches his film, he can use a second adjustment. It changes the size of the opening, technically known as the aperture, through which light enters the camera.

The aperture works like the pupil of an eye; it may be enlarged or contracted according to the light requirements of the moment. This is done with a ring of thin, overlapping metal leaves called the diaphragm, located inside the lens. These leaves are movable. By turning a control on the lens, the leaves can be rotated back out of the way so that all the light reaching the surface of the lens passes through. A turn in the opposite direction will close the aperture down smaller and smaller until it becomes a tiny hole the size of a pinhead - as the seven examples on the opposite page show.

Aperture sizes are measured on a standard scale of numbers called

"f-stops." Since there is the possibility of some confusion here, it is worth pausing to dispel it. The letter "f" has nothing directly to do with focusing or focal length, as some people think. Focal length is a characteristic of the lens that is explained in full on pages 112-113, and the photographer need not concern himself with it here. All he needs to know is that the "f" in f-stop gives him a handy and constant yardstick for measuring, and thus controlling, the amount of light that he wants to let into his camera. If he sets his lens at f-2, the light transmitted will be the same as it would be with any other lens, no matter what its size, shape or design — so long as it, too, is set at f-2. The value of this is obvious. Once the photographer is familiar with the f-stops needed under various light conditions, he can take pictures anywhere, any time, and with cameras or lenses he has never used before. The standardized f-stops take care of that; they

are used on practically all lenses.

The commonly used f-stop numbers run as follows: f/1.0, f/1.4, f/2, f/2.8, f/4, f/5.6, f/8, f/11, f/16, f/22, f/32. f/45, f/64. F/1.0 is the largest of these and admits the most light. In the language of photography it is the "fastest." Each f-stop after that is half as "fast" as the previous one - it cuts light flow in half. Thus a lens that is set at f/2 admits half as much as one set at f/1.4 and only a quarter as much as one set at f/1.0. The variation over the full range of f-stops is enormous; a lens whose aperture is closed down to f/64 admits less than a two-thousandth of the light that comes through a lens set at f/1.4. Few lenses are built to use the whole scale of apertures. A standard lens for a 35mm camera, for example, might run from f/2 to f/22. A professional studio camera lens designed for use under strong floodlights does not have to be that fast. It may close down to f/64, but open up only to f/5.6.

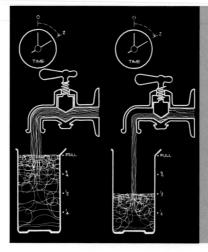

The flow of light into a camera can be controlled by aperture size just as the flow of water into a glass can be controlled by the faucet setting. Here a faucet running wide open for two seconds fills a glass. If it runs half shut it fills only half a glass in that time period. Similarly for light: An aperture half open admits half as much light as one fully open in the same time. Thus the aperture setting controls the rate at which light enters the camera, in contrast to shutter setting, which controls how long the light flow continues (page 74).

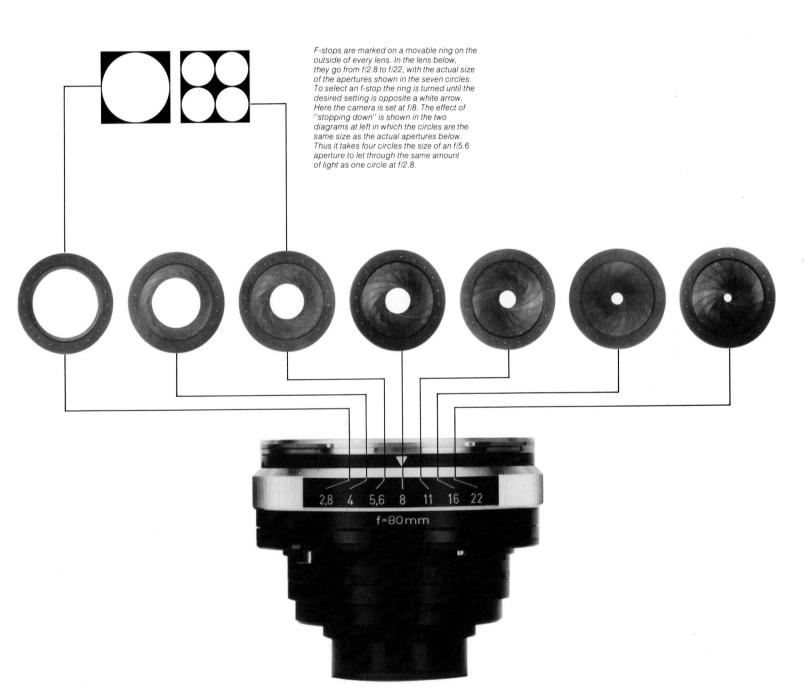

The Aperture as a Controller of Depth of Field

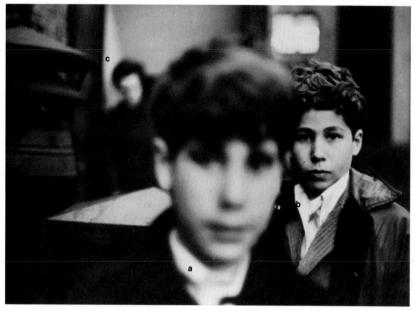

A change in aperture size not only affects the amount of light entering the camera; it also has a profoundly important effect on focus: As the aperture decreases in size, more of the background and foreground in a given scene becomes sharp (for the optical principle involved, see pages 124-125). This zone of sharp focusing is known as "depth of field," and by skillfully manipulating it the photographer can emphasize certain details of his pictures while playing down others.

The two large photographs shown on these pages were taken under identical conditions but with different aperture settings. To take the photograph above, the camera's diaphragm was opened to its widest aperture, f/2, and the lens was focused on a boy about seven feet away (see side view of the photogra-

pher and his subjects, above right). The resulting photograph shows a shallow depth of field: Only the middle boy (b) is sharp, while both the boy in front (a) and the man behind (c) appear blurred. But when the camera's smallest aperture, f/16, is used (opposite page), quite a different picture emerges. The camera's point of focus—the middle boy—is unchanged. But the depth of field is now great enough to yield sharp images of the other figures as well.

With most cameras, determining depth of field is relatively simple. If the camera has a ground-glass focusing system, the objects in a scene will appear as sharply in or out of focus on the ground glass as they will in the final photograph. In addition, lenses often incorporate a depth of field scale. This appears as pairs of numbers with

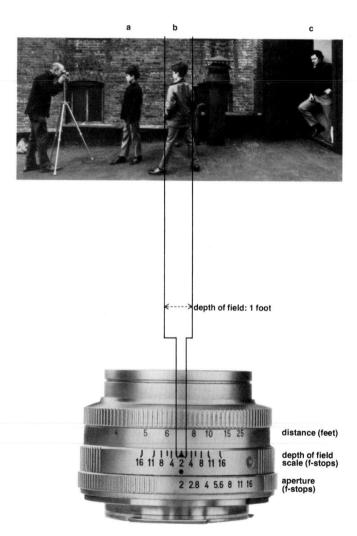

At its widest setting of f/2, marked by the bottom ring, the depth of field on this lens when focused at seven feet is barely deep enough to include the middle boy at (b) in the side view of the scene above. The bracketing marks—i.e., the vertical lines—on the center ring, when read against the camera's distance scale on the top ring, indicate that at f/2 on this lens only objects slightly more than six feet but less than eight feet from the lens will be sharp in the picture when it is taken.

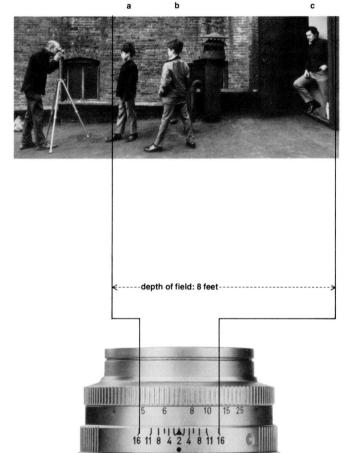

When the lens is closed down to its smallest aperture, f/16, almost the entire scene before the camera becomes sharp at the same focusing distance of seven feet. And the photographer can check this on the depth of field and distance scales. For, as the bracketing marks for f/16 show, now everything between about five feet and 13 feet will appear distinct. Subjects outside these limits cannot be photographed in detail without altering the focusing distance.

2 28 4 5.6 8 11 16

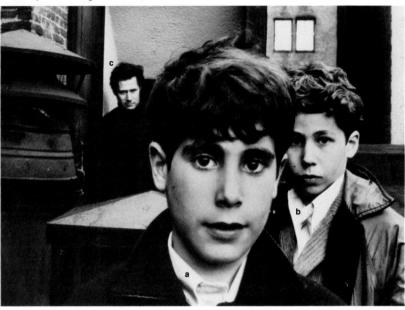

"bracketing" marks printed on the side of the lens. When the lens is focused, a quick check of these numbers tells the photographer what part of his picture will be in focus and what part will not be. The lens shown here has such a scale. The bottom row of numbers records the f-stops. If the photographer wishes to take a picture at f/2 (lens at left) he turns the bottom ring until the f-stop setting is directly beneath the fixed indicator dot. Then he looks at the middle row of numbers, noting the small vertical bracketing marks above them. These mark, when read against the top row of numbers, show - in feet - what will be in focus. Since his lens setting is f/2, he takes his reading from the figure "2" in the middle row. The bracketing marks for f/2 show that only a narrow range between six and

eight feet away will be in focus. Being able to calculate depth of field from the distance scale on the lens can be of great value to the photographer. If he is using a rangefinder camera like that on page 64, all of his picture will appear sharp in the viewfinder. He will have no way of telling, other than by experience, what will be in focus and what will not be - except by consulting the distance scale. There are other advantages too. Suppose he is setting up to take a picture of a deer that he hopes will run through a glade in front of him. When the deer comes there will be no time to focus or think about depth of field. But he need not worry if he checks out depth of field on the distance scale ahead of time. Then he can simply click his shutter at the instant he feels the composition is right.

Using Shutter and Aperture Together

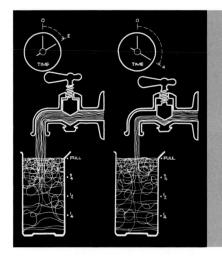

The quantity of light that reaches a piece of film inside a camera depends on a combination of aperture size and length of exposure. In the same way, the water that flows from a faucet depends on how wide the valve is open and how long the water flows. If a two-second flow from a wide-open faucet fills a glass, then the same glass will be filled in four seconds from a half-open faucet.

Although the shutter and aperture are both devices for controlling light, their effects in making photographs are basically different, as the preceding pages have shown. These differences can be used together to produce interesting and varied results.

The photographer can select *any combination* of shutter speed and aperture that delivers the proper amount of light, since each succeeding f-stop cuts the amount of usable light in half and each increase in shutter speed does the same. Therefore, the two can be worked together very simply: As shutter speed increases, aperture diameter must increase. The same amount of light will be admitted by f/22 at one second, by f/16 at half a second, by f/11 at a guarter second, and so on.

What such combinations can produce may be seen in the three photographs at right. In each of them focus was kept constant while shutter and aperture settings were balanced to admit the same total amount of light into the

camera, producing three correct exposures. But the three identical exposures resulted in three quite unidentical photographs. In the first picture, a small aperture produced a photograph with considerable depth of field that included background details quite sharply; but the shutter speed needed to compensate for this tiny aperture had to be so slow that the rapidly moving flock of pigeons showed up on the film only as indistinct ghosts. In the center photograph, the aperture was enlarged and shutter speed increased; the background is less sharp but the pigeons are visible, though still blurred. At far right, a still larger aperture and faster shutter speed produced yet another kind of picture: Almost all background detail has been sacrificed, but the birds now appear with great clarity.

Some of the extraordinary effects that professional photographers have achieved by playing around with these controls—and with focus—are shown on the following pages.

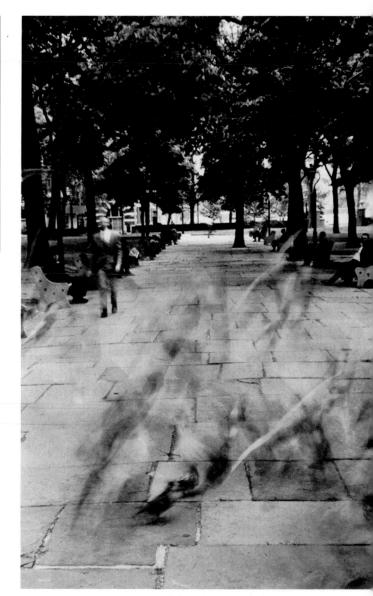

A small aperture (f/16) produces great depth of field; in this scene even distant trees are sharp. But to admit enough light, a slow shutter speed (1/5 second) was needed; it was too slow to capture the pigeons in flight.

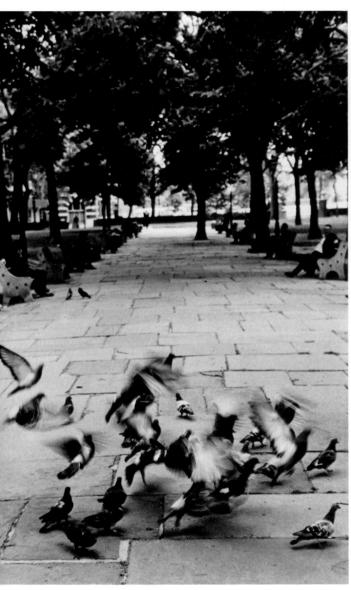

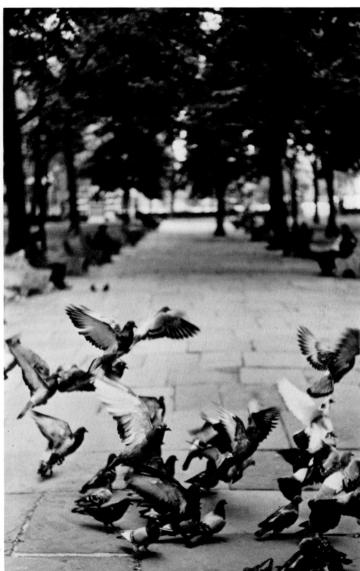

A medium aperture (f/4) and shutter speed (1/100 second) sacrifice some background detail to produce recognizable images of the birds. But the exposure is still too long to freeze the motion of all the birds' wings.

A fast shutter speed (1/500 second) stops the motion of the pigeons so completely that the flapping wings are clear. But the wide aperture (f/2) needed gives so little depth of field that the background has become blurred.

Setting Exposure Automatically

In some cameras control over exposure has been almost totally automated. A computer sets aperture or shutter speed or both to suit the illumination measured by a built-in meter. Two types of automation are the most common. With one, called shutter-priority automation, the photographer selects the shutter speed while the camera picks an aperture that will give proper exposure. With the other - aperture-priority automation - the photographer sets the aperture and the camera chooses a shutter speed. Either type lets the photographer override the automation or shut it off.

Shutter-priority automation is helpful when the photographer wants to stop movement in rapidly changing lighting situations. He selects a shutter speed fast enough to freeze the action, and the camera then compensates for changes in light by altering the aperture. This ensures correct exposure and stopped motion, but it can create significant differences in depth of field, as illustrated in the pictures on this page.

Aperture-priority automation is useful when the photographer wants enough depth of field to keep near and far subjects in focus under varying illumination, and when he wants exposure control to operate entirely automatically in very dim light. However, this type of automation may blur motion (opposite).

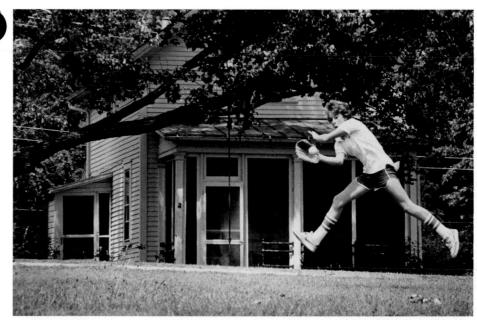

In the two pictures of a boy catching a ball at right, shutter-priority automation let the photographer pick an action-stopping shutter speed (1/500 second) while the camera adjusted aperture for different lighting conditions. Both shots are correctly exposed and both stopped the motion. In strong light (top), the camera set a small aperture, f/16, that kept everything from foreground to background in sharp focus. In shade (bottom), the camera demanded a larger aperture of f/2 for correct exposure, reducing the depth of field so that the background blurred.

In these two pictures, the tricky problem of keeping widely spaced subjects in sharp focus under radically different lighting conditions is readily handled by an aperture-priority camera—in which the photographer selects the aperture and the camera sets the shutter speed for correct exposure. In the pair of pictures at left, the photographer chose a small aperture (fl/11) for sharp focus on both the woman in the foreground and the one in the background. In sunlight (top), the camera set a speed of 1/1000 second, fast enough to correctly expose the negative, and also to freeze a passing bicyclist. But when the women were in shade (bottom), the camera set a slower speed (1/60 second), and the bypasser became a blur.

RICHARD AVEDON: The Madwoman of Chaillot, 1950

Using the Controls Creatively

Sharp, clear pictures, each image plainly outlined and brilliantly visible, are the first goal of the photographer. But once you have learned how to manipulate the camera's controls to make pictures like that, you quickly realize you often want something different. Some pictures look better soft or even fuzzy, like Richard Avedon's evocation of a play's mood (left). In others a detail can be made to jump out at the viewer if it is precisely in focus while everything around it is out of focus. A moving object may seem more natural if it is deliberately blurred instead of frozen in action-or, paradoxically, if it is stopped clear and sharp while its background is blurred. One scene may demand the dark dullness of underexposure, another the flat brilliance of overexposure. In these and other ways the photographer can evoke the essence of a scene, the feeling of a character, the meaning of an event, and communicate them in his own way. And that is what photography is all about.

Achieving such special effects, however, requires even closer attention than usual to coordination of the controls. Slow shutter speeds are often desired to blur or extend the image of a moving object; but a slow shutter speed increases exposure so that the lens must be stopped down. If the small lens opening increases sharpness more than is desired, some other means of restricting the light entering the camera—a screening filter over the lens, for example - may be required. To make some objects sharp while others are not, lens opening and focus setting must be adjusted to restrict depth of field to the region desired (and shutter speed must then be adjusted to control exposure). Often special accessories are used. "Soft focus"—an overall veiling that eliminates hard edges but does not necessarily blur the images — can be achieved by placing a diffusing device over the lens: a glass disk with ruled lines, even a nylon stocking.

To capture the element of fantasy in the tragicomedy *The Madwoman of Chaillot*, Avedon employed a variety of techniques: careful shutter and aperture adjustment, dramatic lighting, even special processing of his negative and print. The soft, unearthly result nicely conveys his impression of his subjects. "These women," he said, "are all holding onto their illusions; they're ghosts of another time."

Like figures in a dream, actresses from the play The Madwoman of Chaillot seem to drift forward out of a haze. Photographer Avedon achieved the effect using a relatively slow shutter speed (1/60 second at f/8) to allow the figures to blur slightly as they moved; brilliant background lighting further dissolved hard edges and "washed out" the scene. In the darkroom, the negative was developed to produce a grainy effect and portions of the print were bleached with chemicals to lighten the background still more.

Focusing for Essentials

FARRELL GREHAN: David Alfaro Siqueiros, 1966

These two pictures are an exercise in emphasis. In the one at left, the face of the subject is decidedly out of focus - violating what would seem to be a cardinal rule of portrait photography. And yet the picture is a fine portrait of a painter whose talent and intensity are perfectly expressed not in his face, but in strong, paint-splotched fingers carelessly holding a cigarette. In the picture at right one would expect a small, rather conventional-looking woman, even if she is a princess, to become lost in a brilliant array of tall, drawn-up soldiers in smartly belted uniforms. And yet there is little question here who the subject of the photograph is.

Many good pictures, and some great ones, are built on telling details like these, deliberately emphasized to convey a single impression or idea. To isolate such details, a photographer obviously must first decide which are the significant ones, and then zero in on them. This can be done by moving in close to the subject - something amateurs constantly forget to do-and then focusing to get the significant detail sharp. Finally, to make sure that the context does not draw the eye away from the essential detail, the photographer can blur surrounding elements by opening the diaphragm of his camera to a wide aperture setting, giving him a restricted depth of field.

Shallow depth of field highlights the subject's hands while keeping his face out of focus only inches behind. The picture was taken with a 35mm single-lens reflex camera, at 1/30 second and f/2.8.

To emphasize his subject, photographer Mark Kaulfman focused close in on her, using a 200mm lens on his 35mm single-lens reflex. A setting of f/6 (at 1/250 second) threw the troops in front and behind out of focus.

Long Exposures to Span Time

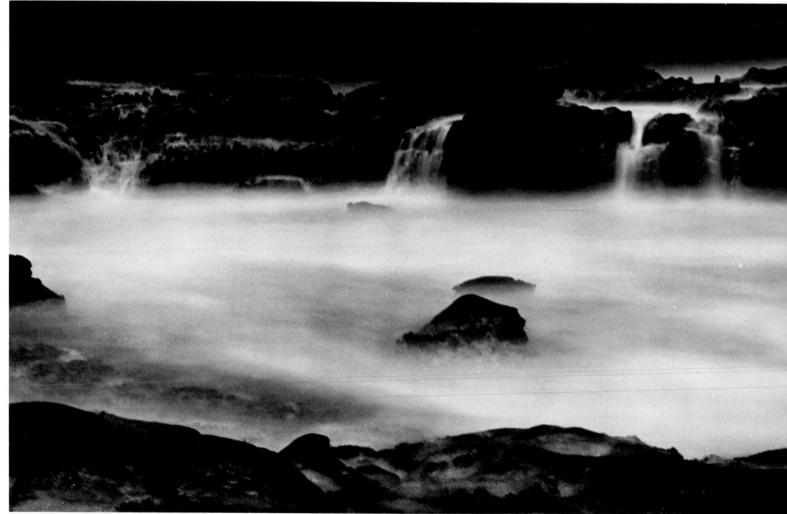

WYNN BULLOCK: Sea, Rocks and Time, 1966

A three-minute time exposure of waves surging along the California shore creates a scene of unearthly beauty. Bullock used a 4 x 5 view camera on a tripod; he balanced the long exposure with a small aperture (f/32) and a filter over the lens to reduce the amount of light. The result contrasts the softness of the water with the angular hardness of the rocks.

Time exposures—made by leaving the shutter open for several seconds, minutes or even hours—can reveal a world of surpassing beauty and surprise. By compressing many moments into a single image, a time exposure can suggest a feeling entirely detached from the

normal flow of time—as Wynn Bullock's photograph of a specific site along the Pacific Coast (above) seems to represent a timeless, placeless, almost primeval scene.

In a different way, time exposures can be used to record patterns that

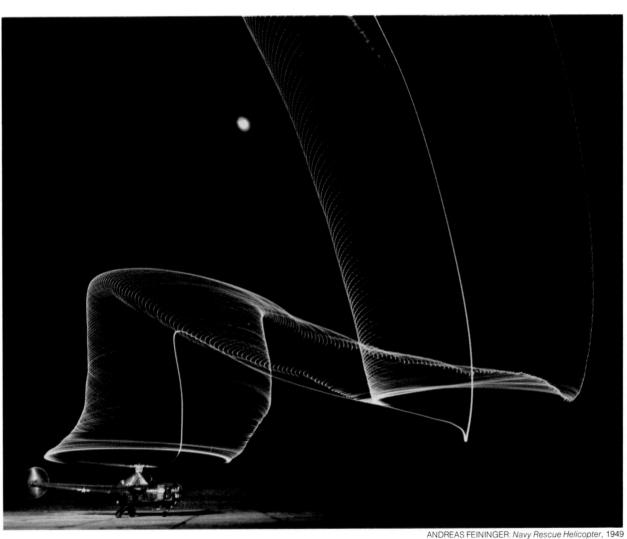

ANDREAS FEININGEN. Navy nescue Helicopter, 1949

escape the unaided eye—the swirl of highway traffic at night or the arcs of stars in the sky. To produce the photograph of a Navy rescue helicopter taking off at right, photographer Andreas Feininger meticulously prearranged the helicopter's flight and had the pilot rehearse two takeoffs before shooting the picture. "The surprise in this photograph," he later explained, "is seeing the total flight pattern—something we cannot see in this form in actuality—as a design that is aesthetically pleasing, a graph of motion and time."

The graceful pattern of a helicopter's flight is traced on film by lights on the rotor blades. Andreas Feininger took the picture with a 4 x 5 view camera on a tripod. He used two exposures: the first, a short one of the floodlighted fuselage; the second, a time exposure at f/16, lasting as long as the helicopter remained in the field of view.

Two Ways to Capture Action

When the camera is used to record moving objects, shutter speed becomes the most versatile tool the photographer has at his command. A fast shutter speed can freeze motion that the eye sees imperfectly, or cannot detect at all. The results are frequently striking: A boy engaged in an idle game suddenly seems to be walking on air (right); a boxer's face is distorted by the impact of a punch; a photo finish breaks an apparent tie by showing that one horse won the race by a nose.

At slower shutter speeds the camera creates quite a different kind of effect. By allowing a moving object to blur slightly on the film, a photograher can convey a strong impression of motion, akin to what the eye and brain actually perceive. In the photograph opposite, for example, a carefully chosen shutter speed allowed the surrounding dancers to blur, giving the feeling of the whirling ballet, while capturing the relatively motionless central figure.

There are no hard and fast rules for matching shutter speed to subject matter. In fact, fast and slow shutter speeds may both produce evocative photographs of the same scene. The real trick is in knowing when to take the picture. A photographer ultimately depends on his sense of what Henri Cartier-Bresson calls "the decisive moment"—that fleeting instant when an expression, a pose or a pattern reveals the essence of a motion or event.

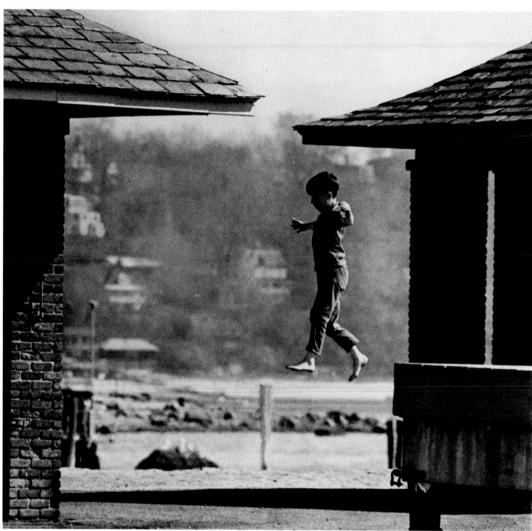

FREDRIC WEISS: Boy Jumping, 1968

A small boy, jumping from a beach float, was intercepted in mid-flight with a 35mm single-lens reflex camera, using a shutter speed of 1/1000 second and an aperture of 1/5.6.

To capture the effect of whirling motion ▶
around a poised ballet dancer, photographer
Herbert List, using a rangefinder camera, chose a
shutter speed of 1/5 second at f/5.6.

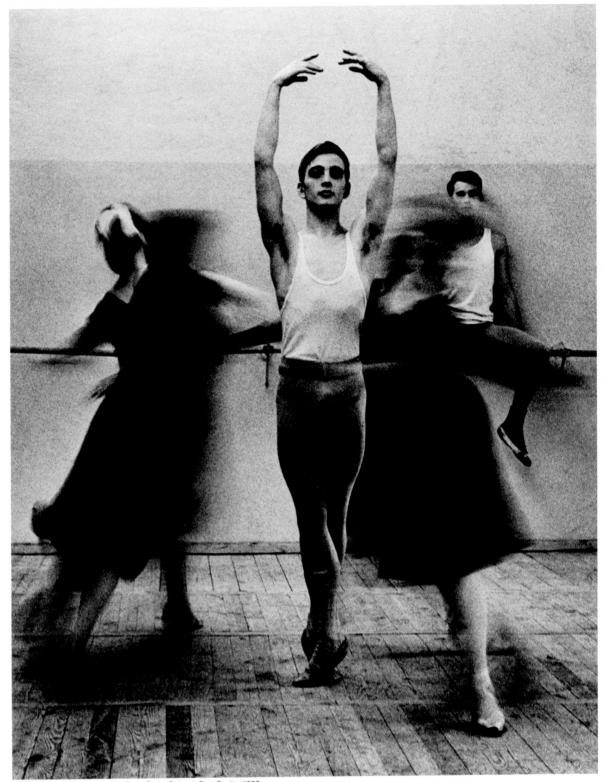

HERBERT LIST: Training in the State Ballet School, East Berlin, 1966

Selective Blurring to Emphasize Movement

A still photograph cannot literally show motion happening, but it can convey and even exaggerate an impression of movement. This can be done, as in the photograph of the dancers on the preceding page, by leaving the shutter open long enough for the image to move on the film, but not so long that the subject becomes unrecognizably blurred.

Motion can also be suggested by the two methods illustrated in the pictures on these pages. For the shot of the young thrill-seekers reproduced at left, the photographer employed a technique called panning. A slow shutter speed is used, and the moving object is carefully followed with the camera. The object will then generally be sharp but everything else in the picture will appear blurred.

A more sophisticated variant creates a half-sharp, half-blurred picture (opposite) by mixing available light with electronic flash. Once again the shutter is set for a relatively slow speed - a setting that will properly expose those parts of the image most brightly lit by the available light, but will underexpose the other parts. Wherever there is enough illumination for correct exposure from the available light, the image will blur because of the long exposure time. During exposure, a flash is fired to illuminate the parts of the subject that will not get sufficient exposure from available light; because the flash is brief, those parts come out sharp.

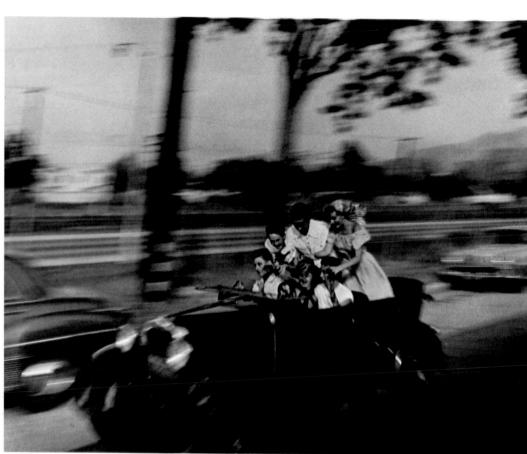

RALPH CRANE: Hot Rodders, 1949

To catch the excitement of hot-rodding youngsters, Ralph Crane set his 4 x 5 portable view camera at 1/50 second and f/11, and kept it aimed at the speeding car. The movement turned the landscape into a blur.

A long exposure combined with an electronic
flash gives an impression of motion in this rodeo
picture by allowing some parts of the image to
blur while freezing other parts. The left sides of the
rider, saddle and bucking bronco were
illuminated by the setting sun during the entire 1/4-
second exposure, and they blurred. The rider's
back, however, was illuminated mainly during the
brief burst from the camera's mounted flash;
hence such details as the stitching and back buckle
of the vest and the saddle cinch ring appear sharp.

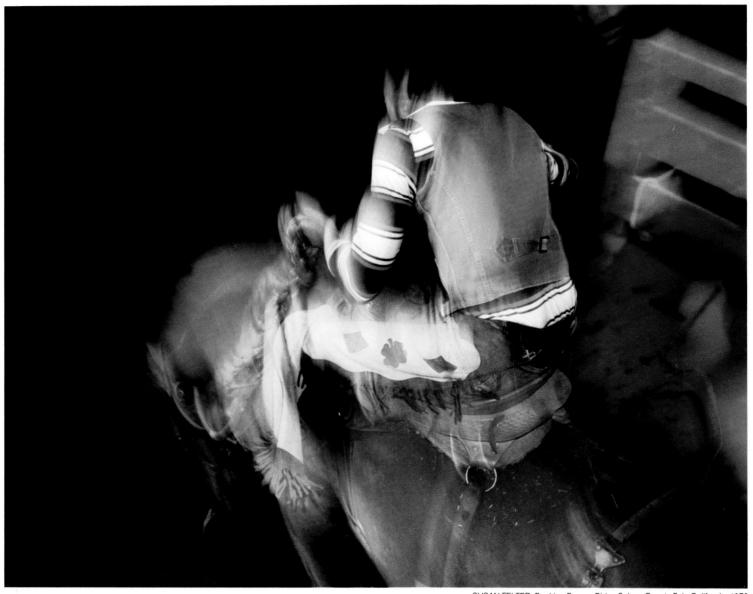

SUSAN FELTER: Bucking Bronco Rider, Solano County Fair, California, 1978

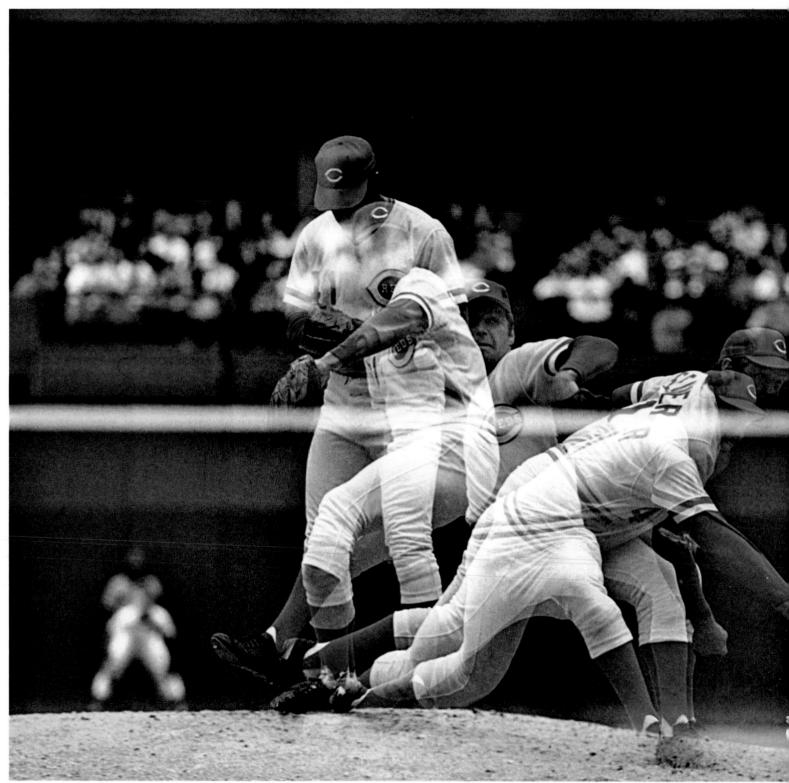

JOE DIMAGGIO: Tom Seaver, 1978

Multiple exposure is another way to suggest motion in a still picture. The result can be a precise analysis of the stages of an action (*left*) or an abstract vision of a stationary subject photographed with a moving camera (*overleaf*).

Until recent years, most of these motion studies were photographed in studios under controlled conditions. In complete darkness, the camera shutter was kept open as rapidly repeating bursts of light froze the subject intermittently throughout a sequence of actions and recorded them on a single frame of film (page 53). But with the development of motor drives that automatically advance the film, and then cock and release the shutter to shoot as many as six frames per second, it became possible to make similar action photographs under almost any conditions.

A single-lens reflex camera equipped with a motor drive caught the Cincinnati Reds' star pitcher Tom Seaver in five positions during the second it took him to make his delivery. To record the different positions on the same piece of film, the camera's film-rewind button was depressed, keeping the film from moving forward.

A motor drive is ordinarily used to take a series of separate pictures in rapid succession, but for the multiple-exposure image of a major league pitcher's delivery at left, freelance photographer Joe Di-Maggio (a distant relative of the famous major leaguer) disengaged the gears by which his motor drive would have normally advanced the film in his camera. The film stopped, but the shutter kept clicking to create a vivid dissection of a classic pitching motion.

A motor drive was also used to make the multiple exposure reproduced on the following page. But instead of recording the action of a moving subject, the photographer moved his camera while taking 12 shots of a motionless object. In the resulting photograph, a gleaming glass tower in Manhattan becomes a multifaceted abstraction.

To get this shimmering vision of a Manhattan skyscraper, the photographer held down the film rewind button to stop the film advance, keeping all exposures on one transparency, and pivoted the camera downward; in this way he caught the image of the building on different portions of the film, creating a pattern of repeats. To heighten the effect, a crosshatched filter on the lens broke up the light like a prism.

FRANCISCO HIDALGO: Avenue of the Americas, New York City, 1972

On Choosing Lenses 102

Why Lenses are Needed 104
The Pinhole as a Controller of Light 106
The Lens as a Controller of Light 108
Positive and Negative Lenses 110

The Many Effects of Focal Length 112

Perspective 114
Distance Distortion 116
Depth of Field 118
How Distance Alters Depth of Field 120
How F-Stop Alters Depth of Field 122

A Versatile Optical Design 124

The Normal Lens 127
The Wide-Angle Lens 128
The Long Lens 131
The Zoom 132

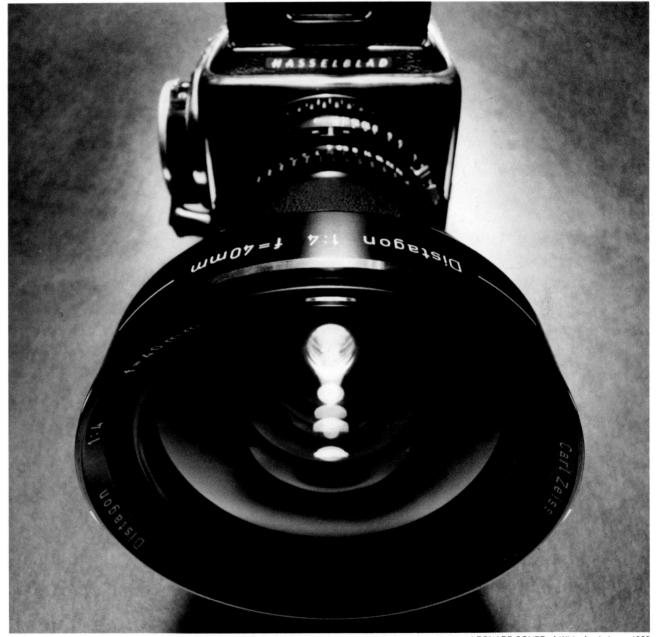

LEONARD SONED: A Wide-Angle Lens, 1969 101

On Choosing Lenses

The lens is the most important part of any camera. A camera can have all the ingenious gadgetry that inventors can devise—automatic shutters, snap-in film cartridges, electronic flash units—but it will not give the kind of pictures you want unless it has a good lens and the right lens. But what do we mean by "good" or "right"?

Quality in a lens is measured entirely by the sharpness and accuracy of the image it projects. A sharp image is achieved by the use of special optical glasses, several different kinds in several layers, each layer ground to exquisite tolerances, all the layers combined into a mechanical unit that moves smoothly and exactly for focusing. The result will be an extremely complex piece of optical machinery such as the one shown on page 124. Good lenses are not inexpensive, but for the photographer interested in making good pictures, they are essential.

But having picked a good lens, you still may not have the right one. Lenses come in four different types—normal, long, short and zoom—to do different jobs. The most generally useful is the normal lens, so called because the size and perspective of its images seem normal and lifelike to the eye. The short, or wide-angle, lens gives a wider view and smaller images than the eye sees. The long lens magnifies distant objects so that you can get a large image without moving up close. The zoom is an adjustable combination lens that can be set to give the angle of view desired; most operate over only a limited range, from short to normal or normal to long, but a few can be varied from short to long.

Lenses of any of these types made by reputable manufacturers can be assumed to be good ones. And yet two lenses of the same type, designed to do the same job, perhaps even made by the same company, may vary quite widely in price. The price difference probably reflects a difference in the speed of the lenses—i.e., one will admit more light than the other will, permitting picture taking in dimly illuminated rooms or at faster shutter speeds. The faster—and more expensive—lens can be used over a wider range of lighting conditions than the slower one, but otherwise one will perform as well as the other.

Therefore, the right lens for a man prowling at dusk for moody pictures of wildfowl in swamps will have to be a fast one in order to provide him with enough light to make his pictures. It will also have to be a long one, for ducks are shy and unless they can be pulled in close by the lens, they will appear on film as pinpoints. Thus it is the kinds of pictures a photographer wants to take that will ultimately determine the kinds of lenses he will want to own.

For general-purpose photography, here are some specific guidelines for buying suitable camera lenses.

1) If you are getting a camera with interchangeable lenses, start with a normal lens. (This is the one that ordinarily comes with the camera, anyway.) Familiarize yourself thoroughly with it. Do not buy other lenses until you feel a

strong need to take the different kinds of pictures that they can provide.

- 2) Get your lenses one at a time and think ahead to what you may someday need in the way of an assortment. A good combination for the 35mm camera, recommended by George Karas, head of the Time-Life Photo Lab, consists of the following three: a 50mm normal lens for general use, a 28mm wide-angle lens for photographing interiors and for close-in work with groups of people, and a 105mm long lens for making portraits and for pulling in more distant subjects. (Cameras using larger film than 35mm require proportionately longer lenses, as explained on pages 127-131.) A zoom could substitute for either the short or the long lens recommended, but the gain in versatility should be balanced against higher cost, some slight loss in optical quality and maximum apertures that are no greater than f/3.5. Be wary of ultra-wide-angle (below 20mm) and extra long (above 300mm) lenses; they may be considerably more expensive than the less extreme types, and they are so specialized their usefulness is limited.
- 3) Do not waste money on extra-fast lenses. The difference between a good \$150 lens and a good \$500 lens may be only a couple of f-stops. In all but the dimmest light a lens that can open to f/2.8 is adequate with modern high-speed film.
- 4) Consider a second-hand lens. Many reputable dealers take used lenses in trade and they may be bargains. But look for signs of hard use—dented barrel, scratched lens surface, a slight rattling that may indicate loose parts—and be sure to check the diaphragm to see that it opens smoothly to each f-stop over the entire range of settings.
- 5) Test your lens. The only sure way is to take pictures with it in your own camera, so always insist on a trial period or a return guarantee. A simple test for the most common lens faults can be made at home by placing the camera on a tripod or tabletop and focusing it on a sheet of newspaper (two pages) that is taped flat to a dark surface and evenly lit. Be sure the camera is close enough so the sheet fills the view, then take two pictures: one at the lowest f-stop, one in the middle range. When the pictures are developed, check the prints to see that all horizontal and vertical lines came out straight and that there is no blurring or graying along the edges and in the corners.

These rules will be much more useful if you know something about how lenses work, what they can do— and why. With all the shop talk about millimeters, f-stops and depth of field, it is easy to forget that all lenses do the same basic job: They collect the light rays coming from a scene in front of the camera and project them as images onto a piece of film at the back. This chapter explains how this happens, how it can be affected by changes of lens size, lens aperture and subject distance— and, most important, how you can exploit these factors to make the kinds of pictures you want.

Why Lenses Are Needed

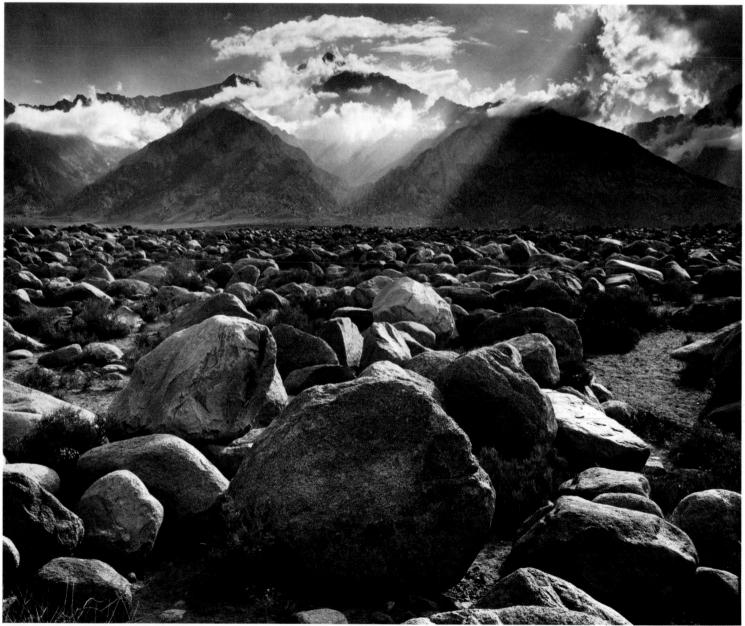

ANSEL ADAMS: Mount Williamson, California, 1943

Picture making, like human vision, depends on light. It is the light reflected from objects like the rocks and mountains opposite that we—or our cameras—see in the form of images in our eyes or on our film. But before we are able to see such images, the eye or the camera must deal with the basic nature of light.

Light, when it hits an object, bounces off in almost all directions from all points on that object. For that reason, you cannot simply place a square of sensitized film in front of a man, hoping to get an image of him on it. The rays that bounce off the man would hit the film in a complete jumble and the result would not be a picture but a uniform blur over the entire surface of the film. For simplicity's sake, the drawing at the right shows only a few rays coming from only two points on the man, his pipe and his coat-tip, but their random distribution over the entire film makes it clear that they are not going to produce a useful image. The "pipe rays" will hit the film all over its surface, never creating in any one place an image of the pipe. The same thing happens to the "coat rays," "ear rays," "hat rays" and so on.

To form an image, what is needed is some sort of a light control device in front of the film—something to direct the light rays so that they do not hit the film in a jumble all over its surface at random; something, in short, that will select and aim the rays to make a coherent picture, putting the pipe rays where they belong and the ear and hat rays where they belong. How this sorting out and directing of light rays to form images can be accomplished is shown on the following pages.

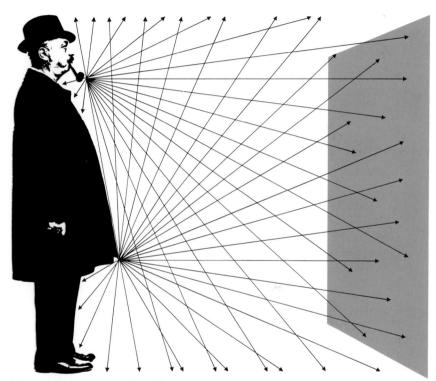

Uncontrolled light rays, shown reflected from two points — the subject's pipe and the bottom of his coat — travel in almost all directions toward a sheet of film placed in front of the subject. Rays from the pipe strike the film all over its surface and so do rays from the coat; they never form an image of pipe or coat at any place on the film. The result is not a picture but a totally exposed sheet of film.

The Pinhole as a Controller of Light

Although all the light rays bouncing from an object cannot produce an image on a flat surface, a careful selection of rays can do so. Suppose there is a barrier with a small hole in it, like that in the drawing below. Now all but a few rays from each point are deflected by the barrier. Those few that do get through, traveling straight from object to film, can make images.

For example, the few rays from the man's pipe that get through the hole all fall on a certain spot near the bottom of the film. Only that one spot on the film registers an image of a pipe. Similarly, rays from the coat, the shoes, the ear, the hat brim—from every point on the man—travel to other precise points on the film. Together they form a complete image—but upside-down and reversed. Everything that was at the top of the man appears at the bottom of his image on the film and everything at the bottom appears at the top. Similarly, left becomes right and right becomes left.

The image-making ability of the pinpoint hole has been known for several thousand years and has long been put to use in the camera obscura, a darkened room whose only light source is a small hole in one wall. On the opposite wall will appear an image of the scene outside, formed by the light rays coming through the hole.

The camera obscura is, in fact, a room-sized primitive camera. Shrink the room down to shoebox size, reduce the hole to 1/50 inch wide, place a piece of film in the other end and it will make an acceptable picture; the photo-

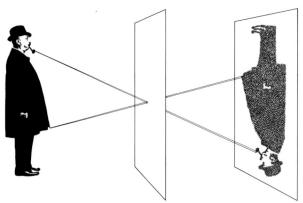

To take this picture of a fence and barn in California, landscape photographer Ansel Adams replaced the lens of an ordinary camera with a thin metal disk pierced by a pinhole opening 1/50 inch in diameter. The film was exposed for a full 6 seconds. The way the pinhole produced an image is illustrated in the diagram at left. Only a few rays of light from each point on the subject can get through the tiny opening and these strike the film in such tight clusters that blurring is reduced to a minimum. The result is a soft but acceptably clear photograph.

For a second photograph of the same scene, Adams increased the size of the opening to 1/8 inch, which meant reducing the exposure time to 1/5 second. The result is a hopelessly fuzzy picture. As shown in the diagram at right, the larger hole permits a greater number of rays from each point on the subject to enter the camera. These rays spread before reaching the film and are recorded as large circles. Because of their size, these circles tend to run into one another, creating a blurry photograph.

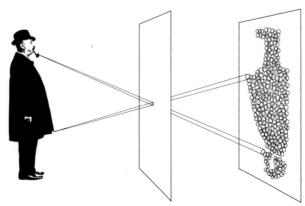

graph on the opposite page was made with such a camera. The trouble with this pinhole camera is its tiny opening, which admits so little light that very long exposures are needed to register an image on the film. If the hole is enlarged appreciably, the picture it makes becomes fuzzy, like the photograph on this page. Why this happens is explained in the two drawings.

Examine the image in the drawing on the opposite page. You will note that it is actually composed of a great many small areas represented by tiny circles. That is because the hole, small though it is, actually admits a great many light rays. These, coming at slightly different angles, continue through the hole in slightly different directions. They fan out into a cluster and when they hit the film they cover a small circular area on it. If the hole in the barrier is made larger (drawing below) a cluster of light rays from the pipe will get through to the film and cover a wider circle on it. The larger the circles are, the more they will overlap their neighbors and the blurrier the picture will be. These tiny circles, which make up all images, are known as "circles of confusion."

It is obvious that in order to get sharp pictures, the circles of confusion should be as small as possible. But the only way to achieve that with a pinhole camera is to use a tiny opening admitting little light and requiring long exposure times. To take fast exposures with great amounts of light, a different method of light control is needed. That is what a lens can provide.

The Lens as a Controller of Light

Four centuries ago a Venetian nobleman named Daniel Barbaro tried an interesting experiment. He enlarged the opening of his room-sized camera obscura and fitted into it a convex lens taken from the spectacles of a farsighted old man. To his delight, the lens projected images so superior to those previously supplied by the simple opening that Barbaro wrote he could see "gradations, colors, shadows, movements, clouds, the rippling of water, birds flying and everything else."

Barbaro had found a new and better way to convert light rays into images in the camera obscura of his day. With the advent of photography, this discovery proved even more significant. For not only can lens cameras provide sharper images than pinhole cameras—as can be seen by comparing the photograph at right with the one on page 106—but they admit enough light to take pictures in tiny fractions of a second. Thus it is possible to hold a lens camera in your hands and take an unblurred photograph of a moving object—something impossible to do with a pinhole camera.

Most modern photographic lenses are based on the convex lens, the same type used by Barbaro. The convex lens - thicker in the middle than it is at the edges - can collect a large number of light rays from a single point on an object and refract, or bend, them toward each other so that they converge at a single point, as shown in the diagram at right. This point of convergence, called the focal point, falls on a vertical surface called the focal plane. In a camera, a strip of film stretched across the focal plane records a series of tiny images formed by an infinite number of converged, or focused, rays.

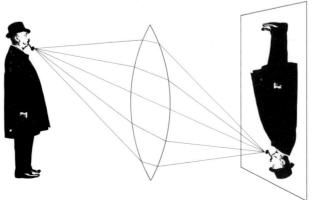

Photographed this time through a convex lens, Ansel Adams' barn scene is as good as —or better than—the one on page 106 taken with a pinhole camera. Most important, its exposure time, instead of being 6 seconds, was only 1/100 second. This is because the lens is much bigger than a pinhole and thus admits far more light. The diagram at left shows how the lens handles all this light by collecting many rays reflected from a single point and redirecting them to a corresponding single point on the film.

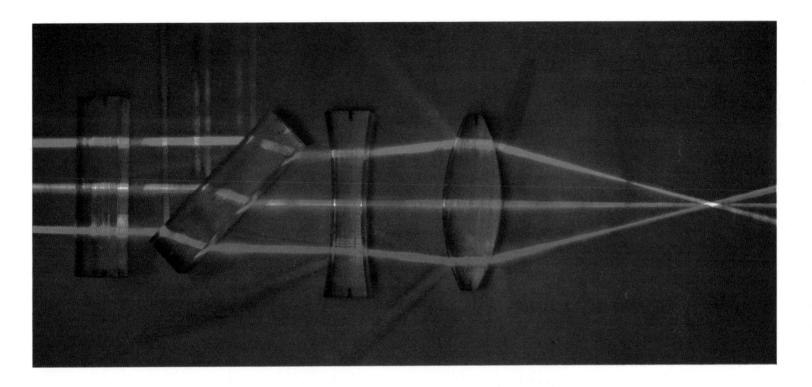

How do lenses control and redirect light? They do it by taking advantage of a property of light itself. When light rays pass through one transparent medium, such as air, into a different transparent medium, such as glass, the rays may be bent. This is the phenomenon of refraction. How much bending takes place depends on the shape, thickness and density of the new material, as well as on the direction of the light rays. Some of the possibilities are shown in the photograph above.

For refraction to take place at all, the light must strike the new medium at an angle. If it strikes head on, as it does in the first of four clear plastic blocks in the photograph, the rays simply pass

through without bending. But if the block is tilted so that the rays strike at an angle, some of the rays are reflected away while others enter and are refracted downward. They resume their former direction when they leave the block and re-enter air.

When light strikes blocks with curved surfaces, however, the pattern of refraction changes. Instead of being bent uniformly, the beams are bent at various predictable angles—spread apart by concave surfaces, directed toward each other by convex surfaces, such as those of simple camera lenses. The focal point, where the rays cross each other, is the point at which the convex lens forms its images.

How refraction works can be seen in this photograph showing three beams of colored light passing through four blocks of clear plastic. The beams, entering from the left, strike the first block head on and are therefore not refracted. But the next block has been placed at an angle, so that some of the rays are reflected, or bounced away from the surface. The rest are refracted downward, resuming their former direction on the other side. The concave surfaces of the third block spread the beams apart, but the last block—a convex lens like the basic light-gathering lenses used in cameras—draws the rays back together so sharply that they cross each other.

Positive and Negative Lenses

Lenses are classified as either positive or negative according to the type of image they provide. Both types are useful in photography.

A convex lens, thicker in the middle than at the edges, is described as "positive" because it bends light rays together and thus can project actual images on a flat surface. A concave lens is called "negative" because it spreads light rays apart and therefore cannot form an image on a flat surface.

Despite its inability to project images on surfaces, a negative lens has its uses. It produces clear images for the eye, if not for the film. Anyone who has looked through a magnifying glass - which is a convex lens-knows that unless he holds it a proper distance from what he is looking at, the image he gets will be fuzzy. He has to focus the magnifying glass by moving it closer or farther away to get a sharp image. But if he looks through a concave or negative lens, he does not have to focus it at all; everything will be clear. The image will appear smaller (drawing opposite), but it will be sharp, upright, nonreversed and in focus, no matter how close or how far away the object is.

This type of image is exactly what is needed in the viewing apparatus of a viewfinder camera. Therefore, a camera uses a positive lens to take the picture and a negative lens in its viewfinder. Put the camera to your eye and you have an instant—and always sharp—view of the scene in front of you, a view that can be made to match exactly the picture that the positive lens in the camera projects on the film.

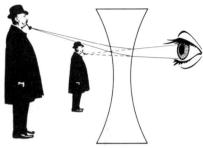

Because of the way the eye handles light, a concave lens produces an image that seems smaller and closer than the subject is. When you look at a man through a concave lens the light rays coming from his pipe to your eye are actually bent in the lens and deflected outward, as the solid lines in the diagram indicate. But you do not see the light as bending —you see it traveling in straight lines. To your eye those light rays have taken a path straight through the lens (broken lines); this makes them appear to have originated from a point nearer the lens than the subject actually is. With all points on the figure brought closer in this manner, the apparent distance from head to foot —as seen through the lens —is shorter than it really is and the total image produced is therefore smaller.

These two photographs show how differently convex and concave lenses behave. In the one on the opposite page the lens in the center of the picture is a convex, or positive, one. It acts like a magnifying glass and we can see only a small part of the clown's suit—considerably enlarged—through it. Like any convex lens, it is able to project an image of the clown on the ground glass in the foreground of the picture. By contrast, the second picture shows a concave, or negative, lens. We see a reduced image of the entire clown through it. And because concave lenses spread light, this one fails to project an image on the ground glass; it produces only a blur.

The Many Effects of Focal Length

A lens with a short focal length retracts light sharply partly because of its greater thickness and curvature. The rays of light entering from the left are bent so much

that they cross a short distance beyond the lens. The diagram opposite shows how this type of lens used in a camera produces a tiny image close to the lens.

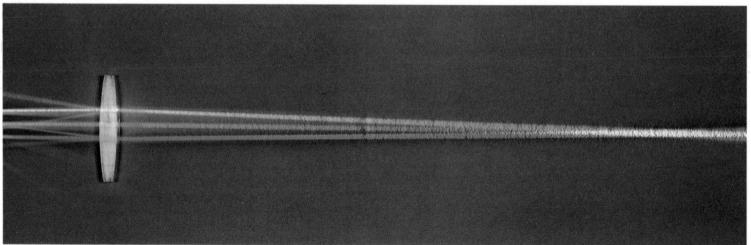

A lens with a long focal length refracts light less sharply because of its thinner shape and flatter curvature. The beams do not cross until they

are well beyond the lens. The second diagram shows the results of this change in focal length: a larger image farther away from the lens.

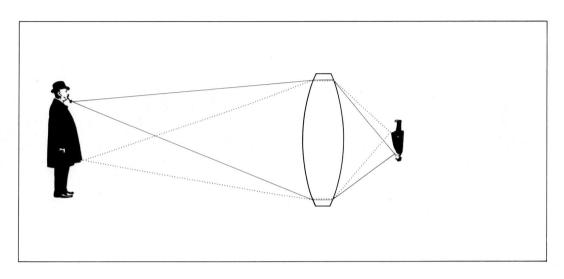

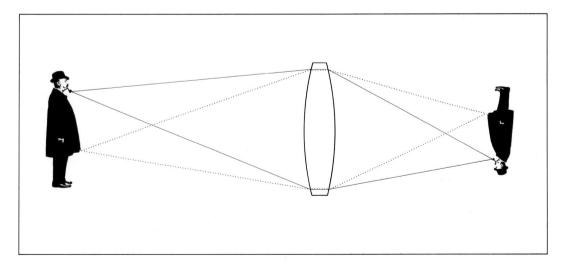

Whenever a photographer prepares to take a picture, one of the first questions he is likely to ask himself is: "Do I want my subject bigger, to dominate the picture? Or do I want it smaller but with a wider view of the surrounding scene?" There are two ways he can control the relative size of his subject: He can move his camera or he can stay where he is and use a different lens.

Some lenses create smaller images than others do because they bend light more sharply (thickness, curvature and density of glass all have an effect). Their sharply bent rays come to a focus very close behind the lens, so that all the rays making up the image fall within a small area, as shown in the top diagram at left. With a simple lens, the distance between this focal point and the center of the lens, which determines the size of the image, is known as the focal length. It is generally measured in millimeters and marked on the metal barrel of the lens.

By using lenses of different focal lengths, the photographer can take remarkably different pictures of the same scene. He can stand 50 feet from a tree, for example, and with a lens of short focal length get a picture of the entire tree, with some sky and hills thrown in. With a lens of longer focal length he will get only a part of the tree, but that part will be greatly enlarged, showing details of leaves and bark pattern.

But the size of the image is not all that focal length influences. The rest of this chapter will be devoted largely to a discussion of the many interrelated effects of focal length—on perspective, depth of field, f-stop, distortion of apparent distance and finally on the artistic results a photograph can achieve.

Perspective

When a photographer wants to change the relative size of the image, does it make any difference whether he does it by moving up closer to his subject or by switching to a longer lens? Indeed it does. These pictures show some of the subtle and surprising differences that result from these two approaches.

The top row of photographs is an experiment with lenses of different focal lengths. The photographer stood in one spot to make three pictures: first using a lens with a focal length of only 28 millimeters on his 35mm camera, then with a 50mm lens—the medium focal length most commonly used for general picture taking with this camera—and finally (far right) with a rather long 105mm lens.

Predictably, the shortest lens took in the widest view of the room and gave the smallest image of the woman; the longest lens gave the narrowest view, producing, in effect, simply an enlargement of a detail from the original picture. The woman's head is bigger but so is everything else—pillows, plant, the window behind her head. This enlargement causes no change in relative perspective because the woman's relationship to nearby objects does not change—her head occupies the same section of the window in all pictures, never moving any closer to the sash that is directly above her.

Now look at the pictures in the lower row. These were all taken with the 28mm lens, placed progressively closer to the woman. As the camera moves closer, the perspective changes. In the right-hand picture the woman's head, for example, is no longer in the middle of the window but is overlapping the sash. This change in the perspective is what you would encounter if you had moved closer to the woman yourself.

Three views of a woman, each shot from 15 feet, show how lenses of different focal lengths change image size but not perspective. Angles of view are reduced as larger images of the subject, (S) in the diagram, fill the film. The first picture was taken with a 28mm lens (angle aa'), the next with a 50mm lens (angle bb') and the third with a 105mm lens (angle cc').

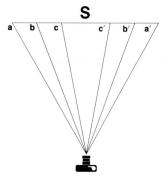

These pictures show how changes in distance affect image size and perspective as well. The camera was moved 15 feet (dd') to 9 feet (ee') to 3 feet (ff') distant from the subject (S). The decreasing distance enlarged foreground images more than background ones to give the three different perspectives.

Distance Distortion

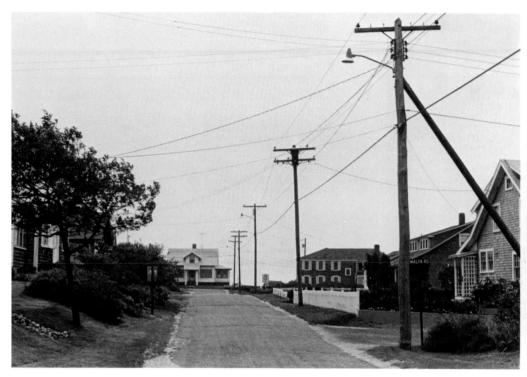

As long as you do not move your camera, changes in focal length have little apparent effect on perspective, as shown on the preceding pages. But if you move the camera and change focal length, perspective alters dramatically. Sizes and distances of objects are distorted, producing effects that are sometimes useful, sometimes a nuisance.

The picture above, taken by a lens of medium focal length, shows no distortion. If you were standing just where the photographer stood, this is about what you would see. More important, this is how you would see it. The poles would seem spaced as they are and the far house would seem about as big, relative to the poles, as it does here.

The pictures center and opposite show how these normal relationships are distorted, first with a lens of short focal length from up close, then with a long lens from far back. In each case the camera was positioned so that the nearest pole appears the same size and in the same position. But through the short lens, distant things seem more distant and smaller, with the long lens they seem larger and closer and the well-spaced poles appear jammed into a fencelike row.

These effects enable a photographer to play off camera position against focal length. If he moves up and uses a short lens to cover a broad view, distances will be stretched out. If he backs away and uses a long lens to get a large image, all objects will be magnified and squeezed together.

The cause of this distance distortion is the discrepancy in relative sizes between foreground objects (the closest pole) and background objects (the house). The short lens exaggerates the size difference: The house is very small compared to the pole. The long lens goes to the other extreme, making the house almost as tall as the pole. Since the human brain gauges the distance between objects partly by comparing their relative sizes, a house that looks almost as tall as a nearby utility pole will seem very close to it, whereas one that is a tenth as tall will seem far away.

The house looks strangely small and distant in the picture above, taken by a short-focal-length lens, and strangely large and close in the long-lens picture to the right, because of the great difference between the angles covered by the two lenses. As the diagram shows, a lens of short focal length, covering a wide angle (ab), can fill its picture with the nearby pole while the house occupies only a small part of the whole view. Thus the house comes out small compared to the pole. The long lens does the opposite. When its narrow angle (cd) is filled by the pole, the house and pole appear nearly the same size in the picture. It is these discrepancies in relative sizes that seem like differences in distance to a person looking at the picture.

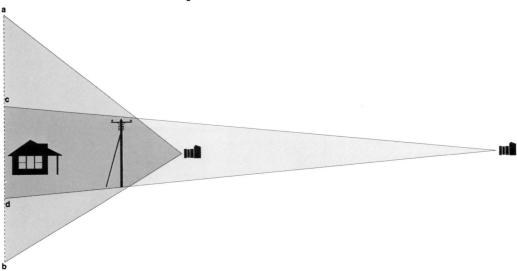

Depth of Field

In addition to controlling image size and perspective, focal length has an equally important influence on depth of field — that is, on the extent of the scene, from near to far, that will be sharp in the picture. There is a simple rule for this: The shorter the focal length of a lens, the greater the depth of field. The two photographs shown here demonstrate this. In each the camera was in the same position and focused on the floral wreath (a) in the di-

agram. But in the one above, taken with a 28mm lens, much of the scene is sharp, all the way from point (b) to point (c). In the other, taken with a 135mm lens, the in-focus area, from point (d) to point (e), is limited to a foot or so of grass on either side of the gravestone.

To understand why, we must return to the matter of circles of confusion explained on page 105 and recall that all images are made by clusters of light rays that form tiny circles on a piece of film. The purpose of a convex lens, we have also learned, is to bring rays together so that at the focal plane they form the tiniest possible circles—not much more than 1/1000 inch across with a high-quality lens. But for other objects slightly nearer or slightly farther away than the object in focus, these circles of confusion will be slightly bigger. The human eye is not itself a good enough instrument to distinguish between extremely tiny circles of con-

fusion and those not so tiny; all look the same size to it. But there comes a point when circles of confusion get large enough for the eye to see the difference. That is where blurring begins.

Why this happens sooner in a long lens than in a short one—why the picture at the right, taken with a long lens, seems blurrier than that at the left—is explained in the two diagrams.

In both diagrams, the white circle at the center of the film plane represents

what the eye will tolerate as acceptably in focus. In the left-hand diagram it is clear that the rays landing on this circle embrace an extensive area of the scene—all the way from point (b) to point (c). Blurring does not begin until the lens tries to see past those two points. In the right-hand diagram the rays that are acceptably sharp to the eye come from a much smaller area—only from point (d) to point (e). Everything else looks fuzzy, just as in the picture.

How Distance Alters Depth of Field

Depth of field is influenced not only by focal length (pages 118-119) and aperture (pages 122-123), but—perhaps surprisingly—by the distance from camera to object. What the lens is focused on will have a marked effect on how fuzzy the rest of the picture will be.

Again, a simple rule: The closer you are to the object you are focusing on, the fuzzier everything else will be-or. put another way, the less your depth of field will be. These two pictures of a sun-deck railing show this clearly. They were taken with the same lens, the same shutter speed and the same f-stop. The only difference between the two is that in the one on this page, the photographer placed his camera about three feet from the nearest post and focused on it. The resulting depth of field is so limited that even the far side of the post is out of focus and the rest of the picture is a useless blur. In the second picture he moved back to 12 feet, but still focused his lens on the same post. The result is a dramatic extension of the depth of field.

But even the influence of distance on depth of field cannot be considered entirely apart from that exerted by focal length. Suppose the photographer had to achieve greater depth and yet could not move back from his subject. One way out: Shift to a shorter lens, which even when used close up gives extended depth of field.

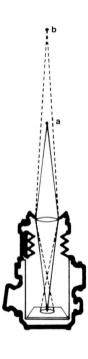

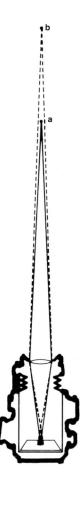

The two diagrams, center, explain why so much of the far photograph is out of focus, while most of the near one is not. With the camera close to object (a) (left-hand diagram) and focused so that (a) projects a sharp image on the film plane, then an object farther away—at (b)—will be blurred because its light rays will converge considerably in front of the film plane, as the crossed broken lines show. The resulting circle of confusion on the film will be large and (b) will be fuzzy. But if the camera is moved back a considerable distance, (b) is not much more distant from the lens than (a); rays entering the lens from both points form circles that are more nearly equal. As a result, focusing the camera to produce a sharp image for (a) produces only a small circle of confusion for (b)—not big enough for the human eye to detect and hence producing no noticeable blur.

How F-Stop Alters Depth of Field

Focal length not only affects depth of field directly (pages 118-119) and indirectly by its influence on subject distance (pages 120-121), but also plays a role in still a third way: by its involvement in f-stops. The f-stop also helps determine depth of field, as demonstrated by the pictures on pages 80-81.

The actual size of the f-stop, the diameter of the aperture, depends on focal length. The relationship is a simple mathematical one: the f-stop number for any aperture is arrived at by dividing the diameter of the aperture into the focal length of the lens. Thus if the aperture actually measures 50 millimeters in diameter and the lens has a focal length of 100 millimeters, the diaphragm setting for that aperture will be $100 \div 50$, or f/2.

This connection between f-stops and focal length means that the same f-stop is not the same size hole for all lenses. F/2 on a 50mm lens, for example, will turn out to be a hole of smaller diameter than f/2 on a 100mm lens.

This may seem like a complicated way to mark lens openings, but the mathematical and optical principles involved are less important to the photographer than their result in practice: Apertures of the same f-stop—whatever their actual diameter—create equally bright images on the film. To maintain this equal brightness, a 100mm lens needs a hole double the diameter -four times the area-of one for a 50mm lens, since it must spread the image over an area four times as great. But this larger hole affects the sharpness of things in the foreground and background-it is one reason why long lenses have less depth of field than short lenses do.

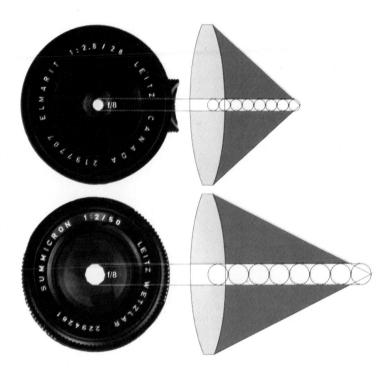

These two lenses show why the same f-stop requires a larger aperture in a long lens than in a short one. At top is a lens of 28mm focal length; below it is a 50mm lens. Both are set at f/8. This means that the aperture in each lens must be of such a size that its diameter will go into its focal length eight times. The diagrams, by actually lining up eight aperture-sized circles and fitting them into the focal length of each lens, make it clear that for the same f-stop a longer focal length means a larger aperture. This is true for any setting. The larger aperture is needed because the longer lens spreads its image over a larger area — it must collect more light rays to keep its image as bright as the image from a shorter lens set to the same f-stop

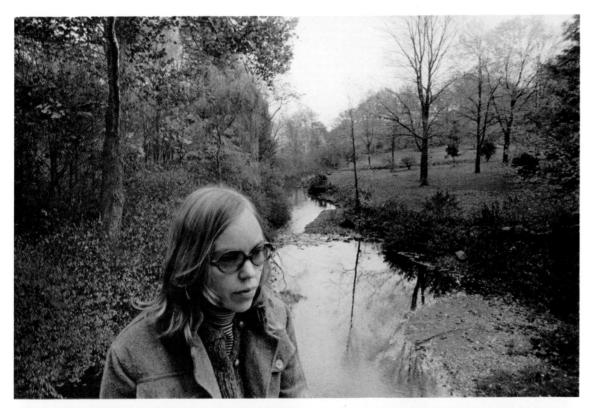

These photographs were taken from the same spot by the two lenses opposite. The differences between them demonstrate how the characteristics of lenses determine the appearance of a picture. With the lens of short focal length (upper picture) the images are small and the angle of view is wide. The aperture is small, providing great depth of field, and the perspective exaggerates distance so that the trees in the background seem far away. With a longer lens (lower picture) the image is larger and the angle of view narrower. The aperture is larger (as can be seen in the picture of the lens opposite), making the depth of field shallower; everything in the background is fuzzy. However, it is still possible to make out some of the trees well enough to see that they appear much closer to the woman than they do in the top picture.

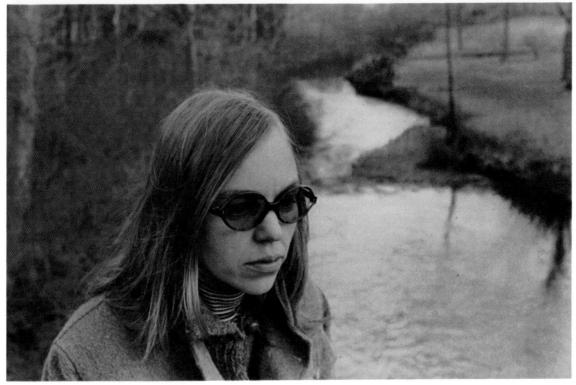

A Versatile Optical Design

If you were to slice open a modern camera lens, as has been done at right, you would discover a surprisingly complex structure of glass and metal. For the best camera lenses today are actually combinations of different lenses, calculated to provide more precise focusing under a wider range of light conditions than a single piece of convex glass ever could. The number of separate lens elements in such a compound lens may vary from two in an inexpensive lens for a simple camera to 12 or more in an elaborate zoom lens.

A compound lens is the lensmaker's solution to the problem of aberrations. These are the blurrings or distortions of images that result from the way lenses themselves handle light.

Not all light rays behave the same way as they pass through the lens and this creates a number of problems. For one thing, different colors bend at different angles-blue more than red, for example. Therefore, though a blue ray and a red ray may be traveling together from a single point and thus enter the lens together, they come out at slightly different places and as a result do not hit the film at exactly the same spot. This characteristic is known as chromatic aberration. It creates an overall fuzziness in pictures, whether blackand-white or color. Other strange effects also show up in colored pictures

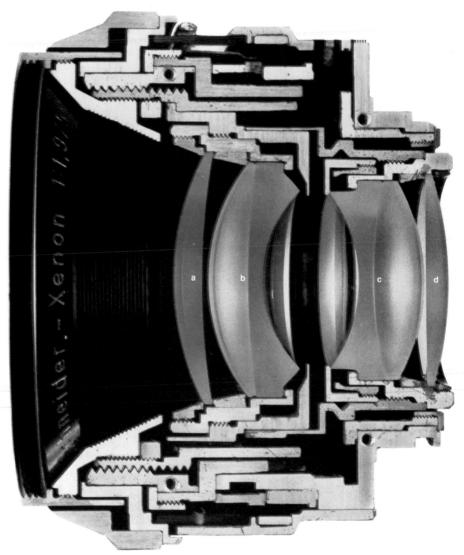

A modern compound lens, as this cutaway view shows, is usually a single convex lens sliced in two with some other pieces of distortion-correcting glass placed in between. The front half of the convex lens (a) has a two-piece element of special color-correcting glass (b) behind it. Farther back is another color-correcting element (c) and finally the back half of the convex lens (d).

— a blue edge to a tree trunk, a yellow edge to a human face.

There is no way to avoid chromatic aberration if only one piece of glass is used in the lens. But if more than one is used, the defect can be overcome. This is because the curvature of the lens and even the kind of glass it is made of will affect the bending of individual rays. The lensmaker takes advantage of this. Knowing the exact amount of chromatic aberration that his first lens has, he designs a second one of a different kind of glass and with a different curvature calculated to produce a chromatic aberration that is the exact opposite of the first. When the two lenses are used together, the aberrations cancel each other out and all colors originating in one point come to a focus at the same point on the film.

This technique of canceling optical errors by inducing opposing ones is applied to the many other aberrations that afflict simple lenses. That is why an expensive lens contains many pieces of glass designed by computers, ground to tolerances of a few millionths of an inch and tested with laser beams. Each element helps correct the aberrations caused by the others, while itself contributing aberrations that the others correct. At the end, after careful optical balancing, all comes out even and a sharp image appears on the film.

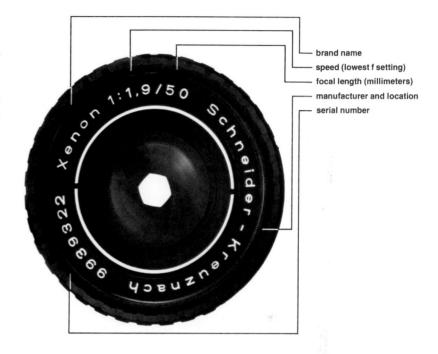

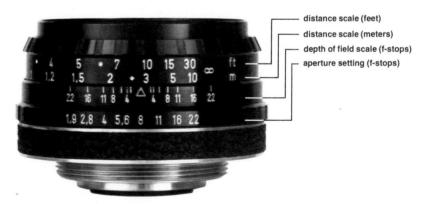

All the necessary information about a lens is marked on it, as these front and side views of the lens opposite show. On its front (top photograph) are its brand (Xenon), its speed (f/1.9), its size, or focal length (50mm), its maker's name and location (Schneider, Kreuznach, Germany), and its serial number (9939322). Distance and aperture scales are marked on the side of the lens.

HENRI CARTIER-BRESSON: Jerusalem, 1967

The Normal Lens

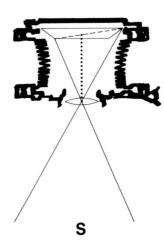

If the focal length of a lens (dotted line) is about the same as the diagonal measurement of the film (broken line), the lens is considered "normal." When focused on a subject (S) it collects light rays from an angle of view of about 50°—the same as the human eye—and projects them onto the film within the same angle.

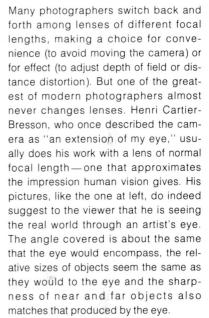

All these characteristics are the result of the normal lens's focal length. But a focal length that makes a normal lens for one camera makes a wide-angle lens for another. What constitutes normal depends on the film size. When the focal length of the lens equals the diagonal measurement of the negative, the image will be normal (diagram at left). For example, a frame of 35mm film measures about 43 millimeters diagonally, so a 43mm lens is normal for that film (although lenses from 40mm to 55mm are also considered normal and most 35mm cameras are sold fitted with a 50mm lens as standard equipment). For the larger negative size of a twinlens reflex camera—its picture is usually 85 millimeters in diagonal - a normal lens is 80mm and for still larger films the focal length of the normal lens increases proportionately.

This photograph of Hasidic Jews in Jerusalem shows how Henri Cartier-Bresson uses the normal lens to excellent advantage. All four figures are at different distances from the camera, yet all appear in proper size and perspective. There is no flattening or distortion, as there might have been had a lens of longer or shorter focal length been used, and almost all parts of the scene are sharp because the 50mm lens that Cartier-Bresson used on his 35mm camera provides good depth of field.

The Wide-Angle Lens

In the diagram below, the focal length of the lens (dotted line) is about two thirds of the film diagonal (broken line). This makes it a wide-angle lens: It produces a viewing angle of 75°, or about 50 per cent more than the eye could see clearly if focused on the same subject (S). The focal length of a typical wide-angle lens for a 35mm camera is 28mm, for a 21/4 x 21/4 twin-lens reflex 55mm.

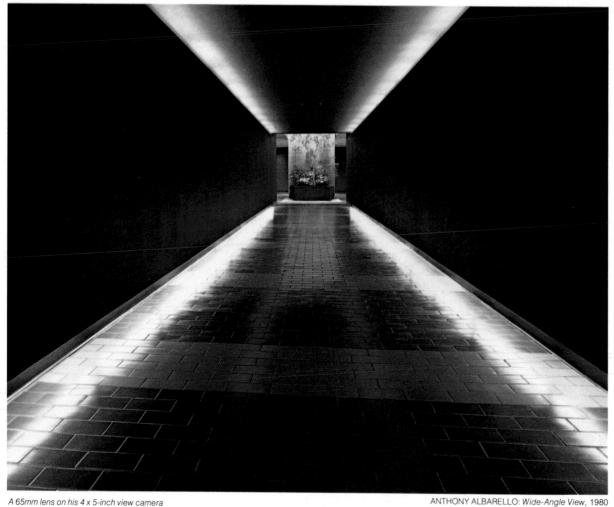

(comparable to an 18mm lens on a 35mm camera) gave Anthony Albarello the wide viewing angle and great depth of field he needed to shoot the entire entrance of an architect's office from a doorway at the end of the corridor. However, the lens

exaggerated the length of the corridor and made objects in the lobby seem unnaturally small.

ANTHONY ALBARELLO: Wide-Angle View, 1980

The obvious value of a wide-angle lens is that it gets more subject onto the film than does a normal lens. It allows the photographer to stay close to his subject and capture all of it; he can get his picture even if he is prevented from backing off far enough to use a normal lens.

Assigned to photograph a lobby entrance (opposite), freelance Anthony Albarello found himself halfway out of the door as he tried to include all of the spacious lobby. An ultra-wide-angle lens solved the problem: It took in the six-foot width of the hall, keeping its full length in focus, and yielding the desired image of rectilinear elegance.

He had to give up something in perspective, however: The 50-foot corridor appears much longer, the 10-foot-high plant in the lobby seems tiny, and the ceiling of the hall looks somewhat lower than its nine feet.

Occasionally, size distortion, a characteristic of short lenses, can be used to artful advantage as the portrait of Joe Louis illustrates. It makes the fists of the boxer unnaturally large to emphasize their sledge-hammer quality.

A more frequently useful advantage of the wide-angle lens is its great depth of field. A photographer working at close quarters at a party, for example, lacks time to change focus as he snaps guests around the room. With a wide-angle lens, however, his subjects will be in acceptable focus no matter where they happen to be standing, leaving him free to concentrate on the action.

The fists that brought the world heavyweight championship to Joe Louis are emphasized in this brooding portrait. Using a 21mm lens and shooting the picture from only 3 feet away, the photographer got the effect he sought by deliberately exploiting the wide-angle lens's tendency to exaggerate the size of near objects at the expense of distant ones.

JOHN DOMINIS: Leopard at Sunset, 1965

The Long Lens

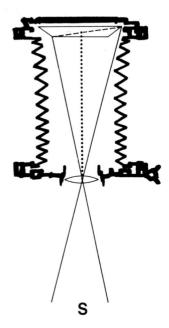

A lens is considered long for a camera if its focal length (dotted line) is appreciably greater than the picture diagonal (broken line). It then collects light over an angle that is narrower than that covered by human vision, producing an enlarged view of a restricted area (S). For a 35mm camera, a popular and useful long-focal-length lens is 105mm; for a 2½ x 2½ reflex the comparable lens is 200mm.

Silhouetted against an enormous setting sun, an unsuspecting leopard enjoys a meal as it is photographed with a 35mm camera through a 1,000mm lens from 200 yards away. The extreme narrowness of the angle of view—about 2°—has reduced the field to about the size of a thumbnail when viewed from arm's length. In order to cover the film with such a tiny scene, the images have been magnified many times and perspective is so compressed that it is almost impossible to determine depth.

Long lenses reach out like telescopes to provide a greatly enlarged image of a distant object. But there are subtler qualities that can also be exploited. All wildlife subjects, because of their elusiveness, are better handled from a distance. Here the long lens's extremely limited depth of field comes in very handy. Often there are leaves or bushes between animal and camera. When the animal itself is in sharp focus, the intervening foliage often can be made so blurry that, as if by magic, it disappears. Similarly, a background of broken branches or other distracting material can be turned into a neutral and pleasing blur so that the subject itself emerges far more clearly and powerfully than it appears to the human eye.

Finally, there are the dramatic effects gained by depth distortion. What makes the picture opposite memorable is the extreme magnification of the sun—which with a normal lens would have appeared to be about the size of a dime.

These characteristics also adapt long lenses to portraiture. Most people get self-conscious when a camera is poked close to them and their expressions become artificial. A long lens allows the photographer to maintain sufficient distance so that the subject relaxes. It also avoids the distortion that occurs when shorter lenses exaggerate the size of features that are closest to the camera—usually the nose.

For 35mm cameras, the most useful long lenses are the 85mm and 105mm, both excellent portrait lenses. Very long lenses are difficult to focus; they are rather bulky and heavier than conventional lenses. Since a hand tremor is enormously magnified by the magnification of the lens, use a tripod or brace the camera against your body.

The Zoom

The zoom lens enables a photographer to glide in for a close-up or pull back for a panorama without moving, refocusing or changing equipment. The zoom works these wonders with optical elements that move in relation to one another, altering the lens focal length and hence the viewing angle and the size of the image while still keeping the image in focus.

Zooms are now available in practically all focal lengths for 35mm SLRs as well as some other camera types. Some zooms adjust from a wide angle of 24mm to normal focal length, others from about 35mm to a moderately long 80mm. A popular type covers the range from about 70 to 200mm—zooming from the moderately long view preferred by many for close-up portraits to lengths that greatly magnify distant subjects.

These versatile lenses were once scorned by serious photographers because of their optical flaws; now, however, zooms almost match fixed-focallength lenses in overall sharpness. But some problems remain. Few zooms have a greater maximum aperture than f/3.5, and most cause straight lines to appear slightly curved at the edges of the frame.

The zoom's ability to move in as events unfold (right) naturally endears it to photojournalists, but the lens offers esthetic advantages as well. With a zoom, a photographer can compose and crop his image in the viewfinder. The lens also can create surreal blurred effects if it is zoomed during a long exposure.

An 80- to 200mm lens fitted to a 35mm camera follows a fast-moving football game in a way that would have been impossible with a fixed-focal-length lens. The photographer used the 80mm focal length (top) to take in the entire field and the spectators during a field-goal attempt. A fraction of a second later — without pausing to readjust focus — he zoomed to 200mm to isolate linemen leaping in a futile attempt to block the scoring kick.

MANNY RUBIO: Field Goal, 1980

From Camera Obscura to Computer Control 136

Cameras That Made History 140
A Faster Lens to Freeze Motion 142
Smaller Size, Brighter Image 144
"The Mammoth" 147
Portraits Cheaper by the Dozen 148
Adding the Third Dimension 150
A Swiveling Lens for Panoramic Views 152
The "Detective" for Quick Snapshots 154
"You Press the Button, We do the Rest" 156
A Gun to Shoot Action 158
Dissecting Motion with Many Lenses 160
Bird's-Eye Views from a Rocket 162
The Newspaperman's Standby 164
The First Candid Camera 166

PHOTOGRAPHER UNKNOWN: At Peter Britt's Studio, c. 1860

From Camera Obscura to Computer Control

The camera, oddly enough, was invented many centuries before photography. In the form of the camera obscura, it projected a view of an outdoor scene into a darkened room, directing light rays from the scene through a small hole in one wall to form an image on the opposite wall. During the 11th Century a number of Arabian scientist-philosophers were amusing themselves with camera obscuras made out of tents. In the late 15th Century Leonardo da Vinci described the "dark chamber" in knowledgable detail.

When one of Leonardo's countrymen, a Neapolitan scientist and writer named Giovanni Battista della Porta, became interested in camera obscuras toward the end of the 16th Century, he reacted as millions of amateurs have ever since: he got a camera of his own. He experimented with a lens to sharpen the image and then invited some of his friends in for a show. Seating them in the room facing away from the aperture, he uncapped the lens. On the wall could be seen a group of actors hired to play a little drama outside. Della Porta's guests, unhappily, were not amused by his motion picture show; the sight of tiny human forms cavorting upside down on a dark wall sent them into panic. Not long after, their host was brought before a Papal court on a charge of sorcery; he somehow wriggled out of the trouble, but found it prudent to leave the country for a while.

By the end of the 17th Century camera obscuras were serving practical ends. They were made in the form of movable chambers and sedan chairs so that artists could carry them around, get inside, and trace land-scapes and cathedrals in accurate perspective, using translucent paper placed over a ground-glass viewing screen. One of the first fully portable models was designed by Johann Zahn, a German monk. Zahn's camera, a wooden box nine inches high and two feet long, had not only a lens that could be moved in and out in a tube to focus the image, but an adjustable aperture to control the amount of light entering the box and a mirror that cast the image, right side up, onto a translucent screen on top so that it could be viewed from outside the box. Zahn's device was identical in principle with the modern single-lens reflex camera and had he had some kind of light-sensitive plate to put into it he would have invented photography.

However, virtually nothing was known about photographic chemicals at the time and it was not until 1826 that a French lithographer and inventor, Joseph-Nicéphore Niepce, applied new discoveries about light-sensitive compounds and finally supplied the missing element. Niepce coated a sheet of pewter with an asphalt solution, inserted it in an artist's camera obscura much like Zahn's and placed it on his windowsill. After an exposure

of eight hours he succeeded in making the world's first photograph: a dim, fuzzy image of his farmyard in central France.

After some years of effort, Niepce joined forces with a Parisian scenery designer and impresario, Louis Jacques Mandé Daguerre. Like Niepce, Daguerre did little to improve the camera, but he did find more sensitive chemicals. In 1839, after Niepce had died, he announced the first practical photographic process to the world. His daguerreotypes, which took exposures of about half an hour to produce, were surprisingly sharp. But he could photograph only still lifes, buildings and landscapes; people simply could not hold still long enough for their images to be recorded.

At the announcement of Daguerre's breakthrough, one of the men present, an Austrian professor named Andreas von Ettingshausen, immediately recognized the problem: The crude lens Daguerre was using was far too inefficient in gathering light (by modern standards, it had a speed of about f/17). On his return home, von Ettingshausen reported this news to his friend and colleague Josef Max Petzval, a professor of mathematics at the University of Vienna; he also introduced Petzval to Peter von Voigtländer, head of a prestigious family optical firm. It took nearly a year for Petzval to compute the design of a new lens and have it properly made, but the result was worth the effort. Built into a special camera made for it by Voigtländer (pages 142-143), it admitted nearly 16 times as much light as Daguerre's (its speed was about f/3.6) and reduced exposures to less than a minute.

Petzval's lens was to be the photographer's standard for 60 years thereafter. Known everywhere as "the German lens," it turned photography from a novelty into a practical craft. Thousands were produced by Voigtländer for use in his own and other cameras; and other entrepreneurs in Europe and America made many more thousands of copies. Voigtländer soon built a second factory in Germany to handle the demand, helping to lay the cornerstone of the German photographic industry. By then, however, Petzval had quarreled with his partner, contending that he had not been properly rewarded for his achievement, and the two men split up. Although Petzval was honored later as one of the founders of photography, he died a lonely and embittered man.

The camera in which Petzval's lens was most often used was the large and heavy view camera employed by nearly all professionals and amateurs through most of the 19th Century, but now seldom seen outside the studio. It was a tripod-mounted wooden box, with another box sliding inside it like a tight-fitting drawer (later replaced by a flexible leather bellows) to move the lens back and forth for focusing. The photographer adjusted focus while looking at the image on a ground-glass screen in

the back; the screen was then replaced with a plate holder for picture taking.

With the introduction of faster plates in the late 1870s, the camera needed a new element: a mechanical shutter that could dependably produce exposures in fractions of a second. The first shutters were not built inside the camera, but were accessories that the photographer fitted over the front of his lens. One, the "guillotine," or drop shutter, was the essence of simplicity: a sliding board with a rectangular hole in it. When the photographer released the shutter, the board dropped, letting light pass through to the lens during the instant the rectangle moved past. Rigged with rubber bands, this type of shutter allowed photographers like Eadweard Muybridge (page 160) to stop a horse in midgallop with speeds of close to 1/500 second. The first focal-plane shutter, operated like the guillotine but with an opening of adjustable size, was used by a British photographer named William England as early as 1861. The other main type, the leaf shutter, was first introduced by Edward Bausch in 1887.

By the 1880s a variety of ingenious special-purpose cameras also appeared: giant cameras to produce giant prints (enlarging was still impractical); multilens cameras that could record many small and inexpensive portraits on a single plate; stereo cameras that created an illusion of three dimensions; panoramic cameras that took in broad views (picture section following). But all of these devices were still too unwieldy and expensive for most amateurs. Also, with few exceptions they still involved the loading, unloading and developing of one plate at a time. Then, in 1888, a single event launched photography on its way to becoming a hobby for everyone: George Eastman, a former bookkeeper in a Rochester, New York, bank, announced to the world the invention of his Kodak No. 1, the first true hand-held camera designed to use roll film (page 156).

The Kodaks were aimed at the snapshot market; the dream of a small yet versatile camera for serious photography was still unfulfilled. In the spring of 1925, however, a handy little camera was displayed at the Leipzig Fair. Made by the German optical works of E. Leitz, it was called the Leica (from "LEltz CAmera"); it used a roll of 35mm film to provide 36 exposures; it had a fast focal-plane shutter and a high-quality f/3.5 lens.

The Leica had started as a gleam in the eye of Oskar Barnack, head of Leitz's experimental department, some 20 years before. Barnack, whose health was poor, was nevertheless an avid hiker and amateur photographer and liked to pursue his pastimes on Sundays in the Thuringian Forest. After panting up and down hills with his 5 x 7 view camera and a suitcase full of equipment, he began to dream of a camera he could simply put in his pocket or sling from his shoulder. Barnack's idea—"kleines Negativ, grosses Bild" ("small negative, large picture")— started to take shape. At first he tried cutting his 5 x 7 plates into small pieces and using them in an experimental cam-

Many artists of the 17th and 18th Centuries used a camera obscura for precise preliminary sketches for paintings of landscapes, buildings and even portraits. The portable model shown above worked exactly like the modern reflex camera. Light entering through the lens was reflected by an angled mirror inside the box; the mirror projected a right-side-up image on the ground-glass screen at the top, which was shielded from surrounding light by a folding hood. The artist placed a thin piece of paper on the glass and traced the image, achieving perfect perspective with a minimum of effort.

era, but the tiny negatives were too coarse to produce decent enlargements. Later, when he started working for Leitz on a motion-picture camera, he thought of using that camera's film, which was specially prepared to record fine detail in a small negative.

The film made the difference and the Leica in its later form set the standard for the modern hand camera that could take almost any kind of picture under almost any conditions. One lever advanced the film and wound up the mechanism of the focal-plane shutter, which could give a range of exposures from one second to 1/1000 second. The extremely fast lens allowed picture taking indoors without special lighting and a rangefinder mechanically connected to the lens gave accurate focusing. Most important, the camera was so small and simple to use that it could be taken anywhere and operated without fuss.

Barnack's Leica revolutionized photography. Along with similar precision cameras like the Ermanox (page 164) it became the new tool of photojournalists as well as an increasing number of amateurs, who prized its ability to catch unposed, natural pictures. And in turn such photographers began to support an ever-growing market for other types of small, versatile cameras, each with its own distinctive advantages. The twin-lens reflex, which enabled the photographer to focus through a separate lens coupled to the taking lens, was made popular by the introduction of the Rolleiflex in 1927; and in 1937 the Exacta provided a versatile small camera that could be easily focused through the taking lens, the 35mm single-lens reflex.

Such developments in fine cameras were spectacular enough, but the real camera explosion came after World War II with the success of two families of cameras for the amateur. One type, invented by Edwin H. Land, accepts instant-developing film and produces a finished print seconds after the shutter clicks. (Land was inspired to create the picture-in-a-minute camera by his small daughter: When he was taking snapshots of her one day, she impatiently asked how soon she could see them and was heartbroken when he explained about the delay involved in developing and printing.) The other post-World War II innovation is small cameras—some use tiny, economical 110 film—that operate automatically, their electronic controls guaranteeing acceptable pictures regardless of the user's expertise.

Both these families of modern cameras give the photographer the simplicity that won amateurs to George Eastman's first Kodak. Film magazines snap into place so that there is no threading. Light-sensitive devices gauge illumination and automatically set shutter or aperture for exposure. Even focusing is automatic in some cameras. Such automation, once capable of only crude control, has become so refined and precise that it is applied to the finest cameras. Professionals who once scorned automatic operation now leave technical drudgery to the electronic controls and concentrate on creating a picture.

Cameras That Made History

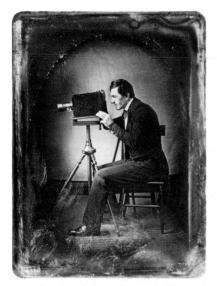

One of America's first daguerreotypists, Jacob Byerly (above), peers into the viewing screen of his camera, a plain box with a lens hardly changed from the centuries-old camera obscura. The group portrait at right, taken with a camera much like Byerly's, shows the lifelike detail characteristic of daguerreotypes. The smallest child, unable to hold still, appears blurred; the other figures are sharp, although no one appears to be enjoying the ordeal.

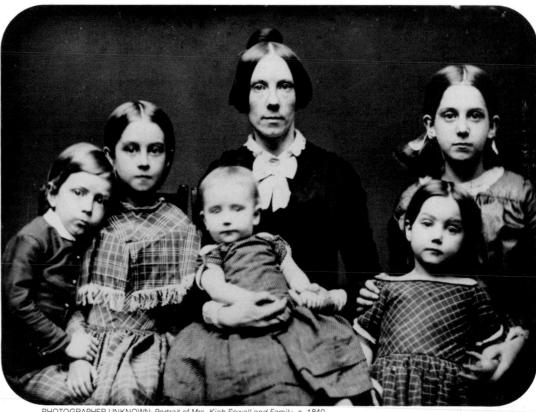

PHOTOGRAPHER UNKNOWN: Portrait of Mrs. Kiah Sewall and Family, c. 1840

The daguerreotypes that introduced photography to the world in 1839 were amazingly sharp and detailed pictures despite the fact that they had been made in a crude camera. Daguerre had simply modified a portable camera obscura, the device artists had long used as a sketching aid (page 138), so that it would accept a light-sensitive plate.

While Daguerre's invention was acclaimed as miraculous, its limitations soon became obvious. The combination of poor lenses and slow-acting chemicals required exposures of up to 20 minutes in bright sunlight before an image could be recorded in the camera. Scoffers predicted that photography would never get beyond the novelty stage. But in scarcely more than a year they were being proved wrong. Thanks to improvements in light-sensitive compounds and a few optical innovations (opposite), exposures could be made in less than two minutes. Customers were soon flocking to newly established daguerreotype studios - on the continent, in Britain and, before long, in the United States - where, with the aid of headrests and arm supports, they tried to hold still for the camera.

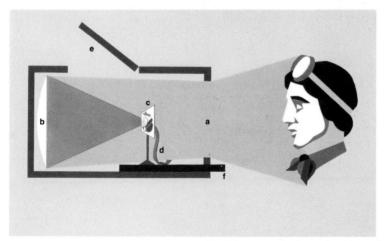

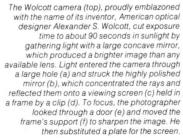

A front view of Alexander S. Wolcott's mirror camera (top), patented in 1840, shows the circular light-admitting hole, the rectangular plate holder and the curved reflecting mirror behind it. Typical of the tiny pictures this type of camera took is the one above, now badly deteriorated, of Henry Fitz, a telescope maker who helped Wolcott build a larger camera of similar design. Although Wolcott's mirror instruments made serviceable pictures, they soon became obsolete as lens design improved.

A Faster Lens to Freeze Motion

Viennese instrument maker Peter von Voigtländer (above), alert to photographers' demands for a fast lens and efficient camera, snapped up the new lens design brought to him by a mathematics professor, Josef Max Petzval. Voigtländer's technicians built the lens from Petzval's calculations and planned a camera especially for it. The camera, a finely made instrument, was sold disassembled in an elegant wooden case (right).

The first cameras made do with the crude lenses inherited from the camera obscura—lenses that were adequate for the sensitive human eye but too limited in light-gathering power to make photographs easily. Before photographers could take clear pictures of everyday scenes, they needed a lens mathematically designed for use in a camera. In January 1841 a maker of telescopes and other optical equipment, Voigtländer and Son, unveiled a camera—no modified camera obscura but a true photographic instrument—that was fitted with a lens designed

by Josef Max Petzval, a 33-year-old professor of mathematics at the University of Vienna. The camera, which understandably turned out looking like a small telescope, used circular plates to record the full image projected by the lens. But it was the lens that mattered. It gathered 16 times more light than other types and made possible the recording of poorly lighted scenes and moving crowds (opposite)—capturing these difficult shots with remarkable clarity but with strange tints that were due not to the lens but to the crude chemicals then in use.

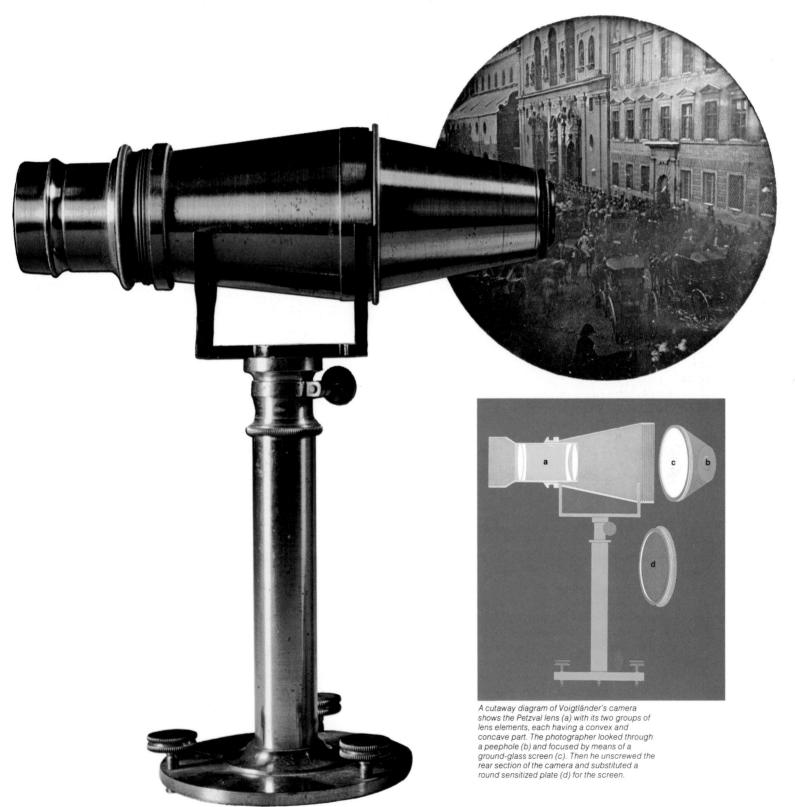

Smaller Size, Brighter Image

One of photography's pioneers, an English country squire turned scientist named William Henry Fox Talbot, took a different route from that of Petzval to speed up picture taking. At first Talbot, like his contemporary Daguerre, had used a large camera obscura. But he found that an exposure of even one full hour in full sunlight often failed to get a picture. Then Talbot realized that tiny cameras, using lenses of short focal lengths, would be much faster. The light gathered would be concentrated on a small area rather than dispersed over a large one; the brighter image thus cast would be recorded faster by the weak photographic materials he was forced to use.

Talbot fitted microscope lenses—the most carefully made lenses produced up to that time—to the little cameras, which his wife dubbed "mousetraps." The cameras were very small indeed, as the photograph above indicates,

some of them measuring only two and a half inches on a side. With one of these cameras, Talbot made his first successful photograph, a picture of a window in his manor house. The exposure time had been cut to a half hour, but the picture was so small—one inch square—that he dismissed it as looking like the work "of some Lilliputian artist." Lacking any means of enlarging his pictures, Talbot abandoned his mousetraps and concentrated his efforts on developing photographic materials sensitive enough to work in larger, conventional cameras.

But the mousetraps he discarded were to become, nearly a century later and in a much more sophisticated form, the cameras most people used. For Talbot had the right idea: The key to speed in picture taking was a small camera whose short-focal-length lens made the most of dim light by concentrating it on a small piece of film.

In this early photograph, taken in two parts and pieced together, Talbot and his assistants put on a busy show. Talbot himself (center) prepares a camera to take a portrait of a waiting customer (the ring behind the sitter will serve to keep his head steady during the exposure). At left, an assistant copies a painting; at right, another photographs a statue. In the background a technician puts negatives on racks in the sun to make positive prints. At far right, the kneeling man holds a target for the taker of this photograph to focus on.

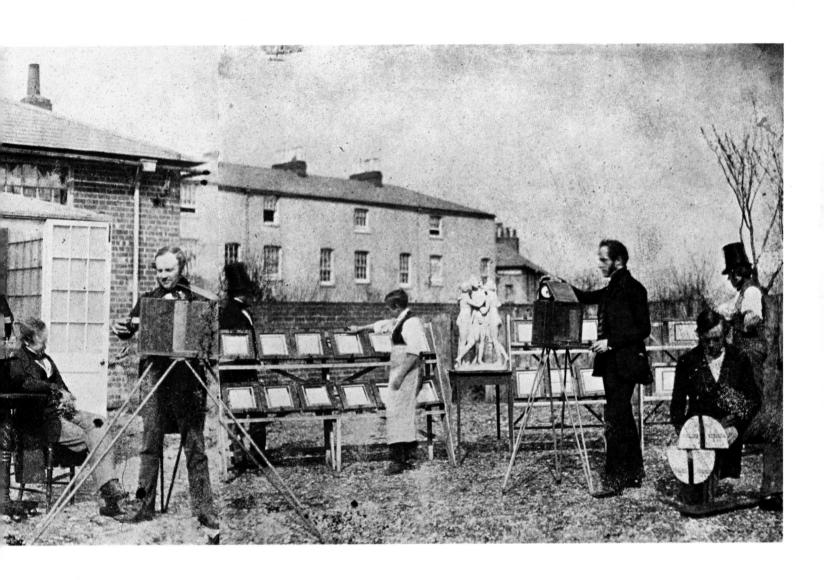

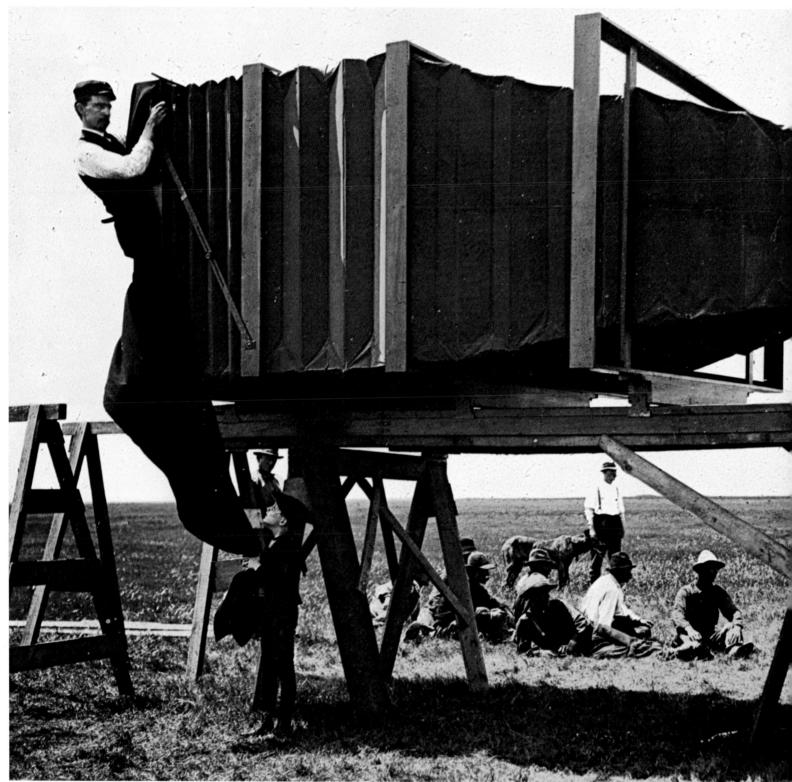

PHOTOGRAPHER UNKNOWN: "The Mammoth," c. 1900 146

"The Mammoth"

During photography's early decades, enlargements were difficult and expensive to make and often turned out hopelessly blurred. If you wanted big pictures you used a big camera. Many photographers had cameras that took 11 x 14-inch plates and larger and larger ones were built as the demand for big pictures grew. Among the first true giants was the one designed in 1858 by C. Thurston Thompson, an English photographer who specialized in reproducing works of art; his camera, a full 12 feet long, took photographs three feet square.

The largest camera of them all (*left*) was built in the United States around 1900. Named the Mammoth, it was designed for officials of the Chicago and Alton Railroad Company, who wished to have a single, perfectly detailed portrait of their newest luxury train. Having accomplished this feat, the Mammoth, like its prehistoric namesake, vanished, a victim of its own size and clumsiness.

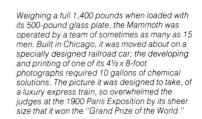

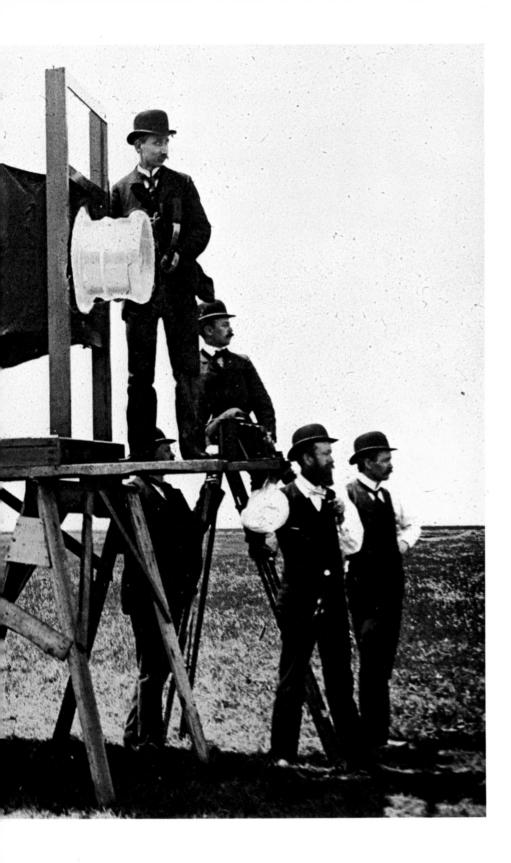

Portraits Cheaper by the Dozen

Photographic portraits found instant popularity because they were much cheaper than painted ones, but even so they cost more than most people could afford. In 1854, however, a French photographer named André Adolphe Eugène Disdéri brought portraits within reach of practically everyone by inventing a new type of camera. Equipped with several lenses, it cut costs by taking as many as a dozen pictures on one $6\frac{1}{2} \times 8\frac{1}{2}$ inch plate.

Disdéri's innovation went largely unnoticed until 1859, when the Emperor Napoleon III, about to embark for Italy, halted his troops in front of the photographer's studio and went inside to have his portrait made by the new method. After word of this got around, Disdéri suddenly found himself besieged by Parisians wanting their own portraits made. Within months, the rage for these tiny likenesses — called cartes-de-visite because they were often left by visitors in place of printed calling cards - spread across France, England and the United States. To serve the seemingly insatiable demand, hundreds of studios throughout Europe and America were established, and photographers competed to cut prices even more. The size of the individual portraits got even smaller as photographers devised ways to squeeze as many as 12 images on a single plate.

An early carte-de-visite camera had a focusing knob on each lens. Some cameras had lenses of different focal lengths so that views of different sizes, ranging from full-length to close-up, could be taken simultaneously.

In a carte-de-visite print (left), shown before being cut into separate pictures, a young lady tries out six coy poses. They were taken with an improved camera that allowed the photographer to mask sections of the plate so that he could expose one view at a time. Thus the customer could strike several different poses for the price of one. The inventor of such tiny multiple portraits, Disdéri—shown above in one of his carte-de-visite photographs—became the Emperor's court photographer, made a fortune, spent it and died a pauper.

Adding the Third Dimension

Two girls appear in a stereo photograph taken in 1853. When seen through a stereoscope like the one at right, which used a pair of lenses to magnify the two images, the slightly different views merged and the girls stood out in relief. This viewer is an ornate affair on a stand; most were inexpensive hand-held models.

By the early 1860s a new photographic fad was sweeping Europe and America: stereoscopic photographs. These were pictures in pairs, viewed through a twin-lens device called a stereoscope, which made each pair merge into a single view that seemed startlingly three dimensional, like a perfectly detailed model of the actual scene. Almost every middle-class household boasted dozens, sometimes hundreds, of these pictures. Family and friends gathered in the parlor to gape at each new set - the pyramids of Egypt, Parisian street scenes, the wonders of Peking, views of the Holy Land — all of them seeming to spring to life in vivid perspective before the eyes of the viewer.

Stereo photography was based on a long-known phenomenon of vision: that the eyes receive two slightly different views of a scene, which the brain translates into a single image having three dimensions. Thus a pair of pictures supplying slightly different views to each eye created the illusion of depth when seen through the stereoscope. Among the first to make a camera specifically designed for the job was an English optical instrument maker named John B. Dancer, who in 1856 patented a device (opposite) that took two pictures simultaneously through lenses set slightly apart.

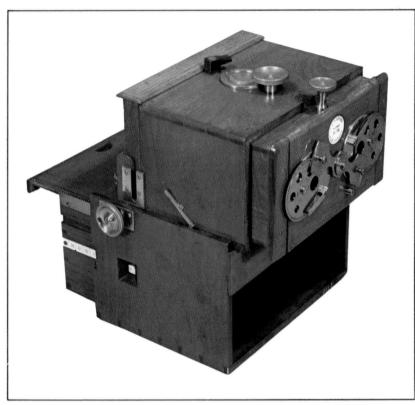

A box on a box, Dancer's device combines a stereo camera atop a plate-storing magazine. The camera has two lenses mounted 2½ inches apart, about the distance between the pupils of a person's eyes. In front of each lens is a revolving disk with holes of different diameters, one of which was selected to provide the aperture size needed for the correct exposure. In front of the disks is a double-ended paddle used as a shutter; turned by hand, it uncovered the lenses for focusing and taking pictures.

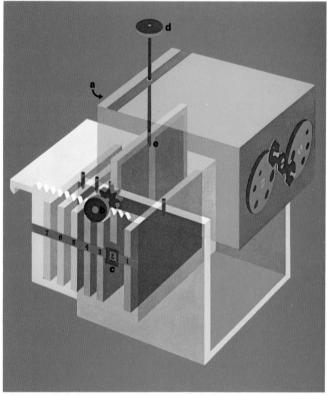

With Dancer's magazine-loading system the photographer could prepare the camera in advance for a series of stereo pictures by stacking plates in the drawer of the box below the camera. Once he had focused his subject on a ground-glass screen at the back of the camera, the photographer replaced the screen with a plate-changing back (a). He then turned a knob (b) to operate a gear that moved the plate-carrying drawer forward. As a plate came into position, its number appeared in the window (c) on the camera's side. He lowered a rod (d), screwed it into a threaded hole (e) on the top of the plate and pulled the plate up into picture-taking position. After exposure was made the plate was lowered, the rod unscrewed and raised, and the drawer moved forward to bring a fresh plate into position for the next picture.

A Swiveling Lens for Panoramic Views

Landscapes and cityscapes were handy subjects for early photographers. But they were at a disadvantage compared with painters: The standard cameras could take in only part of a scene, since few lenses had a viewing angle exceeding 40 degrees. When a photographer wanted a view of a city or mountain range he had to take overlapping views and paste them together.

In 1844, however, Friedrich von Martens, an engraver-photographer living in Paris, built a camera that could take scenes like the one shown below, embracing an arc of 150 degrees. The secret was a swiveling lens, which swept around a scene, "wiping" a continuous image across a daguerreotype plate five inches high and 17½ inches long.

In later years similar panoramic cam-

eras were used for pictures of large groups of people like the student body of a school. Some of the results contained a bizarre element, for a fleet-footed prankster could get his likeness into the same picture twice by outracing the camera's panning mechanism. After being photographed at one end of the group he ran around to be snapped again at the other end.

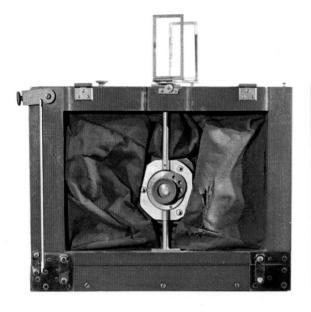

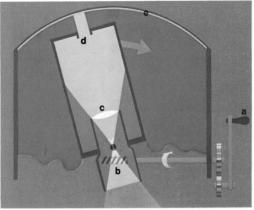

The von Martens camera (diagram) was the first to use a swiveling lens and a curved plate, devices used in the later panoramic camera pictured at far left. In the von Martens instrument, a hand crank (a) turned a gear (b) that swiveled the lens (c) in its flexible leather mount; in the later camera the lens was moved by turning the viewfinder on top. The lens had a mask with a slit (d) to restrict the image projected onto the plate (e) to a narrow strip; as the lens turned, the strip image moved across the plate, building up the picture in much the same way that a focal-plane shutter does. Like most daguerreotype pictures, it was a mirror image, reversed left for right.

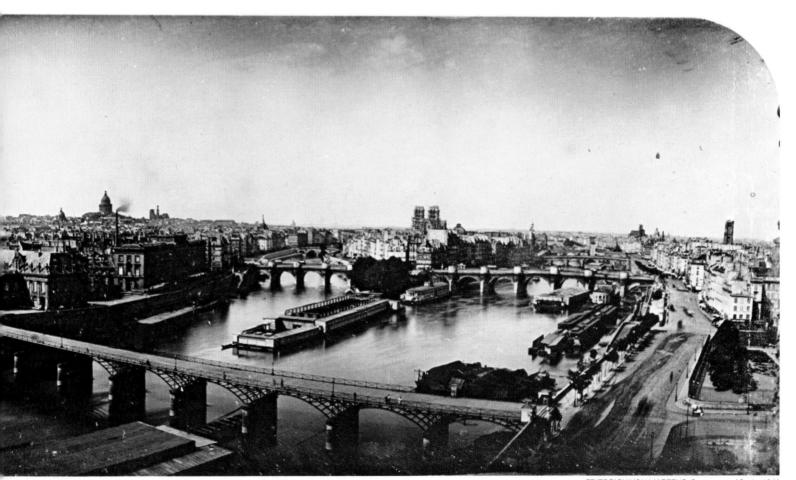

FRIEDRICH VON MARTENS: Panorama of Paris, 1846

The "Detective" for Quick Snapshots

So long as cameras remained large and cumbersome, photography's appeal as a hobby was bound to be limited to a few dedicated enthusiasts. In the 1880s, however, a number of camera manufacturers in Europe and America began to produce miniature models, many of which could be camouflaged or concealed within the user's clothing. Popularly known as "detective cameras" - not because they were employed in police work but because the owner could skulk about unnoticed as he took pictures - these devices came in every imaginable form, disguised as cravat pins, handbags, shoeshine boxes, ordinary packages, walking-stick handles, even revolvers. The "revolver camera" (far right) was a popular model; though it was hardly conducive to keeping a subject at ease, it was easy to aim and shoot.

Fanciful as some of the detective cameras might have been, they did enjoy a brief vogue—some 15,000 "concealed vest" cameras like the one at right were sold in three years. Capturing the public's imagination as novelties, these miniature devices introduced thousands to the fun of photography and helped bring about a new kind of picture: the unposed snapshot.

A vest camera, a disk-shaped gadget six inches in diameter (above left), could be hidden inside a man's jacket (below). By turning the center knob, the photographer made six round pictures on a single plate.

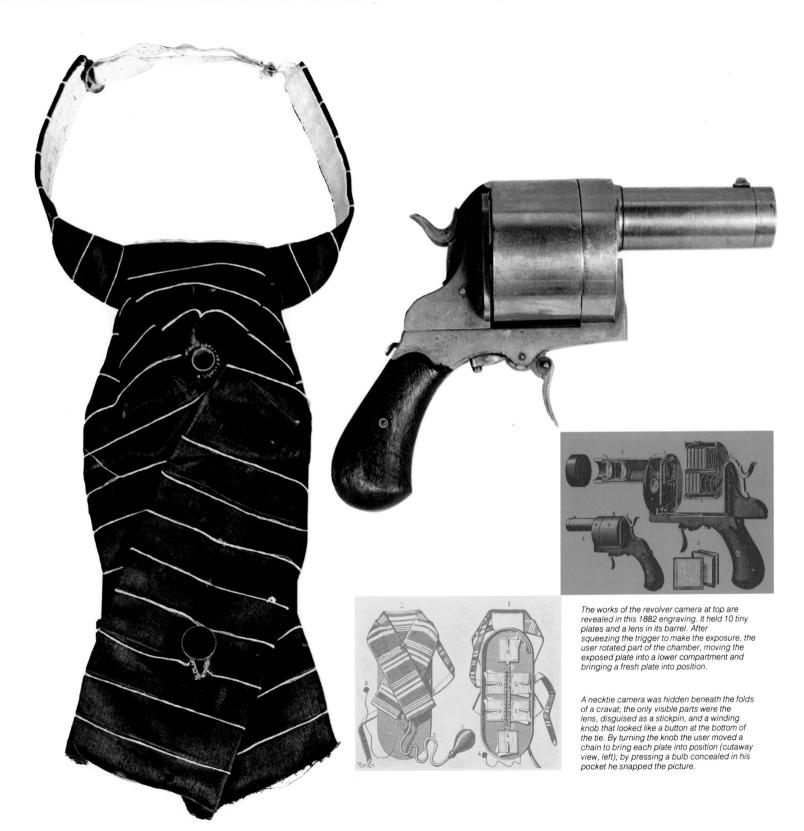

"You Press the Button, We Do the Rest"

Holding the camera is pictured in a Kodak snapshot while aboard ship in 1890. With advertisements like the one at center right, Eastman launched highly successful campaigns for his Kodak No. 1 and subsequent models. Other manufacturers, climbing on the bandwagon, used the Kodak as a standard of comparison—as in the Hawk-Eye ad at bottom right—to claim that their models were better.

No single event did more to popularize photography than George Eastman's introduction of the simple box camera in 1888, accompanied by the famous slogan above. Eastman foresaw that, given the proper, easy-to-use equipment, millions of ordinary people would "desire personal pictures or memoranda of their everyday life, objects, places or people that interest them. . . ."

Eastman's original model, the Kodak No. 1 (shown opened for reloading at right), was a box less than seven inches long and four inches wide. Its onespeed shutter was set at 1/25 second - fast enough that subjects did not have to strain to hold still - and its fixed-focus lens assured that everything more than eight feet distant would be reasonably sharp. The pictures were circular, not masked to a rectangular shape, in order to take advantage of the entire image projected by the lens. But what won over ordinary people was simplicity. There was no fumbling around with plates, for the Kodak was the first camera designed to use roll film and it came loaded with enough film to make 100 exposures. Nor did the amateur have to worry about developing and printing. He paid \$25 for the loaded camera, including a shoulder strap and leather case. The price also covered the cost of processing the first roll of film; when he had made his 100 exposures he mailed the unopened camera to Eastman's Rochester, New York, plant, where the negatives and prints were made. To receive his camera back fully reloaded and ready for use again, the customer mailed along with it an additional \$10, a fee that also prepaid the processing costs for the new roll of film.

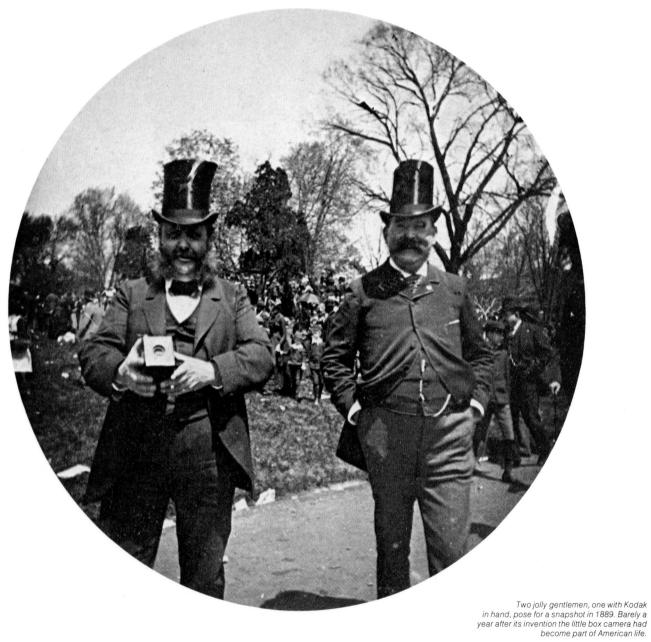

In the late 1870s, a French professor of physiology and natural history, Etienne Jules Marey, made the first step toward capturing all of an action instead of just freezing part of it. Long interested in analyzing the ways in which animals move, he turned to photography in the hope that he could break down their motions into sequences, each step of which could be studied individually. By 1882 Marey had designed a gun camera (above) whose trigger set in motion a clockwork mechanism; the clockwork turned a sensitized plate on which 12 postage-stamp-size pictures were made in a second. The exposure for each was very brief: 1/720 second. In 1887, Marey invented a "chronophotographic" camera that took sequence pictures on a roll of sensitized paper; three years later he replaced the paper with transparent celluloid film on which he was able to record as many as 60 individual exposures per second. This instrument foreshadowed the modern motion-picture camera.

Marey's gun camera took the 12 tiny pictures at left of a bird in flight. The camera had a lens in its barrel and a shutter at the front of its breech. A drum-shaped magazine, shown detached above the gun, held a load of 25 circular plates, each with a dozen picture-taking areas around its rim. To load the camera, the drum was placed on top of the breech and a slot was opened so that the first plate fell into a chamber directly behind the shutter. The user closed the slot, removed the drum magazine, then sighted on his subject and squeezed the trigger to get his 12 rapid-fire shots. The drum was then remounted and the gun turned upside down so that the plate dropped into a storage compartment for later developing.

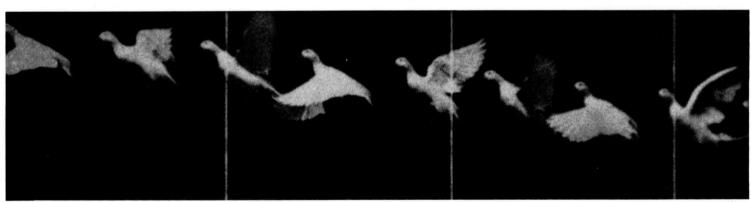

E. J. MAREY: Flight of a Duck, c. 1890

Marey's roll-film sequence camera (shown in a top view at left) took photographs in a horizontal strip like the one above. The film, driven by a hand crank, moved from a storage spool to the focal plane in the middle of the compartment, where it stopped for exposure, and then was wound on a take-up spool. The shutter, also operated by the crank, made individual exposures of 1/100 second, fast enough to avoid blur in pictures of a flying duck.

Dissecting Motion with Many Lenses

A wager about horses led to some of the most graceful photographs of motion ever taken - sequence views that were made not by a single-lens camera like Professor Marey's, but by a battery of lenses and shutters rigged to snap one after the other. This method was developed by Eadweard Muybridge (a brash Londoner born Edward Muggeridge) in response to a request from Leland Stanford, the railroad millionaire who was also a former governor of California and a racing-stable owner. Stanford had argued with a friend over the question of whether a running horse ever had all four hooves in the air at once. Stanford, the story goes, had wagered \$25,000 that this was so and he hired Muybridge to prove the point with stop-action photographs.

In 1878, Muybridge set up a bank of 12 separate cameras, spaced at intervals of 27 inches, beside a race track. Each camera had a shutter with a speed of 1/1000 second and to each shutter release was attached a black thread stretched chest high across the track. As one of Stanford's horses sped by, it broke the threads in sequence to work the shutters one after the other. The result was 12 separate photographs, each revealing a different stage in the horse's gait. The incontrovertible evidence of the photographs proved that Stanford was right: At one point all four hooves were off the ground.

The publication of Muybridge's photographs created a mild sensation in both scientific and photographic circles; at the invitation of scientific societies he traveled in Europe, where he lectured on animal motion and met Marey. In 1884 he accepted an offer from the University of Pennsylvania; there he built special multilens cameras (above) and photographed hundreds of different animals and humans in action, including the young lady in the diaphanous nightgown shown here.

To take the pictures at right, made simultaneously from three sides, Muybridge used three special cameras, each with 12 picture-taking lenses plus one for viewing (top). Each lens made a separate picture on its own glass plate, which was held with the others by an elongated plate holder (shown below the lenses). Muybridge arranged the three cameras as in the diagram above; the shutters were synchronized to work together so that each stage of the girl's movement was recorded from three directions.

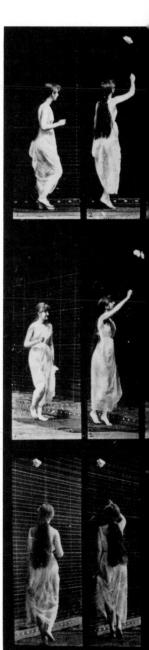

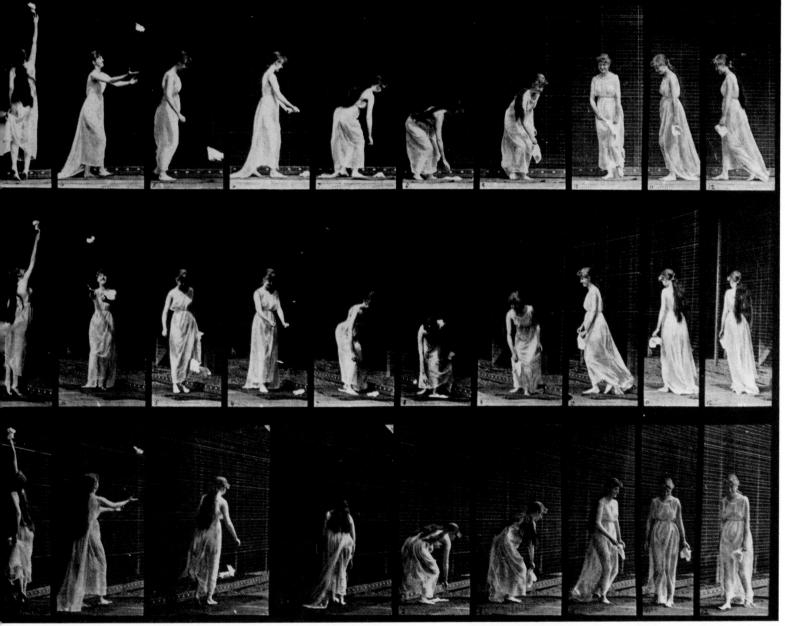

EADWEARD MUYBRIDGE: Motion Study of a Girl Playing with a Handkerchief, c. 1885

Bird's-Eye Views from a Rocket

As early as the 1860s photographers had gone up in balloons to make detailed records of cities, landscapes and battlefronts; small cameras had also been attached with some success to high-flying kites and even to the breasts of trained pigeons.

By 1903 a still more startling form of aerial photography was in the offing. In that year a German engineer, Alfred Maul, patented a rocket camera that caught the interest of the Kaiser's generals for its potential usefulness in military reconnaissance. After nine years of work and many experimental models Maul successfully launched the device shown at right. The camera, shot skyward by a rocket and returned to earth by parachute, made a single exposure automatically as it reached the apex of its flight. To test its durability in warfare, soldiers were ordered to fire at the descending camera to see if they could effectively knock it out. Although Maul's invention survived the test and produced good pictures, it was never used in combat: Airplanes and dirigibles, both invented in the early 1900s, provided superior camera platforms. Not until after World War II did rocketborne cameras come into their own as superb instruments for space studies.

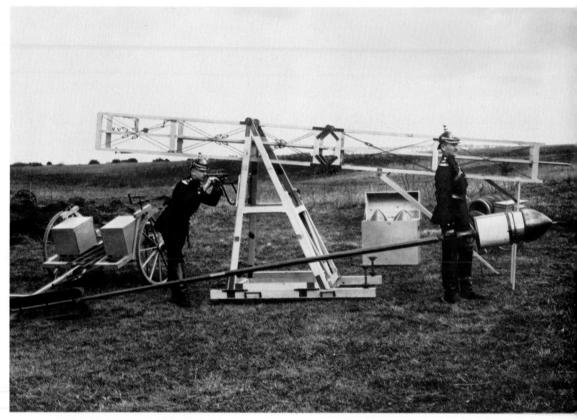

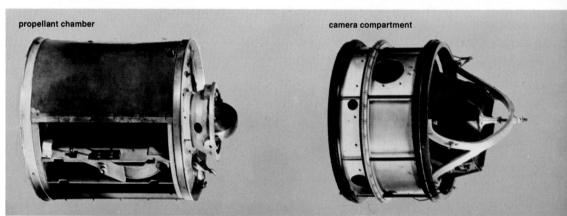

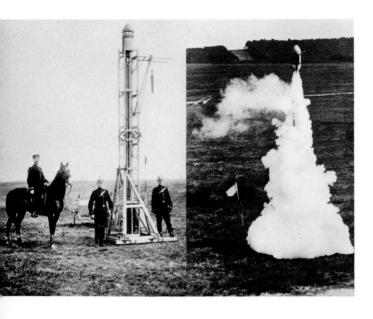

At a rifle range near Dresden, German soldiers (far left, above) prepare a rocket camera and its launching tower for a test-firing in 1912. With the rocket in place, all is ready for the launch (center), and the camera blasts off in a billow of smoke. When the rocket burned out at 2,600 feet, the camera made a single exposure, like the one shown above, and floated back to earth.

■ The rear compartment of the rocket's casing (far left) held the gunpowder propellant, a stabilizing gyroscope and the parachute. The center section contained the camera, its lens behind the largest of the holes in the casing. The nose cone, equipped with an automatic shutter release, fitted part way over the camera to protect it during firing. When assembled, the rocket was attached to a 15-foot-long guiding stick.

The Newspaperman's Standby

Early in the 20th Century, the public was introduced to a new dimension in journalism: action news pictures made with the high-speed, single-lens reflex camera. The first real "press" camera, it was portable, its fast lens and focalplane shutter could freeze even a speeding car (opposite), it focused easily through the taking lens, and its large picture size allowed the high-quality prints needed for engraving. For nearly half a century many of the most memorable news photographs were taken with the German ICA (right) or its neartwin, the American Graflex.

The versatility of the big reflex made it equally popular with photographers who were not journalists. It capitalized on odd distortions in the pictures caused by the focal-plane shutter. In the photograph at right by J.-H. Lartigue, the impression of speed is conveyed by the apparent forward lean of the car's wheel and the backward lean of the spectators. Both effects are due to the shutter, a fast-moving slit (page 75) that moves vertically across the film, exposing different parts of it at different instants in time. Thus, in taking a picture of a fast-moving car, the bottom of the wheel will be photographed at one point, but when the slit in the shutter reaches the top of the wheel, the whole car will have moved to the right. so that the wheel comes out looking egg shaped. In taking this picture Lartigue had to move his camera to keep pace with the car's movement. This, in turn, gave the spectators their odd appearance, for when the shutter's slit passed across their legs the camera was in one position, but by the time it exposed their heads the camera and film had moved to the right.

While looking down into the tall, light-shielding hood of an ICA like this one, the French photographer Jacques-Henri Lartigue took the picture shown at right in 1912. The camera worked much like modern 35mm single-lens reflexes (page 64)—but used 4 x5-inch glass plates and was fitted with an fl4.5 lens, very fast for its day. Its distorted freezing of motion, so obvious in the racing-car picture, has over the decades become an illustrators' convention; today an artist drawing a moving object may deliberately make it lean forward to convey an impression of speed.

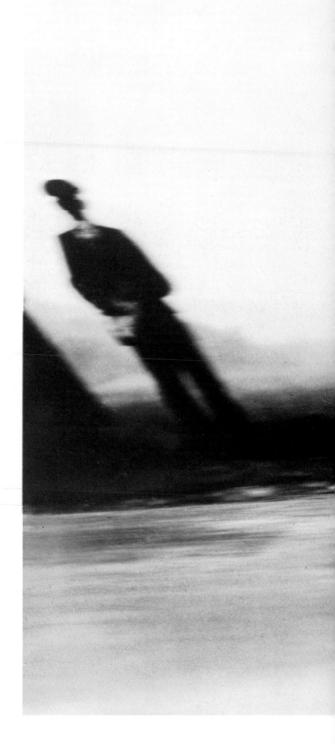

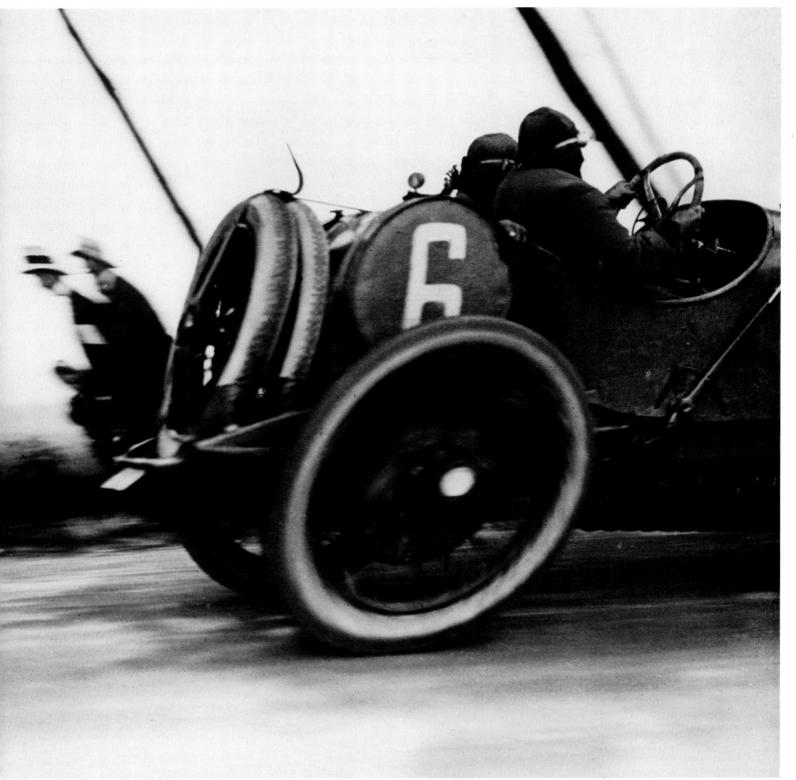

JACQUES-HENRI LARTIGUE: A Delage Racer at the Grand Prix, 1912

The First Candid Camera

The Ermanox first revealed the potential of candid photography. It used 2 x 3-inch glass plates that had to be loaded one at a time. But its small size made practical a lens so fast —f/2 —that indoor shots could be snapped without special lighting, enabling Erich Salomon to catch such intimate views as the scene below of a summit meeting on Franco-German problems.

Not until the 1920s did photographers get a camera that realized the promise of Talbot's mousetraps—a handy, unobtrusive instrument able to take pictures easily in dim light. The first of these candid cameras—to be followed soon by the Leica - was the Ermanox (left), marketed under the slogan, "What you see, you can photograph." In the hands of an expert like Erich Salomon (right), this claim was no exaggeration. Salomon often dressed in formal clothes to crash diplomatic gatherings, where his camera enabled him to record Europe's powerful at work. In tribute to him, the French statesman Briand once remarked, "There are just three things necessary for a . . . conference: a few Foreign Secretaries, a table and Salomon."

ERICH SALOMON: Meeting of Diplomats at Lugano, 1928

The Victorian Pioneers 170

Adapting the Traditions of Art 184

Still Lifes 186
Landscapes 188
Genre Photography 190
The Morality Lesson 192
Romantic Illustrations 194
The Nude 196
A Tool for the Artist 199

A Shared Point of View 200

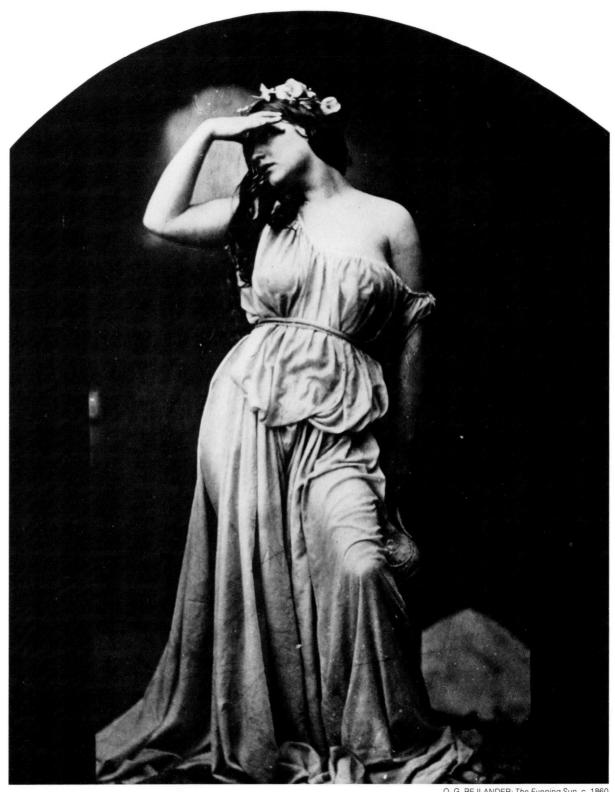

O. G. REJLANDER: The Evening Sun, c. 1860

The Victorian Pioneers

Photography! It burst upon the sedate, self-satisfied world of Victorian Europe with the force of an exploding comet. Within months of the announcement in 1839 of Daguerre's technique, a new profession, a new technology, a new art form and a new craze had come into being. In Paris and London, optical supply houses—where lenses could be purchased—and apothecaries—where chemicals were available—were suddenly besieged by photography enthusiasts eager to acquire their own cameras and prepare their own plates. City balconies blossomed with oddly shaped boxes pointed toward the streets; hovering nearby, anxious neophyte photographers, watches in hand, counted off the minutes necessary to inscribe the image of a tree, a lamppost or a building upon the sensitized plate. If the end result, as often as not, was a mere blur, no matter; the imagination of the enthusiast sketched in the sharply defined images of which the daguerreotype was capable when it was placed in the hands of an expert.

While amateurs all over Europe were happily taking pictures, posing for pictures and collecting pictures, a few men were asking themselves what the true role of photography might be. Some of the answers soon became obvious. In the field of astronomy, for example, François Arago, who introduced the daguerreotype process to a joint meeting of the French Academies of Sciences and Fine Arts in 1839, immediately saw its application to his own discipline; it was not long before some of his colleagues were attempting photographs of the moon and other celestial bodies. And as a means of spreading knowledge of faraway peoples and places, photography quickly proved that it had no peer. Photographers were soon touring the Holy Land, North Africa, the Middle East and some of the more remote reaches of Europe. On the sands of Egypt, along the Way of the Cross in Jerusalem, in the shadow of the Parthenon in Athens, they hauled their bulky equipment, prepared their plates and fought off swarms of flies and mosquitoes to bring back photographic views of the ancient world's majestic ruins. Their efforts seem all the more remarkable because there was as yet no way to reproduce their work directly in books or periodicals; either individual prints of the photographs had to be made and laboriously pasted in by hand, or, as was more usual, the photographs were hand copied by engravers.

In one field, however, the role of photography was far from clear. Almost from the moment of the new medium's birth, a number of photographers began staking out claims in areas that had long been the preserves of painters. Portraits, landscapes, still lifes, nudes and even allegories came to be grist for the photographer's mill. Painting, which for many centuries had been painstakingly perfecting the techniques of perspective and realistic detail, suddenly found its supremacy as an art form challenged by a mechanical

O. G. REJLANDER: Infant Art, 1856

Dimply cherubs, the all-purpose supporting actors in many a neoclassical canvas; were happily adopted by early photographers along with all the other traditions of painting. When the photographer of this one posed his model he may have been dreaming of his own "infant art"; in any case, his major accomplishment seems to have been keeping the child still long enough to take the picture—although the model's eyes have obviously blinked.

device that could record even the most complex scene instantaneously. Confronted with this revolutionary invention, some painters reacted with foreboding. "Painting is dead from this day on!" the French painter Paul Delaroche was reported to have exclaimed in 1838. In one sense he was right, for painting simply as a representation of reality had indeed suffered a mortal wound. Although a photograph could not then convey colors, its unique ability to reproduce the surface of things made it a better mirror of nature than even the most detailed painting. But in a broader sense, Delaroche could not have been more mistaken. By usurping painting's role as the portrayer of the objective world, photography would prove a powerful stimulus to artists, setting them off on a quest for new means of expression.

It is hardly surprising that in the early days of photography many painters, even talented ones, fought back against the mechanical monster that threatened their self-esteem and livelihood. Although the French painter Ingres admitted that photography captured "the exactitude I would like to achieve," for public consumption he appended his signature, as did a number of other painters, to a formal protest issued in 1862, that damned photography as a soulless, mechanical process, "never resulting in works which could . . . ever be compared with those works which are the fruits of intelligence and the study of art. . . ."

Photographers, in turn, resented such pretensions on the part of painters. Some of them had themselves been trained in the art academies of Europe, and they found in photography a new art form. But because of their backgrounds they continued to think of this new form in old and conventional ways. They regarded photography as another kind of painting. The oldest known daguerreotype (page 172), taken by Daguerre himself in 1837, reveals this clearly. It is a still life self-consciously composed in the style of neoclassical painting.

Paul Delaroche, who shortly before had prophesied the death of painting, apparently had second thoughts. Soon he could barely contain his enthusiasm over the artistic possibilities of photography. "Daguerre's process," he wrote in 1839, "completely satisfies all the demands of art, carrying certain essential principles of art to such perfection that it must become a subject of observation and study even to the most accomplished painters." A French newspaper critic was even more lyrical: "What fineness in the strokes! What knowledge of chiaroscuro! What delicacy! What exquisite finish! How admirably are the foreshortenings given: this is Nature itself!"

The daguerreotype had one quality that actually intensified the tendency to confuse photography with painting; it was a one-of-a-kind process. Each picture was a unique thing in itself and could not be copied. Like a painting, it could be carefully composed by its creator and treasured by its owner, who

could rest secure in the knowledge that he had a work of art that could not be duplicated. It was not until widespread use of a process that relied on transparent paper negatives from which any number of prints could be made that this sense of painting-like uniqueness could be threatened. Nevertheless Fox Talbot, the inventor of this process, and others continued, in essence, to imitate painting at first. In the 1840s Talbot published *The Pencil of Nature*, the world's first book of photographs. The edition was a small one of approximately 150 copies, and each photographic print was pasted onto its page by hand. For his negatives and his prints Talbot used fine writing paper that he had treated with chemicals. The texture of this paper gave his pictures softer outlines and tones than those possible with the mirror-like surface of the daguerreotype, which utilized sensitized copper plates. Talbot's subjects were architectural views and still lifes taken around his ancestral home of Lacock Abbey. These softly rendered views gave the little volume the look of an artist's sketchbook.

However, it was not in architectural, still life or landscape photography that the camera made its first and most successful assault upon a preserve of painting, but in the field of portraiture. The invention of photography coincided with the rise to affluence of a large European middle class who clamored for the services of painters able to immortalize them on canvas. By the early 19th Century, the portrait of the paterfamilias, his wife and his children had become a mark of a respectable and prosperous household. But if the demand for portraits knew no bounds, neither did the fees of the most talented artists. What was needed was a quick, efficient means of producing likenesses that on the one hand would satisfy the patron's desire for selfadmiration without pauperizing him and on the other would permit the artist to turn a fast profit. To meet this demand for cheap portraits, painters devised all manner of short cuts, including sketching a likeness from the ground glass of the camera obscura, tracing the subject's profile as it appeared through a translucent screen (an extremely popular type of portrait called a silhouette) and painting miniatures so small that the subjects' heads were frequently less than an inch high. During the early part of the 19th Century the art academies of the Continent, Britain and America turned out, each year, scores of practitioners whose meager talents would never be tested beyond the simple demands of the miniature or the silhouette.

One can imagine the dismay with which these artisans greeted the arrival of photography. Here was competition that was practically unbeatable. For a fraction of the cost of even a cheap oil painting, the sitter could have his image preserved on plate or paper. Despite efforts to denigrate the photograph as "soulless," portrait painters found themselves fighting a losing battle. In a remarkably short time the silhouette became little more than a his-

LOUIS JACQUES MANDÉ DAGUERRE: Still Life in the Artist's Studio, 1837

The earliest daguerreotype known to exist shows the unmistakable stamp of painting. The photographer was Daguerre himself. In a corner of his studio he assembled a few plaster casts, a small framed painting, a wine bottle and folds of material. Lightling his still life dramatically, he achieved a study full of shadows, textures and details.

PHILLIP GRAFF: Group Portrait, date unknown

Like a group of Dutch burghers in an oil painting, four unidentified men adopt a fraternal stance for the daguerreotypist Phillip Graff. The owner of one of many portrait studios in Berlin, Graff developed an improved light-sensitive process for daguerreotype plates that cut down exposure times, making posing for pictures somewhat less of an ordeal.

torical curiosity and the practice of miniature portraiture all but disappeared. In 1830, for example, of the 1,278 paintings exhibited at Britain's Royal Academy of Arts, about 300 were miniatures; three decades later, fewer than 70 portraits of this type were displayed. During the interval, of course, photography had been invented and many portrait painters were driven either into penury or into the practice of the despised new medium itself.

Much of the new photographic portraiture was hardly of a higher order than what it replaced. The comparative simplicity of photography lured hundreds of untrained and unimaginative people, looking for a way to get rich quick, to set up shop and churn out their wares by the score each day. Advances in equipment and techniques reduced exposure times for portraits from 15 or 20 minutes to less than a minute, adding to the comfort of the sitters and the profits of studio owners. In 1849, a mere decade after the announcement of photography's birth, some 100,000 daguerreotype portraits were taken in the city of Paris alone. In London, the boom in portrait photography was even more astounding. Between 1851 and 1857 the number of portrait studios in that city jumped from about a dozen to more than 150. Not untypical was the studio of one Mr. Lorenzo Henry Russell, who styled himself, among other things, a professor of music, a mesmerist and a taxidermist as well as a photographer. For Mr. Russell, the ideal patron presumably was one who could be lulled by soft music, hypnotized by a piercing stare, stuffed for the mantelpiece and then photographed for posterity—all at a modest time payment rate of one shilling a week.

Portrait studios of Russell's day varied from outlandishly ornate salons to sparsely furnished photo factories. Many studios had on hand scores of painted backdrops and pasteboard props, enabling the customer to choose the setting that best expressed his character, his ambitions or his dreams. Portrait photographers, following the lead of portrait painters, tailored these props to their sitters' achievements: an actress might be shown standing before Greek masks for comedy and tragedy; a musician might hold a lute. As often as not the props spoke of the sitter's fantasies rather than his accomplishments; a timid man could pose as an intrepid hunter stalking his prey, a merchant as a scholar surrounded by books and scientific instruments.

American portrait photographers were particularly adept at luring customers with lavish displays. One journalist compared their establishments with "the enchanted habitations which the Orientals erect for their fabulous heroes. Marble, carved in columns . . . [adorns] the walls. . . . Here are gilded cages with birds from every clime, warbling amidst exotic plants whose flowers perfume the air. . . . Surrounded thus, how is it possible to hesitate at the cost of a portrait?" In such portrait palaces the cost might come high—as much as \$15 or \$20. For those who could not afford the fee there

was always a quick-picture emporium around the corner. Here the customer stood in line to buy a ticket representing a prepaid exposure. Then he waited his turn to sit before the camera. As each new sitter entered the curtained cubicle, the cameraman reached into a hole in the wall where a technician handed him a freshly coated plate. After the operator had made the exposure, he passed the plate through a hole in another wall, beyond which a technician completed the work as the cameraman went on to another customer. Art may have been the last thing the owners of such studios worried about, but their 25-cent prints were often as good as—and frequently more straightforward than—the fancier products of the more expensive salons.

By the time portrait studios were in full swing in the 1850s, several important technological advances had eased the lot of both the photographer and his patrons. Most important was the fact that retouching had become a standard practice, enabling photographers to satisfy the vanity of the most self-admiring patrons. *The Photographic News* of London put the case for retouching quite baldly in 1859: "The [retoucher] may correct with his brush defects which, if allowed to remain, spoil any picture. For instance, where a head is so irregular in form as to become unsightly, soften those features which are the most strikingly deformed, and reduce the head to a greater semblance of beauty. Try to discover what good points there are—for all heads have some good points—and give these their full value." The mass of photographers followed such instructions with enthusiasm. What resulted were cosmetic images that revealed little of the character of the sitter.

There were some portrait photographers who refused to retouch and others who limited retouching to backgrounds; among them were some of the most talented men of their time. The earliest of the master portraitists were the Scottish photographers David O. Hill and Robert Adamson. Hill, a painter of some talent, helped to found the Royal Scottish Academy. In 1843 he joined forces with Adamson, a young chemist who had taken up photography. It was Hill's intention to make photographic portrait studies in preparation for a huge group painting he was planning, to immortalize some 470 Scottish clergymen and laymen. The two men worked in the calotype process, which Hill characterized as superior to the daguerreotype precisely because of its imperfections. "The rough surface, and unequal texture throughout of the paper," wrote Hill, "is the main cause of the calotype failing in details, before the process of Daguerreotype— and this is the very life of it. [Calotypes] look like the imperfect work of a man— and not the much diminished perfect work of God."

In their photographs (right) Hill and Adamson showed a deep sensitivity to their subjects' characters that is all the more remarkable because of the difficulties they had to overcome. They worked with bulky equipment, slow

HILL AND ADAMSON: David Octavius Hill, 1845

In a brief but prolific collaboration between 1843 and 1847, the landscape painter David Octavius Hill (above) and the chemist Robert Adamson set high-water marks for portrait photography. Their subjects — more than a thousand faces of mid-19th Century Scotland — range from dour theologians like Dr. Alexander Monro III (top right) to the stone mason-turned-geologist Hugh Miller (bottom right), and include masterfully composed domestic scenes (far right). Almost invariably these portraits display character and spontaneity despite the fact that their subjects were carefully posed and braced to prevent them from moving during exposures that took several minutes.

HILL AND ADAMSON: Dr. Alexander Monro III, 1843-1847

HILL AND ADAMSON: Hugh Miller, 1843-1847

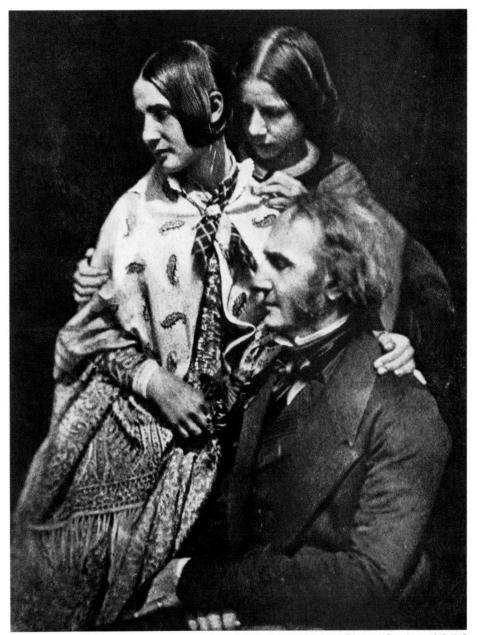

HILL AND ADAMSON: James Fillans and Daughters, 1843-1847

lenses and light-sensitized papers that required exposures in full sunlight of one or two minutes. Nevertheless, the two photographers managed to pose and direct their subjects in such a way as to produce portraits that have life and spontaneity. In their study of Hugh Miller, for example, they captured the flinty nature of the Scottish character and the strength and determination of the Scottish will in a way that few photographers could match even today.

When Hill completed his camera studies, he returned to brush and palette. After 23 years of labor, most of it in his spare time, he finished the group portrait—a work that can only be ranked as a giant mediocrity. It is ironic that Hill, who always believed that photography was merely a tool for the painter, found lasting fame for his practice of the "lesser art," while as a painter his name is all but forgotten.

Another artist who made his mark as a master portrait photographer was the Frenchman Gaspard Felix Tournachon, known to his contemporaries — and to history — by his adopted name of Nadar. Born in Paris in 1820, Nadar studied medicine and then abandoned it in favor of a career as a professional caricaturist. As a young man his ambition was to publish caricatures of every prominent Parisian, and like Hill he turned to photography to record the faces he wished to draw. By 1853, however, Nadar had become so enthusiastic about the artistic possibilities of photography that he all but gave up the pen in favor of the camera and opened his own photographic studio. To this studio flocked the great and near-great, among them the writers Victor Hugo and Alexandre Dumas and musicians like Rossini, Berlioz, Wagner and Liszt. Some came to Nadar because of his reputation for excellence in portrait work, others merely because it was the stylish thing to do. In any case, few who had their portraits taken by the great man himself - rather than by one of his assistants, to whom the lesser celebrities were guided - ever had reason to be disappointed. Unlike many portrait photographers of the period, Nadar avoided complicated props like pasteboard columns and pretentious lighting effects in which the subject's head might be haloed by sun streaming into the studio. By the standards of Victorian Europe, Nadar's style was simplicity itself, and because as a celebrity in his own right he knew most of the people who came before his camera, he was able to draw from them expressions and poses that are at once relaxed and compelling.

Through the work of Nadar, historians have gained penetrating insights into the *haut monde* of the Second Empire and Third Republic. In 1859 a French journalist summed up his contributions: "All the artistic, dramatic, political galaxy—in a word the intelligentsia—of Paris has passed through his studio. The series of portraits that he exhibits is the Panthéon . . . of our generation. Daumier meditates . . . Guizot stands, his hand in his waistcoat,

LEWIS CARROLL (Charles Dodgson): Alice Liddell, c. 1859

Daydreaming, perhaps of Mad Hatters, Alice Liddell, the girl for whom "Alice in Wonderland" was written, appears in a pose evocative of a proper Victorian childhood. The photographer was her storytelling friend, Lewis Carroll. as severe and cold as if he were waiting for silence in the court before launching into a thundering rebuttal—Corot smiles as someone asks him why doesn't he *finish* his landscapes. . . . The photographer has the right to be called an artist."

At about the same time Nadar was at work in Paris, two amateurs were establishing themselves as talented portraitists in England. One was Charles Dodgson, better known as Lewis Carroll, the author of Alice in Wonderland: the other, a true master of the art, was a gentlewoman named Julia Margaret Cameron. Not surprisingly, Carroll excelled in the portraiture of children. His natural sympathy for them and their problems and his delight in telling them stories undoubtedly helped him put his subjects at ease during the long exposures his large-plate camera required. Like most Victorian photographers. Carroll sought prettiness of detail and soulful expressions. He was, however, no mere imitator of established conventions, and time and time again he ignored the "artistic" modes of his era to produce photographs that are at once romantic and authentic. Alice P. Liddell (left), the prototype for the Alice of Alice in Wonderland, is revealed deep in thought, her head resting in profile against the back of her chair. It is superb characterization, and one can easily imagine how this little girl with the pensive look could inspire Carroll to flights of literary fancy.

Although Carroll was an amateur in the sense that photography was only one of his interests, Julia Margaret Cameron was such only in her lack of interest in selling her pictures. Once she discovered photography, it became the passion of her life. Generally speaking, her works fall into two categories: straight portraiture of superb quality, in which she used the camera to reveal the essential character of her subjects; and illustrative photography, in which the subjects are dressed in the garb of literary or historical figures. The illustrative photographs were very much in tune with Victorian taste. It is her portraits that have brilliantly survived the test of time.

Julia Cameron, the daughter of one British colonial official and the wife of another, was born in India in 1815. After her marriage in 1838 to a man 20 years her senior, she spent another 10 years in India before her husband retired from government service, eventually settling at Freshwater, on the Isle of Wight. Her romance with photography did not begin until she was 48 years old, and then almost accidentally. One of her grown children gave her a camera, thinking this harmless diversion might ease the boredom apt to weigh down a lady of leisure and advancing years. If she had been bored, Julia Cameron never was again. A woman of immense determination, comfortable means and good social connections, she brought to photography all the enthusiasm and zeal of a religious convert. She even spoke of her work in devotional terms. Referring to her portraits of Britain's literary and artistic elite,

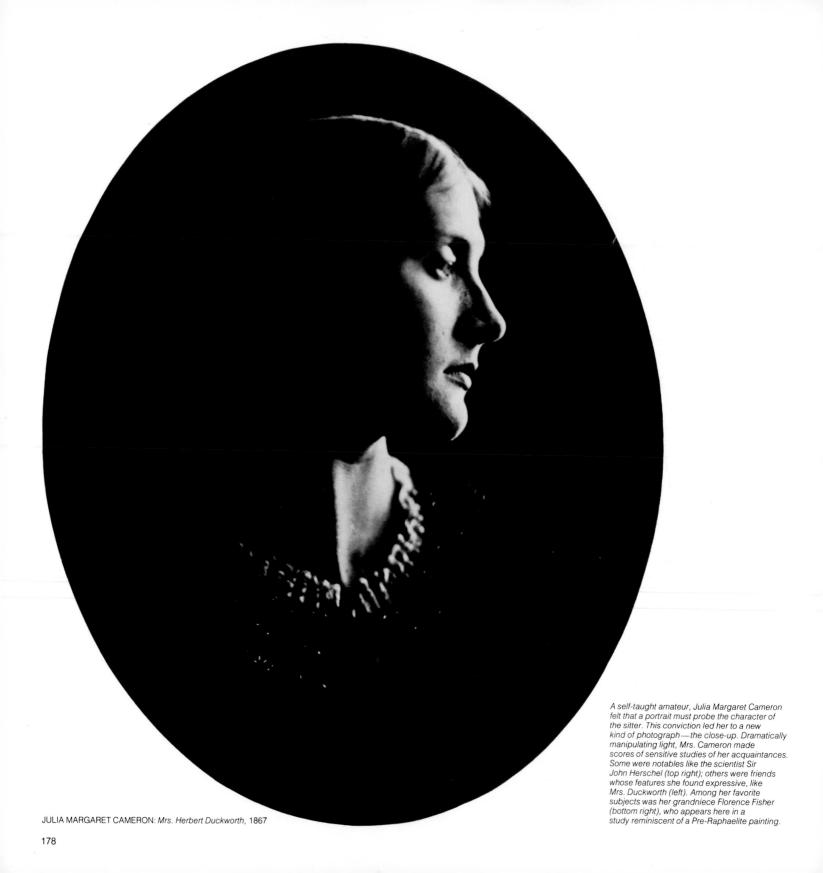

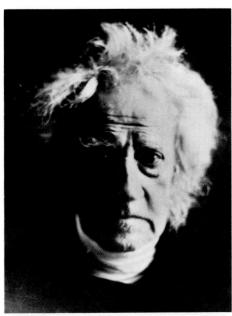

JULIA MARGARET CAMERON: Sir John Herschel, 1867

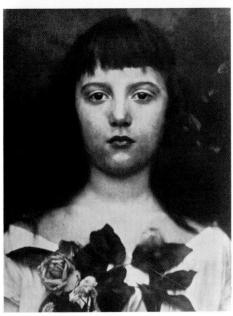

JULIA MARGARET CAMERON: Florence, 1872

she once wrote: "When I have had such men before my camera my whole soul has endeavored to do its duty towards them in recording faithfully the greatness of the inner as well as the features of the outer man. The photograph thus taken has almost the embodiment of a prayer."

While the good lady regarded her photography with reverence, she treated the distinguished visitors at her home more like slaves. No man was too famous, no woman too frail to be spared Mrs. Cameron's bullying until he or she agreed to sit for a portrait. Among those who resisted successfully was the Italian revolutionary Giuseppe Garibaldi, who, while visiting Mrs. Cameron's neighbor and friend Alfred, Lord Tennyson, was accosted by the lady in Tennyson's garden. Not knowing who this interloper was, he simply told her to be gone.

If resisting Mrs. Cameron's plans was painful, sitting for her could be torture. A perfectionist, she would take exposure after exposure, all the while snapping orders at her subjects. Crown Prince Frederick of Prussia, whose word was law within his own domains, apparently made the mistake of lowering his glance while sitting for a portrait. As if addressing a careless child, Julia Cameron commanded, "Big eyes! Big eyes!"

Matters were not eased by Mrs. Cameron's technique. Her belief in subdued light and large photographic plates, and her use of long lenses for close-ups (a technique in which she specialized), necessitated exposures that often lasted for several minutes. After each exposure she would disappear into her darkroom to prepare another plate, leaving her sitter with firm orders not to move a muscle while she was gone. Even chance acquaintances, if their faces intrigued Julia Cameron, stood little hope of escape. One young lady, asked to pose in the manner of ancient royalty, remembered the occasion years later in an article for a British photographic journal. "The studio . . . was very untidy," she reminisced, "and very uncomfortable. Mrs. Cameron put a crown on my head and posed me as the heroic queen. This was somewhat tedious, but not half so bad as the exposure. Mrs. Cameron warned me before it commenced that it would take a long time, adding, with a sort of half groan, that it was the sole difficulty she had to contend with in working with large plates. . . . The exposure began. A minute went over and I felt as if I must scream; another minute, and the sensation was as if my eyes were coming out of my head; a third, and the back of my neck appeared to be afflicted with palsy; a fourth, and the crown, which was too large, began to slip down my forehead; a fifth-but here I utterly broke down, for Mr. Cameron, who was very aged, and had unconquerable fits of hilarity which always came in the wrong places, began to laugh audibly, and this was too much for my self-possession, and I was obliged to join the dear old gentleman. When Mrs. Cameron . . . bore off the gigantic dark slide with the remark that she was afraid I had moved, I was obliged to tell her . . . I had."

It was typical of Julia Cameron to pose a pretty girl with a crown on her head, draping her body in flowing robes and fixing her hair so that it hung loosely down like that of a medieval princess. In subject matter, though not in style, her work—particularly her illustrative studies—was influenced by the Pre-Raphaelite school of painting, which attempted to return to the subjects and artistic conventions of late medieval Europe. To dress up her sitters in costumes and have them illustrate scenes from history or literature was perfect bliss for Mrs. Cameron. Certainly the most famous of these stage-set works is *The Idylls of the King (pages 194-195)*, a series of photographs suggested by Tennyson as pictorial interpretations of his poem. By today's standards these photographs of country bumpkins decked out in mock Arthurian garb appear quaint, to say the least, but to Mrs. Cameron and her admirers they were singular successes.

Julia Cameron was only one of many photograhers who attempted to adapt romantic painting to the photographic print. From the 1850s through the 1870s there was a rage for illustrative photographs intended to elevate the new medium to an exalted status as Art. "Here is room for man and beast for centuries to come," wrote one photography enthusiast in 1857. "Here is land never trodden but by the angels on the day of Creation. This new land is photography, Art's youngest and fairest child. . . . For photography there are new secrets to conquer . . . new Madonnas to invent, new ideals to imagine. There will be perhaps photograph Raphaels, photograph Titians, founders of new empires, and not subverters of the old."

There were to be many candidates for the title of the Raphael or Titian of photography. Mrs. Cameron herself was certainly one, but the most famous — and commercially the most successful — was Britain's Henry Peach Robinson. Year after year Robinson turned out illustrative and allegorical photographs that had been carefully plotted in advance, in which several negatives were combined to form the final print. One of his best-known pictures is Fading Away (page 190), in which five negatives were pieced together to show a pale, lovely girl expiring on her deathbed while her relatives watch over her in attitudes of grief. The picture was an enormous popular success. A few photographers questioned the artistic merit of the composite technique, and some proper Victorians argued the issue of whether a dying girl was a fit subject for photography. Although everyone knew that the scene was staged rather than real, photographs had already become synonymous with truth, and viewers found it difficult to remember that this picture was purely a product of the artist's imagination.

With pictures like Fading Away and The Lady of Shalott, Robinson became the leader of the so-called fine-art movement in 19th Century photography,

H. P. ROBINSON: The Lady of Shalott, 1861

H. P. ROBINSON: Preliminary sketch with photograph inserted, c. 1860

Inspired by romantic literature, the British photographer Henry Peach Robinson devised a "composite" photographic technique that allowed him to produce imaginary scenes. To illustrate Tennyson's lyrical poem "The Lady of Shalott," Robinson pasted a posed print of a woman lying in a boat onto an empty background of water and trees (during the long exposure needed, the boat would undoubtedly have moved on the stream, creating a blur). After retouching the overlapped outlines, he then rephotographed the composite picture and made final prints for sale from the new negative. Robinson usually planned such compositions in considerable detail: at left, a half-finished composite shows a cut-out photograph of a reclining woman superimposed on a preliminary pencil sketch.

whose purpose was to endow the musings of the imagination with the mantle of reality. His colleagues and the general public alike eagerly awaited each new photographic offering from the master's studio, and devoured the truth that came from the master's pen. In his *Pictorial Effect in Photography* Robinson told his admirers quite straightforwardly: "Any dodge, trick and conjuration of any kind is open to the photographer's use. . . . It is his imperative duty to avoid the mean, the bare and the ugly, and to aim to elevate his subject, to avoid awkward forms and to correct the unpicturesque. . . ." Such advice, coming from so famous a photographer, encouraged others to look more than ever to painting for their inspiration rather than to the unique ability of photography to represent the real world.

One who needed no encouragement from Robinson or anyone else was Oscar G. Rejlander, a Swede who moved to England in the 1840s in hopes of establishing his reputation as a portrait painter. As a means toward this end, he took up photography. A resourceful and innovative man—some of his pictures bring to mind Surrealist photographs of the 1920s — Rejlander firmly believed that photography could beat painting at its own game. Around 1856 he produced some pictorial studies inspired by Raphael's Sistine Madonna, in one of which he had little children fill the role of cherubs. Encouraged by generally favorable criticism, he then conceived of what must be one of the greatest oddities in the history of photography - an exceptionally large composition, measuring 16 by 31 inches, entitled The Two Ways of Life (pages 192-193). The allegorical picture, which bears some resemblance to storytelling canvases of the Italian Renaissance, was intended by Rejlander to be a startling demonstration of the photograph's worth as a full-scale study model on which painters could base their own works. However, when it was exhibited at the Manchester Art Treasures Exhibition of 1857 it was viewed as a work of art in its own right. The picture shows two youths in Roman garb being introduced to the adult world by their bearded teacher. One youth turns his eyes toward modestly draped figures representing such virtues as Religion, Good Works, Industry and Knowledge, while the other clearly cannot wait to fling himself into the arms of seminude temptresses who symbolize Licentiousness, Wine, Gambling and other vices. It was a very crowded "canvas," and to produce it Rejlander hired a band of itinerant actors and posed them in small groups for separate photographs. Then, after setting up and photographing an elaborate pseudo-Roman backdrop, he carefully pieced together the 30 negatives to produce the final print.

Although the picture is almost ludicrous in its heavy-handed message, it greatly appealed to the Victorians' sense of morality, and the fact that it was a photograph rather than a painting appealed even more to their newfound love of technology. Many objected to the nudity in the picture, but *The Two*

Ways of Life nevertheless received the ultimate seal of approval: Queen Victoria herself, despite her well-known parsimony, considered 10 guineas a fair enough price to pay for so morally elevating a picture and bought it as a present for her consort, Prince Albert.

In the more fanciful works of Reilander and Robinson, photography that was derivative of Victorian painting began to burn itself out. Other photographers continued to rake around in the coals, attempting to rekindle their craft in the fire. By the 1880s, however, a new movement was coming to the fore, led by an ex-medical student, Peter Henry Emerson, an Anglo-American whose work would influence photographers in both England and the United States. Emerson was the first to campaign against the stand that "art" photographers had taken. He realized that imitation paintings did not make great photographs, and saw that true photographic art was to be created only by exploitation of the camera's inherent potential: its unique ability to capture in a direct way the essence of the real world. Scorning the still-popular pictorial school, in article after article he thundered against such practices as composite printing, costumed models, painted backdrops and sentimentalized views of daily life. A man of strong opinions, with language to match, Emerson characterized Robinson's Pictorial Effect in Photography as "the quintessence of literary fallacies and art anachronisms."

Having thus disposed of prevailing tastes, Emerson laid down his own strictures for camera work: simplicity of equipment; no "faking" by lighting, posing, costumes or props; free composition, unfettered by classical formulae ("each picture requires a special composition and every artist treats each picture originally"); complete avoidance of retouching ("the process by which a good, bad or indifferent photograph is converted into a bad drawing or painting"). Emerson maintained that the ingredients for deeply moving, esthetically satisfying pictures were to be found in the lives and the work of common people, in photographs taken not in the studio among theatrical props, but in the farms and fields of Britain. In his book Naturalistic Photography, published in 1889, Emerson called for a photographic renaissance in which the contrived and artificial would be replaced by the true and real. Several books of his photographs—containing pictures taken in the Norfolk Broads, a swampy area of England where the author had a houseboat — amply proved his point. Pictures like the one of Norfolk cottages (right), which examined the world of English country folk, remain to this day classics of their kind.

While Emerson strongly recommended spontaneity in terms of subject matter he was anything but casual on the subject of photographic technique. In the matter of focusing, in particular, he attempted to apply hard-and-fast scientific principles so that the photograph would reproduce a scene as he

Until Peter Emerson exhibited pictures like this one — a clear, well-composed study of a row of thatched cottages in Norfolk — few photographers had realized that the camera could reveal quiet, authentic beauty in the most ordinary of subjects. Emerson's photographs, combined with his unrelenting attacks on the artificialities of "romantic" picture taking, helped launch photography along the road toward self-realization as an independent art.

believed the human eye saw it: sharp at the point of focus, fuzzy at the periphery. Emerson's concentration on technique, it turned out, led him astray. He came to think that every aspect of picturemaking could be reduced to a set of technical principles and controls—an idea that also appealed to some painters of his time. But when he found there were certain aspects that he could not control to his satisfaction, he entered a period of frustration. Frustration led to despair and despair finally led to denunciation - not just of the principles, but of photography itself. Where but a few years before he was predicting that the challenge of photography would cause the ultimate demise of painting, in 1891 he denounced his own medium as "the lowest of all arts." There was undoubtedly an element of pique in Emerson's renunciation. A volatile and vain man, he could not abide the thought that others, working in the new school of natural realism, were now leading the way toward a new esthetic of photography. Yet he could not destroy what he had already accomplished. Through his earlier writings and photographs, Emerson had greatly influenced a new generation of photographers. He had proclaimed photography as an art in its own right, independent of painting; an art with its own needs, its own laws and its own triumphs. This was to be the art of truth, not the stylized and "ennobling" truth of the pictorialists, but the truth of man and nature, imperfect but real.

P. H. EMERSON: Norfolk Cottages, 1888

Adapting the Traditions of Art

The invention of photography sent shock waves through the 19th Century art world. Painters were soon vacillating between writing obituaries for their own craft and announcing that the camera was a toy that took neither brains nor skill to operate. It was such a revolutionary way to produce pictures, in fact, that no one was quite sure how to use it to best advantage.

But produce pictures it plainly did. and it naturally was turned first to imitation of painting; many of the early photographers simply adapted the conventions - and the clichés - of the older art form to their work. Instead of taking interpretive pictures of the real world around them, as photographers would later learn to do, they made pictures very much as painters made paintings - elaborate still lifes, carefully posed portraits, moody landscapes, formal figure studies, allegorical scenes - and they judged these photographs by what they had grown accustomed to seeing in paintings. At the French Photographic Society's exhibition in 1885, the judges rejected several photographs - including one of a man cutting his corns-because their subject matter was not deemed sufficiently dignified to qualify as art.

In some respects—particularly in matters of composition, lighting and tonal values—photography learned much from its apprenticeship to painting. When Dr. Hugh Diamond, an Eng-

lish physician and amateur photographer, assembled the photographic still life shown at far right, he was drawing upon such venerable motifs as the 18th Century version in oils at right above. Happily he had a good eye and was also a good technician. His photograph contained a wealth of rich tones, textures and details that any painter might envy. But this sort of slavish following of painting more often led photography into blind alleyways. Too many photographers, trying to produce grand works in classical or romantic style, dressed up their models in rented armor or baggy togas and posed them against painted ruins. In the long run such pseudopaintings proved only that the cold eve of the camera could devastatingly expose artificiality for what it was. Most such pictures look silly today.

As photography came of age, however, its practitioners began to realize that they could do more than merely duplicate paintings. Some started to use the camera to document social conditions and record informal scenes of everyday life; still others sought artistic expression in compositions of light and form. Henry Peach Robinson, one of England's foremost photographers, began asking himself some probing questions. "Why," he wondered, "should we try to make our pictures look like the result of other arts? The limitations of photography as an art have not been definitely fixed."

ALEXANDRE-FRANÇOIS DESPORTES: Lièvre Mort et Fruits, 18th Century

DR. HUGH DIAMOND: Still Life, c. 1855

Still Lifes

The first showpieces of photography were still-life compositions that - except for their lack of color-were often all but indistinguishable from paintings. With great care their creators laid out arrays of household objects, flowers, fruit and game in elegant, balanced arrangements, carefully lighted them and then recorded the image. Given the cumbersome equipment and processes then in use, such compositions were a natural starting point for photography. A still-life subject, unlike living creatures, did not twitch restlessly during a long exposure. It could also provide a controlled variety of interesting shapes and textures for the photographer to explore at his leisure.

Among the abler professionals who experimented with still-life themes was Henri Le Secq, the official photographer for France's Historical Monuments Commission. Le Secq was a master technician whose architectural photographs were so sharp in detail that an admirer remarked they were easier to study than the real thing. Yet when Le Secq turned to still life (right), he immediately went beyond mere record making. He had a real painter's eye for masses and a broad range of tones; he even used rough paper for his calotype prints to soften the details. The rich, glowing mixture of whites, grays and blacks thus produced was an early promise that the camera could both record and transfigure what it saw.

HENRI LE SECQ: Still Life, c. 1850

HENRI LE SECQ: Still Life, c. 1850

Landscapes

Because they were forced to carry around more than a hundred pounds of plates, chemicals and darkroom equipment, the first roving photographers had to be strong as well as enterprising men. Yet many ventured forth from the studio world of still life and portraiture, aiming their cameras at broader scenes of farms and castles, rivers and lakes. Some, entranced by the sheer adventure of it all, climbed mountains and struggled across deserts to bring back views of faraway wonders.

Even these photographs, essentially documentary in nature, betrayed the influence of painting. For most professional landscape photographers tried to duplicate, both in subject matter and style, the landscape painting that was popular at the time. The critic Philippe Burty described the different ways they approached their task: "English photographers, like English painters, look for precise renderings, for the hardedged contour . . . in a way they penetrate the pores of the skin, the texture

of a stone, the bark of a tree. In France, on the contrary, photographs are much broader, less precise in appearance: It is obvious that above all the concern is with lighting . . . with the relative values of the masses."

Among the most skilled of the early landscape photographers was the French aristocrat Camille Silvy, who lived in England and sought out its picturesque scenes. A Silvy landscape (right) is a virtuoso display with a proliferation of crisp details, clear reflections and cloud-filled skies. (Like other photographers of the day, Silvy had to use a separate exposure and negative for the bright sky and join it to a negative of the darker landscape below, since early emulsions could not record both successfully at once.) Silvy also managed to imbue his scenes with a mood of unusual peace and tranquillity. This too was characteristic of English landscape painters, whose return to nature was in part an escape from the growing ugliness of England's industrialization.

Genre Photography

The ancient tradition of storytelling in art burst into full bloom during Queen Victoria's reign. Sometimes poetic, more often merely sentimental, this "genre painting" attempted to lend dignity to everyday life. It rarely achieved this goal, but in an age that honored bathos it was hugely popular.

Photography, which so perfectly recorded the commonplace, slipped quite naturally into this tradition. In 1851 the American photographer John, Edwin Mayall advertised "daguerreotype pictures to illustrate poetry and sentiment" at the Crystal Palace exhibition in London. Within the next 10 years hundreds of thousands of photographs portrayed an almost infinite variety of character types, scenes of domestic life and miniature morality tales. More ambitious artists also drew on the tradition. Thus Lyddell Sawyer, an English landscape photographer, introduced a homely scene of courtship. complete with stylized gestures, into a moody landscape scene (far right).

Probably the most famous of the storytelling photographers, before he began questioning photography's goals, was Henry Peach Robinson, a dedicated amateur painter. The first of his more notable efforts was Fading Away (above right), a pathetic scene of a lovely young woman on her deathbed. which he staged by posing models separately and piecing together five negatives. When the picture went on display, one critic complained that Robinson had traded "on the most painful sentiments which it is the lot of human beings to experience." But the photograph was an enormous popular success, starting a craze for similar picturemaking that lasted for years.

H. P. ROBINSON: Fading Away, 1858

PHOTOGRAPHER UNKNOWN: Woman Playing Cards, c. 1860

LYDDELL SAWYER: In the Twilight, 1888

Photography versus Painting: Traditions of Art **The Morality Lesson**

O. G. REJLANDER: The Two Ways of Life, 1857

In the center of Rejlander's well-populated stage (see diagram above), a bearded sage (1) guides two young men across the threshold of manhood. The young man on the left (2) is tempted by a life of dissipation, symbolized by such figures as the Sirens (3), Complicity (4), a group of gamblers (5), an old prostitute (6), idlers (7) and a Bacchante (8). On the right, a youth of higher morals (9) is attracted by figures representing religious penitents (10), a group of workers, including a carpenter and a woman making thread (11), a family depicting the joys of marriage (12), Knowledge (13) and Good Works (14). Between the groups sits the nude, veiled figure of Repentance (15), turning from the evil life to the good.

In 1857 Oscar Gustave Rejlander, a Swedish painter-photographer living in England, exhibited one of the most ambitious examples of pseudo-painting that the camera has ever produced. Separately posing and photographing a succession of hired models, Rejlander assembled no less than 30 negatives into a jigsaw pattern from which he printed a giant composite photograph almost a yard long.

When Rejlander's patchwork panorama went on display at the Manchester Art Treasures Exhibition, it immediately ignited a debate over its morality - mainly because of its nude modelsas well as its merits as a work of art. Rejlander himself tried to avoid the dispute, claiming only that he had developed his technique as a "sketching tool" to enable painters to visualize what their finished compositions would look like. Later, apparently done in by the uproar, he remarked bitterly to a fellow photographer that "the next Exhibition must, then, only contain Ivied Ruins and landscapes forever. . . ."

Romantic Illustrations

King Arthur, 1874

Like Rejlander, the master portraitist Julia Margaret Cameron fervently believed in the camera as a storytelling medium. When her neighbor Alfred Lord Tennyson suggested that she do photographic interpretations of his romantic epic Idylls of the King, she went into a frenzy of picturemaking in her studio. Combing the countryside for models, she found a young girl to pose as the beautiful Lady Enid (right), a porter to be King Arthur (left); for the snowy-haired Merlin (opposite) she conscripted her own husband. After three months and hundreds of rejected photographs, she had proudly assembled a set of 12 illustrations. But the publisher of the Idylls was less venturesome, and reduced her large prints to tiny woodcuts for mass reproduction.

"And Enid Sang," 1874

Sir Galahad and the Pale Nurse, 1874

"So like a shatter'd column lay the King," 1874

Gareth and Lynette, 1874

"And reverently they bore her into hall," 1874

The Nude

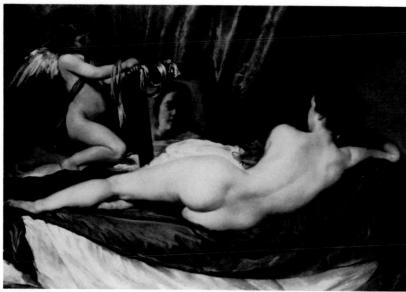

DIEGO VELÁZQUEZ: Venus at Her Mirror, 1644-1648

One of the most difficult of the traditional motifs of painting that photographers came to explore was the human figure. It had long been accepted that academic painters could decorate their canvases with nude nymphs and goddesses, but a photographer who dared the same somehow ended up showing real live girls very naked. To many viewers the result was pornography. Rejlander's *The Two Ways of Life*, for example, was allowed into an exhibition of the Scottish Photographic Society on one condition: that the carnal attractions of the wayward life be deleted.

Despite their differences with Victorian moralists, photographers continued to find the contours and textures of the human body as fascinating a challenge as painters did. But a larger challenge lay in the camera's uncanny ability to reveal the true nature of things. While a painter like Velázquez could transform a studio model into a vision of languid elegance (left), the photographer was bound by what the camera actually saw. If his model appeared unattractive, embarrassed or uncomfortable, the photograph would show it.

The American painter and amateur photographer Thomas Eakins was skilled enough in both arts to realize this, and when he photographed a nude in the style of Velázquez (right), he took pains to achieve a graceful, painting-like effect. Less talented photographers simply ordered their models to take up the same poses they used for painters and snapped the shutter. The results prompted George Bernard Shaw, a camera enthusiast himself, to remind the world of the "terrible truthfulness about photography that sometimes makes a thing look ridiculous."

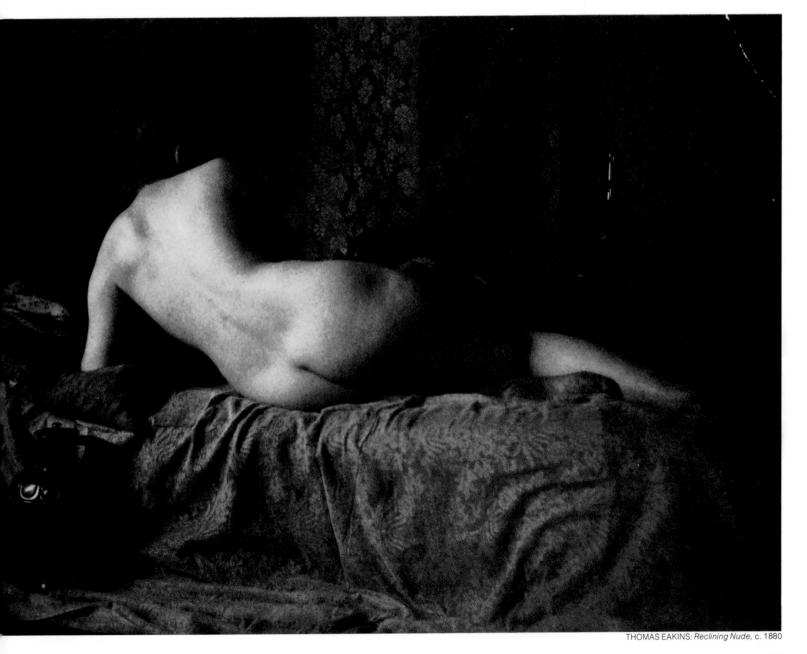

EUGÈNE DELACROIX: Odalisque, 1857

EUGÈNE DURIEU: Figure Study, c. 1853

A Tool for the Artist

Though not all painters would admit it, photography proved to be a valued handmaiden of their art. One painter who did acknowledge its usefulness was Eugène Delacroix, a charter member of the Société Héliographique, France's first photographic society. Working closely with the photographer Eugène Durieu, Delacroix assembled a large collection of nude figure studies like the one at right, carefully posing his subjects to reveal details he would later use in sketches and paintings. Such studies had an immediate practical value for painters, who soon realized that it was far easier to consult a photograph than to keep a model in uncomfortable poses. But Delacroix also insisted that the painter could learn from comparing paintings and photographs. He once invited a group of friends to study Durieu's photographs of nudes, then showed them a series of old-fashioned engravings of similar poses. He later recalled: "We were filled with a feeling of revulsion, almost of disgust, on account of the incorrectness, the mannerisms and the lack of naturalness [in the engravings]."

The purpose of such comparisons, Delacroix was careful to point out, was to train the eye of the painter rather than to compare the relative truthfulness of paintings and photographs. His use of photographic models for paintings repeatedly bore out his philosophy. Thus a Durieu photograph used as a study by Delacroix shows an ordinary model sitting self-consciously on a couch (far left). In the finished painting, however, the artist's imagination has created something quite different—a slender, sensuous concubine in an exotic Algerian harem (left).

EUGÈNE DURIEU: Figure Study, c. 1853

A Shared Point of View

ADOLPHE BRAUN: Le Château de Chillon, 1867

GUSTAVE COURBET: Le Château de Chillon, 1874

Photography began as both rival and imitator of painting, but also became a close collaborator. As the pictures at left suggest, the two arts sometimes shared inspiration quite literally. Adolphe Braun's photograph of the famed castle of Chillon on Lake Geneva was taken in 1867; the French painter Gustave Courbet created an almost identical version of it seven years later when he was in Switzerland. The Courbet painting bears more than a casual resemblance to the photograph. The vantage points are identical, the overall tone and shadowing are strikingly similar, and the details of the embankment and trees appear as they did some halfdozen years before Courbet's visit. Clearly, he based his painting on the photograph. Moreover, he rendered the scene with great precision - a reflection of the fact that photography and painting were beginning to share the idea of realism in representing nature.

With the passage of time, the exchange of inspiration went further. Since the camera was so much better as a recorder of visual facts, painters felt forced to search for more imaginative subjects and styles. Also, new visual experiences created by the camera, like the blurred images of objects in motion, influenced such modern schools of painting as Impressionism and Cubism. These schools of painting in turn suggested a wealth of fresh visual techniques for photographers. In the long run, the rivalry that photographers and painters first insisted would be fatal to one of the arts invigorated both of them.

On Making Better Pictures

A Talk with LIFE Photographers 204

Ten Personal Styles 213
Ansel Adams 213
Gjon Mili 214
Henri Cartier-Bresson 216
Irving Penn 218
W. Eugene Smith 220
Lee Friedlander 222
Ralph Gibson 224
William Garnett 226
Horst 228
Arnold Newman 230

HENRI CARTIER-BRESSON: Little Greek Girl Mounting a Staircase, c. 1963

A Talk with LIFE Photographers

In preparing the original edition of this volume for publication in 1970, the editors of Time-Life Books asked 13 members of the photographic staff of Life how to take good pictures. Rarely have so many gifted photographers assembled at one time to talk about photography. Although the staff of Life was dispersed in 1972, when the publication of the magazine was suspended, the advice offered by those 13 men and women is as valuable today as it was then; it appears below unchanged.

The photographers who work for *Life* are often asked for advice about how to take good pictures. Their answers vary, sometimes considerably, for good photographers rarely use identical techniques. Mark Kauffman and Eliot Elisofon often get their character-revealing pictures of people from a distance, using long lenses to enlarge the image. "Don't get too close," says Elisofon; "unless you're very good at handling people, back off," says Kauffman. But an exactly opposite technique achieves equally superb results in the hands of both Alfred Eisenstaedt and Bill Eppridge, who suggest shooting with normal lenses from close range. Even conflicting advice turns out to be helpful, however, when you understand how the choice of method is dictated by the photographic situation—the surroundings, the character of the subject, the personality of the photographer.

Use a camera you can handle easily

A good photographer concentrates on the picture—his subject, composition, the effect of light, a moment of action. He can't do that if he is worrying about which ring to turn for focus or whether a finger is over the lens. His camera must be so familiar and comfortable that it seems to be an extension of his eyes and hands. This is a strong argument against premature investment in elaborate equipment and in favor of automatic or semiautomatic controls, which are most useful if they can be disengaged when desired. "Anything that can possibly make shooting easier, I'll use," says Eppridge. "I want to think about the picture. The other things are just impediments."

Take pictures — a lot of pictures

Only constant use of the camera develops mechanical skills; it also sharpens timing and awareness of composition. Many photographers carry a camera wherever they go. "You can come across an ordinary group of kids playing in an empty lot when it's overcast," Yale Joel remarks, "and it's just an ordinary scene. But you might pass the same place in late afternoon, before sunset, when the sky is clear and light is pouring in at a low angle, and suddenly it becomes interesting."

When a picture-taking situation confronts a professional, he usually

To capture this swirling, snow-level view of a skier flashing down a slope at Sun Valley, Idaho, George Silk mounted a camera with a wide-angle lens on one ski and used a relatively slow shutter speed of 1/20 second.

makes a great many exposures, so that he will not miss a good angle or an expressive moment. This is not as wasteful as it seems with a 35mm camera. You may use a whole 36-exposure roll to get three of four pictures worth enlarging — but those few are much more likely to be outstanding ones when you can select them from a large number of attempts.

Don't be afraid to experiment

Amateurs are oddly loath to try something out of the ordinary. They give up the chance for many pictures because the exposure meter says the light is too dim, for example. Yet deliberate underexposure can be very effective. Or a good exposure is sometimes obtained despite weak light if the shutter is set very slow—half a second or a full second. You can learn to hold a camera steady for a long exposure—wedge your body into a corner and press the camera to you so firmly that neither you nor the camera can move, or rest the camera on something solid. But deliberate blurring can produce unusual pictures. When Eliot Elisofon was photographing a carved African head, he set his camera on a tripod and focused it, but found the sharp image uninteresting. So he kicked the tripod during the exposure and got a blurred picture that caught the strange, ominous character of the carving far better.

Sometimes an unconventional way of aiming the camera makes a crucial difference. George Silk, seeking a fresh approach to pictures of skiing, fastened a camera to a ski, connected remote controls so he could operate it, and shot pictures as he went down the trail—getting whatever his ski was aimed at, since he could not, of course, see through the viewfinder. The result—snow spraying from ski tips, blurred trees racing past at odd angles in the sparkling light—captured all the exhilaration of the sport.

Along with this general advice, *Life* photographers offer specific suggestions for getting good pictures of popular subjects:

People

Nearly all subjects either freeze up in front of the camera or try to put on an act for it—and the results show that. If you know a man's interests, you may get his mind so firmly onto them that he forgets the camera. The easiest way, however, to preoccupy him is to get some other person or some thing to divert him while you work the camera.

Several of the *Life* photographers make a simple suggestion for a good way to start: Engage the subject in quiet activity. He should not be conspicuously busy; such action usually distracts from the personality of the picture. Rather keep the picture simple, with the person reading, or talking to someone off-camera, or just looking up as he responds to a question. This ap-

proach to close-ups, which tends to keep camera and photographer apart from the subject, generally calls for the use of a long lens. That is how Mark Kauffman catches moods and personalities in unposed photographs. He advises: "Keep the people in a natural setting—doing things they are at ease doing, and use longer lenses. Then watch for the moments that reveal their personality. One time this really worked for me was in photographing Casey Stengel, when he was manager of the Yankees. If a photographer stood right in front of him, Casey would never go through his little war dances and rubber-face acts and arm-waving. But I found that when I used 150mm, 200mm, or even 300mm lenses, and stood back about 50 feet, Casey could go into his act as he talked to a ball player—although he could see me out of the corner of his eye—without it looking as if he were doing it for a photographer. He knew I was there, and I knew he knew I was there, and we played this game for about two years—I probably have a thousand pictures of him—and I never exchanged one word with the man."

Elisofon also suggests shooting unobtrusively from a distance. He says: "You don't have to try to be a candid photographer, hiding behind the bush. Just seat your wife in the garden, for example, talking to someone. Let her forget the camera. Don't get too bossy, or too close."

Many photographers react directly to their subjects' personalities—and vice versa—and they prefer to be up close. Bill Eppridge is one who works this way. He says, "I want a photograph of a person to have a sense of intimacy, of being there. You lose this with an extremely long lens, or shooting from a high or a low angle. Whenever possible, I use a 50mm lens and shoot right at a person, dead on."

Such an intimate confrontation between the photographer and his subject can, if expertly handled, lead to outstanding pictures tense with emotion. This is true of one of the photographs that helped make Alfred Eisenstaedt's reputation, his chillingly evil close-up of Joseph Goebbels, Hitler's propaganda minister. Recalls Eisenstaedt:

"I found him sitting alone at a folding table on the lawn of the hotel. I photographed him from a distance without him being aware of it. As documentary reportage, the picture may have some value: It suggests his aloofness. Later I found him at the same table, surrounded by aides and bodyguards. Goebbels seemed so small, while his bodyguards were huge. I walked up close and photographed Goebbels. It was horrible. He looked up at me with an expression full of hate. The result, however, was a much stronger photograph. There is no substitute for close personal contact and involvement with a subject, no matter how unpleasant it may be."

(Curiously, Goebbels seemed to have no objections to a photograph that clearly revealed his malice. When a few days later his lieutenants called on

Sometimes the only way to get a revealing portrait of a person is to walk right up to him. In 1933 Alfred Eisenstaedt, covering the League of Nations Assembly in Geneva, came upon Joseph Goebbels, Hittler's propaganda minister. Dissatisfied with a long shot he had taken, he moved in on his subject, despite the presence of several husky aides. As Goebbels suddenly looked up in annoyance, Eisenstaedt caught a malign expression on his face that proved all too prophetic of the Nazi terrors to come.

an understandably nervous Eisenstaedt at his apartment, all they wanted were free prints of the pictures they appeared in.)

The choice between a normal and a long lens for pictures of people affects the character of the picture. However, there are also technical considerations that should be taken into account. One is the size distortion that may be introduced in close-ups made with a normal lens. To get a "head shot," filling the negative with a man's face, the normal lens must be brought within a few feet of him; at this distance it exaggerates the size of whatever is nearest and may cause a nose to come out looking oddly large. Another effect of the normal lens that sometimes creates difficulty is the large amount of background it may take into the picture. "Most people try to include too much in the picture," points out Elisofon. "If you are photographing a child playing on the lawn, photograph the *child*, not the trees, the house, and everything else in sight. Photography is really a simple statement, and the clearer it is the better."

Both these problems are solved by using a long lens. It makes front details seem about as large as rear ones, avoiding size distortions. It also eliminates most background. Its angle of view is so narrow that the amount of background is much reduced and what does show up is unrecognizably blurred by the lens's restricted depth of field.

Another technical detail that makes a big difference in pictures of people is the choice of film: Should it be color or black-and-white? "For portraits of men," says Eisenstaedt, "black-and-white is usually best. A man's features like a strong forehead or a wrinkled face come out better in black and white. For a woman, I'd generally use color: A woman's clothes are usually more colorful, particularly if she's wearing a scarf or a bright print. But what is interesting about a man's jacket? Of course if he has raven black hair, brilliant blue eyes and a red tie, then you use color, yes. Otherwise, the color only gives a flat picture. You can get much more drama out of black and white."

Children

Children play on the floor, and that's usually where you should be if you want to get natural pictures of them, holding the camera at their eye level. It may take more than the usual amount of ingenuity to distract them so that they appear at ease; shaking a toy over your head and pleading for a smile doesn't help a bit (but an ability to make really funny faces is invaluable). Birthday parties, when father is dragooned into taking pictures, are actually good opportunities. The children are oblivious to the camera, fascinated by friends and gifts, and generally lively. And pictures of eating—particularly of gooey food like cake and ice cream—are always charming. Here are some suggestions from Martha Holmes (a freelance photographer whose Life

picture stories include one of her two-and-a-half-year-old daughter's attachment to a security blanket):

"I always talk with kids at eye level, and never lean down to them. It's very helpful to get a second person to divert them. A mother can be essential in bringing out the child's look, while the father snaps the picture. With two kids, you're in. They'll relate to each other. Speed is important: take many pictures, fast, have the child move. Use a lot of film. The cost of the film is the least of it, if you get what you want. It's a good idea to photograph children outside. There they are much less restricted, and less aware of you taking each picture. Find a spot out of direct sunlight, if possible, a good background—water, for example, can give a delightful tapestry effect, and interesting reflections—and be careful in composing the picture. Don't have a tree or a bush growing out of the child's head. And get close-ups, the bigger the better."

Animals

Animals seldom act predictably, but if you know something of the habits of your target you can catch many pictures otherwise lost. If you know that a woodchuck stands up for a look around after leaving his burrow, you can be ready for that. If you are after a moving animal like a deer, try and figure out what direction he is likely to come from. You have seen his prints at the poolside, you know where he comes to drink. Hummingbirds, flycatchers and many other species have favorite perching spots. You can get ready for them, remove twigs in the way, prefigure exposure and focus, and just wait. Nesting birds return regularly to feed their young. Find the nests and you can shoot them over and over again.

Long waits are a part of nature photography—hours sometimes—so get comfortable. If you are set up with a tripod, arrange yourself so that you can get your eye to the camera with a minimum of fuss. If you know exactly where the action will be, don't bother to use the viewfinder at all; prepare ahead of time and use a cable release. You can move quite a bit if you do it very slowly. Clear away ground twigs or dry leaves where you are settled; they may snap when you move. If your camera has a noisy shutter you can muffle this somewhat by wrapping it in a towel (but not a white one).

Many animal photographers prefer large cameras for the detail their negatives can provide, but John Dominis, renowned for his pictures of African cats, says, "I find the 35mm quality adequate. I also find the larger cameras too slow and clumsy." Long lenses are a must; you can't get near wild animals without them. A 300mm lens, its awkwardness notwithstanding, is ideal for shooting wildlife with a 35mm camera. It brings you dramatically close and its limited depth of field subdues bothersome backgrounds—and also

foreground foliage, since the latter is often so blurry that the camera sees right through it. Despite its magnification, this lens can be hand-held at shutter speeds of 1/250 second by a reasonably steady hand. For best results, however, use either a tripod or clamp. Add a ball-swivel attachment so you can turn the camera. While not as flexible as a tripod, the crotch of a tree, a downed log, a car hood—any solid base used with a bunched coat or sweater, or even better, a child's bean bag or small sandbag—also makes a good support for a camera. With practice, you can learn to follow moving animals with such a setup and at the same time eliminate all camera shake.

You can get an enormous amount of practice in zoos, and often make outstanding pictures, particularly in outdoor settings. Since the animals are calm and can't get away you can work them over at your leisure.

"Photographing your own pets is something else—you can control the situation," points out Nina Leen. "To make the picture interesting, you must try to get some expression from them, or get them to do something. I always talk to the animals I photograph. I don't expect them to answer, but sometimes they react. I've always loved cats, and I have taken a lot of cat pictures. I construct situations for these pictures: I set out a waste basket with something the cat wants inside, and wait to see what happens; or I hang a string overhead, or give the cat a ball, to see how it plays. I wouldn't worry about lighting so much. It's not so important to see every hair of the cat's fur: What is important is the mood. Natural lighting from a window is often all you need with fast film. Anyway, the best pictures are often the underexposed ones — with that touch of 'artistry' which isn't intended.

"If it's your own pet, you know him. The owner always has a story to tell about his pet. That story could be the beginning of a photograph. If you're always saying, 'You should see him do this' or 'You should see him do that' — well, what you should see, you should take!"

Sports

Many amateurs are unnecessarily discouraged from attempting sports pictures because they think very fast shutters and kits of special lenses are essential. It is true that from the stands you won't catch much of a slide into third base without a fairly long lens, and that you can't freeze a close-up of an end run without a shutter speed of 1/250 second or better. But it is also true that you can get the equivalents of those pictures— or better ones— with the kind of camera and lens that most amateurs own. There are at least three ways to overcome the drawback of slow shutter speeds:

1) Let the action blur. The results may be very effective, for blurring can suggest the idea of movement more clearly than can a precisely frozen image (page 93).

- 2) Pan the camera. That is, move the camera to follow the action as you trip the shutter, tracking the subject exactly in the viewfinder all the while. The background will be totally blurred, but the subject will come out sharp—and the contrast will convey a strong sense of motion (page 94).
- 3) Catch the peak of action, when movement momentarily stops. It is a curious fact that many athletes assume their most dramatic and graceful positions when they are not really moving at all. This point comes when the moving part of the body has gone as far as possible in one direction and is about to reverse direction for the return motion—for example, when the quarterback has cocked his arm as far back as he can and is going to fire the pass, when the high-jumper has reached the very top of his trajectory and is now going to come back to earth. If you catch this point of reversal, when there is no motion, you can capture the power of sports action with a slow shutter speed.

The way to make sports action pictures without an extra long lens is to shoot from the edge of the playing field. Permission to do this is impossible to get in the big leagues, but you can usually wangle it for local school contests. And there is good reason to concentrate on school games, for they offer some of the most colorful pictures.

"Sports photography is all wrapped up in watching, not only the action on the field, but what happens on the sidelines and behind the scenes," says Art Rickerby. "Go into the locker room after the game. A lot of my pictures are shot then—boys running off the field after victory, or lying on the floor in the locker room, in pain, after defeat. I try to photograph all the moods of a sport." School sports provide many opportunities for such off-the-field shots—cheerleaders, an intently watching coach, players on the bench, screaming fans, refreshment vendors, gaudily uniformed band members—and they are what lift a set of sports pictures out of the ordinary.

Houses

Taking a picture of a house from the outside is rather like photographing a landscape (opposite). Yet the architectural character of the house may come across better in details. "A doorway can make an interesting composition in itself," says Henry Groskinsky. "Even a doorknob— a brass one, say, against a black paneled door— can become a piece of sculpture, something abstract as well as functional."

But interiors often say more about a house—and its occupants. Oddly, photographs of rooms may be most expressive when they are empty of people and even of most personal belongings. "You want to see the house," says Mark Kauffman. "Unclutter it. You can't have piles of magazines all around, 18 ashtrays, bric-a-brac and all that. We used people quite a bit in the be-

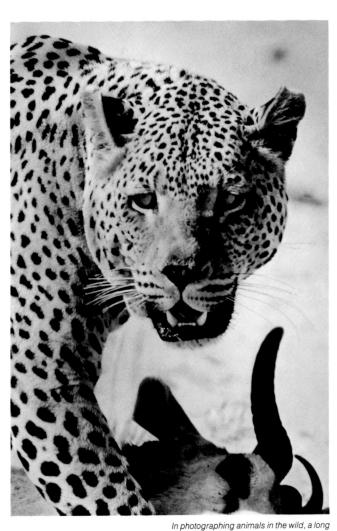

lens is needed if you are not to frighten the subject away. In some cases it is mandatory if the animal is not to frighten you away. John Dominis, who admits he is "frankly afraid of leopards," used a 300mm lens to catch this one, on the plains of southern Africa, glancing up warily from its freshly killed prey.

ginning of the *Life* series, 'Ideas in Houses,' but we found that they rarely look natural. Even children playing on the floor don't look real."

Getting enough light for interior pictures is not necessarily a problem, for without people in the scene, time exposures are practical. You can use the room's own lights, but they generally leave some parts of the scene unacceptably dark. If the room is quite large, one solution is to "paint" it with light. You simply turn off all lights except a floodlamp in a reflector and walk around the room holding it carefully pointed away from the camera. The camera shutter is open, on time exposure, all the while, but the film will record neither you nor the reflector, picking up only what the reflector's light shines on.

Landscapes

The cliché in pictures of scenery is the "foreground object"—tree branches or people framing the view. Cliché it may be, but it works. For the foreground object provides the extra ingredient needed to give a landscape photograph a feeling of depth and space; otherwise the most dramatic vista becomes insipid on film. Dmitri Kessel once relied on a lightning storm to provide the extra ingredient of a scene and Ralph Crane devised an unusual effect with a special type of filter. Crane explains, "Millions of photographers have taken the classic view of El Capitan and Bridalveil Fall in Yosemite Valley. I didn't have time to find a different point of view—and the classic one is simply beautiful. But in the morning when the sun rises, the foreground, full of beautiful trees, is black in a color photograph. To overcome this, I took a light-reducing filter, cut it across and attached it to the lens so that the sunlit background would get less exposure than the foreground. The result was a picture creating a different emotion from those taken before."

In a subtler fashion, lighting can supply the ingredient that gives depth to landscapes. Many striking pictures are taken in early morning or late afternoon light, which casts long shadows and is generally more interesting than flat, bright midday light. Fritz Goro says, "If the light doesn't strike objects in a way I like, I move a hundred yards or so and see if that makes a picture." Dmitri Kessel points out, "In the mountains, you should always look for low, contrasty lighting which will bring up three-dimensional quality. This is especially important in the desert, too."

Following suggestions such as these cannot guarantee good pictures, of course. For the best shots originate in the imagination of an adventurous photographer. Rules are meant to be broken and sound advice should be disregarded in favor of instinct. As Fritz Goro insists, "You must constantly experiment, always trying something different—not for the sake of being different, but in order to improve on what you've done."

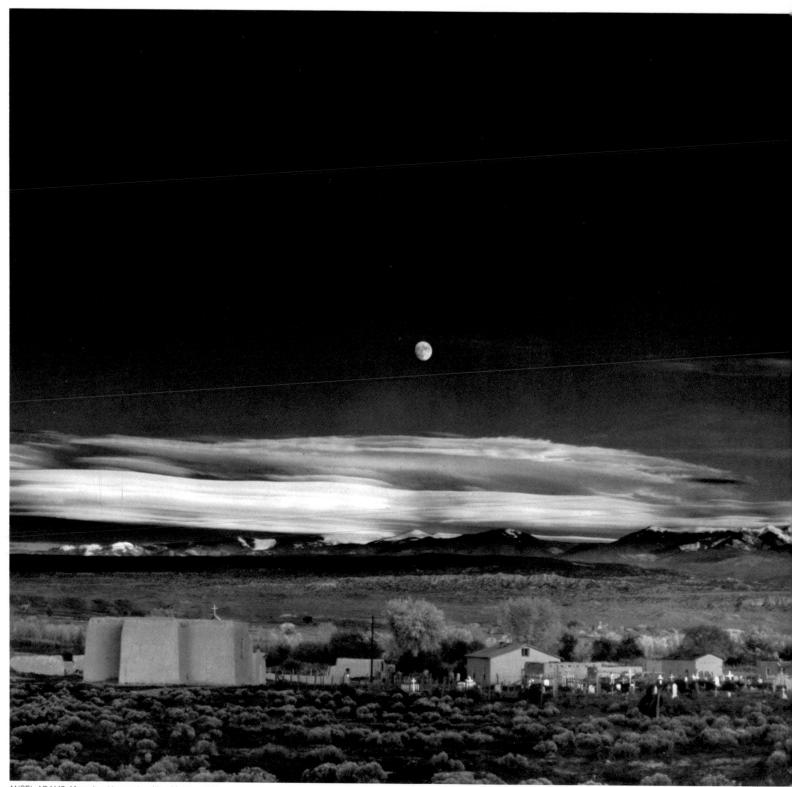

ANSEL ADAMS: Moonrise, Hernandez, New Mexico, 1941 212

Ansel Adams, who took his first boyhood pictures with a box Brownie in the Yosemite Valley, has never stopped photographing the American West, in particular the Sierra Nevada. "It's inevitable for me to take these pictures," he says. "It's there, I feel great excitement, and I take the picture," Adams conveys his own reverence for nature in his exquisite attention to detail, in photographs of brooding landscapes, of wind-battered mountains, of what he has called "the great earth gesture of the Sierra."

He has often planned for weeks or even months ahead to get a scene in just the right light at the right time of year. He has been known to encamp at night, set up his 8 x 10 view camera and go to sleep in a sleeping bag on a special platform he built atop an old Cadillac sedan, with an alarm clock set for

first light. On waking, he has taken his picture and then gone back to sleep on top of the car.

No such calculated wait produced the photograph of moonrise at Hernandez, New Mexico, reproduced at left. It was taken almost by chance. Adams saw the scene as he was driving home. "I had to take it before the light changed," he recalls. "I worked extremely fast, and made it with 15 seconds to spare."

Adams expresses a profound respect for what he photographs. "Some photographers take reality as the sculptors take wood or stone and upon it impose the dominations of their own thought and spirit." He sees his own photographs, however, as "ends in themselves, images of the endless moments of the world."

While Adams' images are pristine, he employs the most modern and sophisticated equipment and techniques to record them. Besides his 8 x 10, which he employs for large, sharp renditions of landscape, he uses a 21/4 x 21/4 Hasselblad for all kinds of work, a 35mm Zeiss Contarex for pictures of people and a versatile 4 x 5 Arca-Swiss for landscapes and architecture "where camera adjustments are essential." The old Cadillac was finally retired; for photographic expeditions in the Sierras, Adams equipped a station wagon built on a truck chassis with a large camera platform and special compartments to hold his scores of accessories.

Gjon Mili

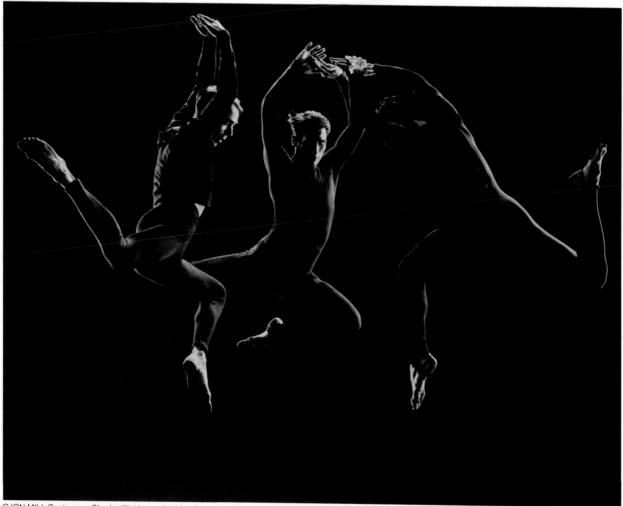

GJON MILI: Centaurs — Charles Weidman, José Limón and Lee Sherman, 1939

Gjon Mili, whose black-and-white photographs are often striking studies in contrast, is himself a man of extraordinary contrasts. Best known as a photographer of the arts, he began as an engineer, with a degree from M.I.T.

Always experimenting with new meth-

ods and devices like strobe lighting, he found distinctive new ways of revealing man's grace—dancers and athletes all trapped in air or frozen with multiple exposures into a delicate frieze of action.

The photographs here show Mili's use of light to delineate both motion and emo-

tion. Dancer José Limón and his partners (above) were photographed at Mili's studio; Avon Long (opposite), who played Sportin' Life in Porgy and Bess, was caught in a night-club performance. In each picture, Mili's technique enhances the performer's own expressiveness.

GJON MILI: Avon Long as Sportin' Life, 1942 215

Henri Cartier-Bresson

HENRI CARTIER-BRESSON: Cape Cod, 1947

Henri Cartier-Bresson likes to pass unnoticed as he takes a photograph, a rather nondescript man in rimless glasses, thinning hair brushed back, shoes shined. He carries his battered little Leica in hand—the chrome taped black to make it less conspicuous—sometimes wrapped in a handkerchief. For most of his pictures he uses a 50mm lens; he also carries a 35mm lens, a 90mm lens, half a dozen rolls of film and a spare Leica body.

For Cartier-Bresson, technique is not the important thing. Intuition is. "Think about the photo before and after, never during," he says. "The secret is to take your time. You mustn't go too fast. The subject must forget about you. Then, however, you must be very quick. So, if you miss the picture, you've missed it. So what?"

Although casual about technique, Cartier-Bresson is rigid in his respect for reality as he finds it. He never alters a scene he photographs—not so much as to raise a blind to change the light. And, once he takes the photograph, he never allows it to be cropped in the darkroom. "The picture is good or not from the moment it was caught in the camera," he insists.

Cartier-Bresson's instinct for unposed composition is unmistakable in these photographs. At left, the essence of July Fourth is caught in a Cape Cod woman whose flagpole had broken but who said to the photographer, "On such a day as this, one keeps one's flag over one's heart." At right, in a street in Madrid, the flat, abstract pattern of windows on a wall in the background heightens the sense of life and movement that is captured in the passerby and the playing boys.

Irving Penn

Severe elegance identifies an Irving Penn photograph. Penn is a portraitist who, in setting out "to create a new kind of fashion picture," created an austere new style of photographic realism. "The way Penn poses his subjects," says one magazine art director, "forces people into the position of revealing themselves."

His wife, who first worked with Penn as a fashion model, describes his sessions: "There are enormous tensions between Penn and his subject while he tries to reach the effect he wants. He spends hours until . . . they both are exhausted. This way, he catches his soul and his subject's."

In stripping people to their real selves, Penn uses odd devices—like cropping off the tops of their heads or posing them in an incongruous setting, as he did when he photographed the Hell's Angels and their motorcycles indoors against the bare wall of a studio (opposite).

Penn takes a long time making a picture because he knows that most people will spend only a brief time looking at it. "A photograph is made to be seen amid the haste of contemporary life. Its viewing time, its communicative spark, is reduced to a few minutes." His portrait (right), of a New York society girl, aged two and a half, epitomizes the effect Penn seeks. "It's like a truth drug," he says. "People read into it all kinds of things about themselves."

IRVING PENN: New York Child, 1953

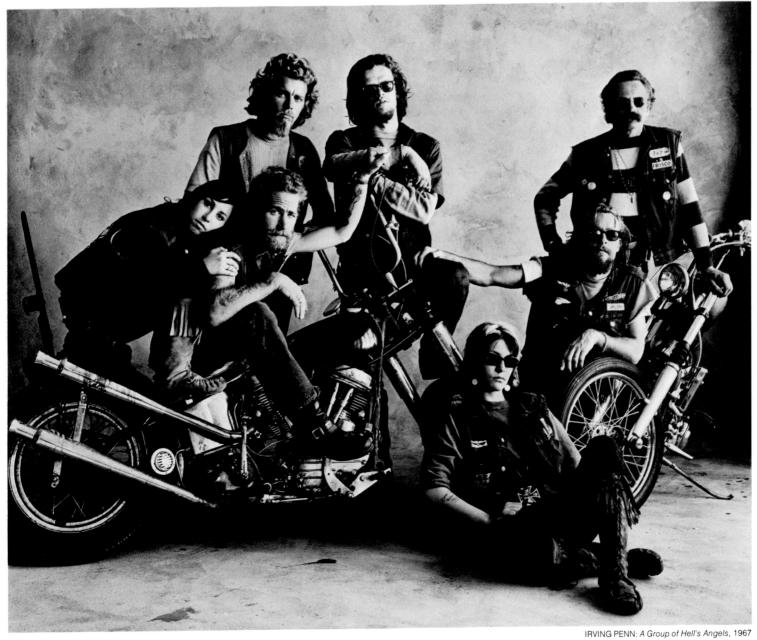

W. Eugene Smith

Before his death in 1978, Gene Smith's compassionate camera had recorded almost every aspect of the human condition, from the trauma of birth to the dignity of death.

As a young *Life* photographer during World War II, Smith took part in 13 Pacific invasions and 23 carrier combat missions—and brought back pictures as unbearable to look at as the realities they portrayed. No one who saw it could ever forget his photograph of the fly-covered, half-dead baby held up by a soldier who had discovered it in a Saipan cave.

In the years after the War, as Gene Smith's camera captured the hope and the harshness of contemporary life, his photographs became classic statements of social concern. "I try to do work that affects people," he said. "I try to lead them with my photographs so that they can draw their own conclusions." Smith's commitment is always visible in the pow-

er of his photographs. "I never made any picture, good or bad, without paying for it in emotional turmoil."

Smith took the picture at right while working on one of his most famous photographic essays, on the poverty and faith of a Spanish village. He had traveled thousands of miles in Spain to find the village he wanted and then spent weeks living in it and getting to know its people. One day a villager who had become a friend asked Smith's help in arranging his father's funeral. Smith drove the man to the county authorities, and later paced about outside the man's house, hesitating to intrude on the wake. At last he asked, and was invited in to take some pictures. As an assistant held a bare flash beside a candle placed near the dead man's head, Smith took two exposures with his Leica. The second photograph, seen here, proved a classic Gene Smith statement.

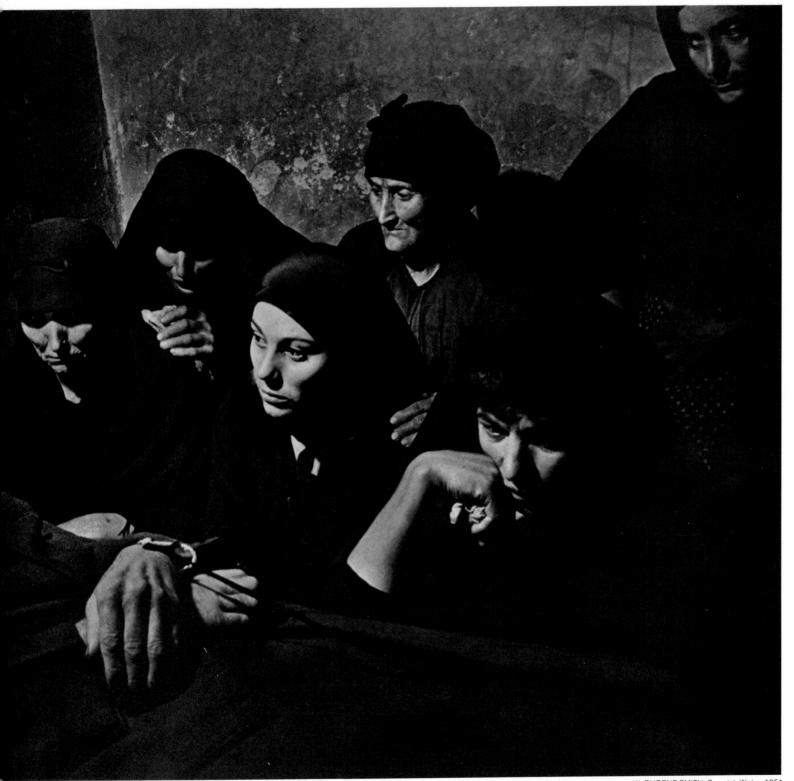

W. EUGENE SMITH: Spanish Wake, 1951

Lee Friedlander

Lee Friedlander's portraits of "the American social landscape," as he calls it, are almost snapshots—perfected to an art. He is prepared to photograph whatever catches his eye. "I'm not a premeditator," he says. "I don't go out looking for a particular thing."

When Friedlander is photographing a scene, he looks at what is happening, as well as what is there. Like Cartier-Bresson, he is interested in the ordinary "nonevent," and works with a Leica and a minimum of extra equipment. "Working with a small camera," he says, "you see things moving all the time, and you have to move into them." The odd details of people in his photographs—partly obscured, blotted or cropped out—imply this movement, giving each scene a suggestion of change.

"The light in a viewfinder moves very fast in a socially inhabited landscape," he points out. "Lots of things happen in a minute or two. I started to photograph the flag in the store window (right) because of the flag. It was a strange place for a flag. The foot just came into it. But I took it at that moment because of the foot, too. I like these things to happen in a photograph."

Friedlander or his shadow often appears in his photographs (opposite, top and bottom). "You spend a lot of time avoiding things," he says. "In photography, you are always avoiding yourself, your shadow. I thought I'd use it. So I took these pictures where I'm there too, as part of the landscape."

As portraits of the American scene, Friedlander's photographs are less statements than questions. He does not say he is photographing the absurd—"but the absurd is out there too."

LEE FRIEDLANDER: New York City, 1967

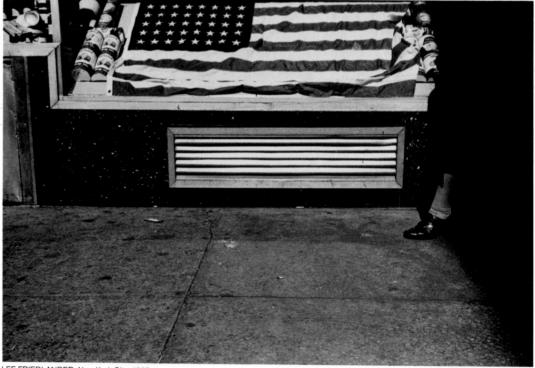

LEE FRIEDLANDER: New York City, 1965

LEE FRIEDLANDER: Route 9W, N.Y. State, 1969

LEE FRIEDLANDER: New York City, 1966

Ralph Gibson

Although seemingly spontaneous, a photograph by Ralph Gibson is not so much observed as produced. Many of his pictures concentrate on fragments and details, as in the image at right of a wellshod foot near rippling water. Much of the dark, mysterious quality that is a Gibson hallmark results from technical procedures. He achieves strong contrasts by deliberately overexposing and overdeveloping the negative; extremely highcontrast printing paper further enhances the effect. Some of his pictures are meant to be seen in sequence. Gibson will start with half a dozen prints that share a particular mood or feeling. With these as a nucleus, he plans and executes the rest of the sequence.

Like Lee Friedlander (pages 222-223), Gibson started as a photographer of the social landscape, recording glimpses of city life as he walked along the street, and he still uses a Leica, the street photographer's favorite camera. The turning point toward a more enigmatic and private use of photography came in 1969 with the photograph opposite. It began as a candid shot: "I was following a person through a door and saw the scene," says Gibson. "I said to 'hold it' and then caught the picture."

Gibson was so impressed with the way this picture captured an indefinable feeling of threat and promise that he began to seek out, or set up, other situations that would express similar emotions. The result in 1969 was the book, *The Somnambulist*, a sequence of 48 photographs that convey dreamlike, sometimes even nightmarish, feelings.

From Days at Sea, 1975

From The Somnambulist, 1969

William Garnett

William Garnett began taking aerial photographs after his first flight across country—hitching a ride in the navigator's seat of an Army troop transport. "The view was perfect," he recalls, "and I decided right then that I had to photograph this great and beautiful land from the air."

He was already a skilled technician with a camera, having worked as a Pasadena police photographer and an Army Signal Corps cameraman. To take pictures from the air, however, he needed the skills of a pilot as well. After obtaining a license, he bought a small plane, equipped it with a trap door, and set out in search of striking landscapes. In 35 years he has logged more than a million miles over America.

"In this country," he says, "mere man is small indeed. The Indians, quiet, stately people, understand this land. With terms like 'Sleeping Rainbow' they describe the marvel of this huge, silent landscape as it changes with the light." Garnett's photographs document this sense of silent splendor. Flying his plane as precisely as he works his cameras (generally three Pentaxes with 35mm, 55mm and 105mm lenses), he composes his photographs "to show future generations what our country looks like nowbefore we change it." There is, indeed, something ageless in his photographs, whether of a New England snowscape (right), or undulating wheat fields in the state of Washington (opposite).

WILLIAM GARNETT: Androscoggin River, Maine, Icebound, 1967

WILLIAM GARNETT: Wheat Fields in Washington State, 1977

Horst

Styles in fashion photography come and go almost as rapidly as styles in the costumes the pictures glamorize. Only a few endure. One that has is the dramatically staged and lighted tableaux of Horst P. Horst (who signs his work with only one of his identical first and last names).

Horst began maneuvering floodlights and spotlights around a studio in 1930 to create fashion photographs that are instantly recognizable as his own. Often he used a dozen lights, burning constantly, to create the powerful patterns of light and shadow that are his trademark. In one of his most famous photographs, shot in Paris just before World War II, a corset-clad model is silhouetted against a brightly lit background, then lighted from one side to emphasize her hourglass shape and to highlight the corset's lacing and construction (right).

Forty years later, Horst used the same combination of side lighting and background to show off five gowns designed by Christian Dior (opposite). But this time he used store-window mannequins rather than live models to simulate a shop display, then added a real doberman named Ira, because, he said, the picture needed something alive. Although it was shot like his earlier photographs, in a studio filled with floods and spots, it was hailed by magazine editors for establishing a new look in fashion photography.

Horst has, on occasion, made a few concessions to the technical changes that have revolutionized photography during his long career. Sometimes he uses a twin-lens reflex camera loaded with color film—as in the picture opposite—rather than the 8 x 10-inch view camera he employed in the 1930s. Otherwise, his procedures have remained unchanged for half a century.

HORST: The Detolle Corset with Back Lacing, 1939

HORST: Effects with Satin, 1978 229

Arnold Newman

When Arnold Newman photographed the British painter David Hockney, he took his camera to the painter's studio, where the setting itself reflected the painter's character and his place in life. This is typical of Arnold Newman's approach to portrait photography, an approach that he has pursued for four decades with such success that many of his pictures have become the portrait by which a celebrated figure is best known.

In the Hockney portrait, the neat, almost fastidious cleanliness of Hockney's studio suggests the clarity of his carefully drafted drawings, lithographs and paintings and the care with which the artist managed his own career. The only change Newman made was to move a big new painting into the camera's view to improve the composition—fortuitously, the painting, which includes a camera mounted on a tripod, revealed Hockney's own interest in photography.

For this informal portrait, commissioned by a film manufacturer, Newman used instant-developing film and electronic flash, but he varies his equipment to suit the job. "I am not going to use an 8 x 10 camera to make a wide-angle photo in a poorly lit room," he said.

ARNOLD NEWMAN: David Hockney, 1978

Bibliography

General

Danese, Renato, American Images. McGraw-Hill,

De Mare, Eric, Photography. Penguin Books, 1964 Focal Press Ltd., Focal Encyclopedia of Photography. McGraw-Hill, 1969.

†Lyons, Nathan, ed., Photographers on Photography. Prentice-Hall, 1966.

Rathbone, B., ed., One of a Kind. David R. Godine,

Rhode, Robert B., and Floyd H. McCall, Introduction to Photography. Macmillan 1965.

Szarkowski, John, The Photographer's Eye. The Museum of Modern Art, Doubleday, 1966.

Wagstaff, Sam, A Book of Photographs. Gray Press, 1978.

History

American Heritage, Editors of, American Album. American Heritage, 1968.

Doty, Robert, Photo-Secession. George Eastman House, 1960.

†Eder, Josef Maria, History of Photography. Columbia University Press, 1945.

Gernsheim, Helmut: Creative Photography: Aesthetic Trends 1839-1960. Faber & Faber Ltd., 1962.

History of Photography. Oxford University Press, 1955.

Newhall, Beaumont

History of Photography. The Museum of Modern Art, New York Graphic Society, 1964. Latent Image: The Discovery of Photography. Doubleday, 1967.

Newhall, Beaumont and Nancy, Masters of Photography. Bonanza, 1958.

Pollack, Peter, Picture History of Photography. Harry N. Abrams, 1969.

Scharf, Aaron:

Creative Photography. Reinhold, 1965 Pioneers of Photography. Harry N. Abrams,

Sipley, Louis Walton, Photography's Great Inventors. American Museum of Photography, 1965.

*Taft, Robert, Photography and the American Scene. A Social History. Peter Smith, 1938. Talbot, W. H. Fox, Pencil of Nature. Plenum,

1968.

Biography

Bry, Doris, Alfred Stieglitz: Photographer. Boston Museum of Fine Arts, 1965.

Eisenstaedt, Alfred, and Arthur Goldsmith, eds., The Eye of Eisenstaedt. Viking, 1969.

Evans, Walker, Walker Evans: First and Last. Harper & Row, 1978. Frank, Waldo, America and Alfred Stieglitz: A

Collective Portrait, Doubleday, 1934. Friedlander, L., Lee Friedlander Photographs. Haywire Press, 1978.

Lartique, Jacques-Henri, Boyhood Photos of J. H. Lartigue. Ami Guichard, 1966.

Museum of Modern Art, Steichen the Photographer. The Museum of Modern Art, Doubleday, 1961. Norman, Dorothy, Alfred Stieglitz. Duell, Sloan and

Pearce, 1960. Steichen, Edward, A Life in Photography.

Doubleday, 1963.

Thornton, Gene, Masters of The Camera: Stieglitz, Steichen & Their Successors. A Ridge Press Book/Holt, Rinehart and Winston, 1976.

Special Fields

Callahan, Harry, Photographs. El Mochuelo Gallery,

Cox, Arthur, Photographic Optics. Amphoto,

Duncan, David Douglas, Yankee Nomad. Holt, Rinehart and Winston, 1966.

Edgerton, Harold E., and James Killian Jr., Flash! Seeing the Unseen by Ultra-High Speed Photography. Charles T. Branford, 1954.

Evans, Walker, American Photographs. The Museum of Modern Art, 1938.

Faber, John, Great Moments in News Photography. Thomas Nelson & Sons, 1960.

Greenewalt, Crawford H., Hummingbirds. Doubleday, 1960.

and Winston, 1977.

Gibson, Ralph, Déja-Vu. Lustrum Press, 1973. Haas, Ernst, The Creation. Viking Press, 1971. Kingslake, Rudolf, Lenses in Photography. A.S. Barnes, 1963.

Lyons, Nathan, ed., Contemporary Photographers: The Persistence of Vision. Horizon Press, 1967. Marten, Michael, John Chesterman, John May and John Trux, Worlds Within Worlds, Holt, Rinehart

Newman, Arnold, The Great British. New York Graphic Society, 1979.

Newton, Helmut, White Women. Stonehill Publishing,

Nilsson, Lennart, Behold Man: A Photographic Journey of Discovery inside the Body. Little, Brown and Company, 1973.

Penn, Irving, Moments Preserved. Simon & Schuster, 1960

Rhode, Robert, and Floyd McCall, Press Photography: Reporting with a Camera. Macmillan, 1961.

Salomon, Erich, Portrait of an Age. Macmillan, 1967. Scharf, Aaron, Art and Photography. Penguin Press,

Stroebel, Leslie, View Camera Techniques. Hastings House, 1967

Thomas, D. B., The Origins of the Motion Picture. Her Majesty's Stationery Office, 1964.

Magazines

American Photographer, CBS Publications, New

Aperture, Aperture Inc., Millerton, New York. British Journal of Photography, Henry Greenwood and Co., London.

Camera, C. J. Bucher Ltd., Lucerne, Switzerland Camera 35, U. E. M. Publishing, New York City. Camera Arts, Ziff-Davis Publishing Co., New York

Darkroom Photography, PMS Publishing Co., San Francisco.

GEO: A New View of Our World, Gruner and Jahr, Inc., New York City,

History of Photography, Taylor & Francis Ltd., London

Modern Photography, ABC Leisure Magazine, New York City.

Le Nouvel Observateur, Directeur General: Claude Perdriel, Paris

Petersen's Photographic, Petersen Publishing Co., Los Angeles

Picture Magazine, Picture Magazine, Inc., Los Angeles.

Zoom, Publicness, Paris.

†Also available in paperback *Available only in paperback

Acknowledgments

The index for this book was prepared by Karla J. Knight. For their help in preparing this book, the editors are particularly indebted to Reginald Heron, Assistant Curator, Equipment Archive, George Eastman House, Rochester, N.Y., Rudolf Kingslake, retired Director of Optical Design, Eastman Kodak Co., Rochester, N.Y., Robert E. Mayer, Manager, Photographic Services, Photo Sales Co., Bell & Howell, Chicago; Beaumont Newhall, Director, George Eastman House, Rochester, N.Y.; Eugene Ostroff, Curator of Photography, Smithsonian Institution, Washington, D.C. The editors also wish to thank the following: Don Bane, Public Information Officer, Jet Propulsion Laboratory, Pasadena, Calif.; Albert K. Baragwanath, Curator of Prints, Museum of the City of New York, New York City; Thomas F. Barrow, Associate Curator, Research Center, George Eastman House, Rochester, N.Y.; Lloyd M. Beidler, Professor of Biology, The Florida State University, Tallahassee: Catherine L. Bollwark Public Relations-Advertising, Paillard Inc., Linden, N.J.: Peter C. Bunnell, Associate Curator of Photography, The Museum of Modern Art, New York City: John D. Callahan, President, Burleigh Brooks Optics, Inc., Hackensack, N.J.; Adeline L Commisso, Copy Assistant, Corporate Information, Eastman Kodak Co., Rochester, N.Y.; Gordon C. Conley, Public Relations Management Supervisor, J. Walter Thompson Co., New York City: Robert M. Doty, Associate Curator, Whitney Museum of American Art, New York City; Harold E. Edgerton, Institute Professor of Electrical Engineering, Massachusetts Institute of Technology, Cambridge; Werner A. Fallet, Assistant Sales Manager, Zeiss-Ikon-Voigtlander of America, Inc.,

New York City; Robert A. Fox, Designing Engineer, Fishers, N.Y.; Hans B. Freund, Assistant Sales Manager, Zoomar, Inc., Glen Cove, N.Y.; Anne W. Brown, Research Assistant, David Havnes. Technical Staff Assistant and Charles C. Irby, Assistant Curator, The Gernsheim Collection, The University of Texas, Austin; Norman Goldberg. Camcraft, Madison, Wis.; David Haberstich, Assistant Curator, Section of Photography, Smithsonian Institution, Washington, D.C.; Gene Hosansky, Director Trade Media Relations, AC&R Public Relations, New York City; Warren Z. Illes Manager, Linhof Division, Kling Photo Corp., Division of Berkey Marketing Co., Woodside, N.Y.: Norman James, James Collection of Early Canadiana, Toronto, Canada; Manfred Kage, Institute for Scientific Photography and Cinematography, Winnenden, Germany: Jeff Karp, Product Manager, Ehrenreich Photo-Optical Industries, Garden City, N.Y.; Henry J. Kaska, Manager, Corporate Information Services, Eastman Kodak Co., Rochester, N.Y.; Norbert R. Kleber. Foto-Care Ltd., New York City; Karl Kleinen, Advertising Manager, E. Leitz, Inc., Rockleigh, N.Y.; Noel deLeon, Engineer of Apparatus. Department of Physics, Columbia University New York City; Albert Levin, New York Metropolitan Sales Manager, Ehrenreich Photo-Optical Industries, Inc., Garden City, N.Y.; Thomas P Mason Jr., Manager, Product Publicity, GAF Corp., New York City; Ray K. Matzker, Assistant Professor of Art, Philadelphia College of Art, Philadelphia, Pa.; Harry Patton, National Museum of American History, Smithsonian Institution, Washington, D.C.; Thomas G. Polanyl, Manager, Gas Laser Research, American Optical

Corp., Research Laboratories, Framingham, Mass.; Alan Porter, Editor, Camera, Lucerne, Switzerland: James E. Robbins, Sales Promotion Specialist, The Singer Co., Graflex Division, Rochester, N.Y.; Donald C. Ryon, Museum Curator, Patent Department, Eastman Kodak Co., Rochester, N.Y.; Charles Seymour Jr., Professor, History of Art, Yale University, New Haven, Conn.; Alan R. Shulman, Publicity Department, Polaroid Corp., Cambridge, Mass.; Arthur A. Smith, American Optical Corp., Research Laboratories Framingham, Mass.; Bernard A. C. Sobel, Product Manager, Burleigh Brooks Optics, Inc. Hackensack, N.J.; Jock Soper, Public Relations Director, Dancer Fitzgerald, Sample Inc., New York City; Fred Spira, Flushing, N.Y.; Barbara J. Strauss-Locke, Manager of Communications, Bell & Howell-Mamiya Co., Mt. Prospect, Ill.; William M. Strouse, Research Physicist, American Optical Corp., Research Laboratories, Framingham, Mass.; Jerry N. Uelsmann, Professor of Art, University of Florida, Gainesville; Harold Vanderbush, Account Executive, Darcy Associates, Inc., Rochester, N.Y.: Lloyd E. Varden, Vice-President, Institute for Graphic Communication, Inc., Wellesley Hills, Mass.; Erna B. Vasco, Advertising Manager, Carl Zeiss, Inc., New York City: David Vestal, Associate Editor, Travel and Camera and Camera 35, U.S. Camera Publishing Co., New York City; Sam Wagstaff, New York City; Jerome Warn, Assistant to the Sales Manager, Ehrenreich Photo-Optical Industries, Inc., Garden City, N.Y.; Fred W. Weitz, Vice-President, Rollei, Inc., New York City; Augustus Wolfman, Editor and Publisher, Wolfman Report on the Photographic Industry, Bayside, N.Y.; Helen Wright, E. Leitz, Inc., New York City.

Picture Credits Credits from left to right are separated by semicolons, from top to bottom by dashes.

COVER: Photographs by David Arky, courtesy Tree Communications and Fil Hunter.

Chapter 1: 11: ® Norman James from the James Collection of Early Canadiana. 18, 19: Alfred Stieglitz, courtesy Boston Museum of Fine Arts, gift of Alfred Stieglitz. 20: Alexander Gardner, Library of Congress; Jacques-Henri Lartigue from Rapho Guillumette, Paris-Margaret Bourke-White. 21: Bob Landry; UPI - John Olson for Life. 22: August Sander. 23: © 1969 Danny Lyon from Magnum. 24: Walker Evans. 25: Lee Friedlander. 26: Werner Bischof from Magnum, 27: C. Robert Lee. 28: UPI. 29: Alfred Eisenstaedt. 30, 31: Edward T. Adams, Wide World. 33: Courtesy George Eastman House. 34: Edward Steichen, courtesy the photographer and the Department of Photography, The Museum of Modern Art. 35: Paul Strand. 36: Imogen Cunningham. 37: Edward Weston. 38, 39: Irving Penn © 1960, courtesy The Condé Nast Publications Inc.: Norman Seeff, 40: Gerald Incandela, Sam Wagstaff Collection. 41: Jerry N. Uelsmann. 43: Léon Gimpel from S.F.P.-Fotogram. 44: Paul Outerbridge, copied by Tom Tracy, courtesy G. Ray Hawkins Gallery, Los Angeles. 45: Helmut Newton, courtesy Voque France, Paris. 46, 47: David Douglas Duncan, Castellaras, France, 48: Franco Fontana, Modena, Italy. 49: Richard Misrach, courtesy Grapestake Gallery. 51: Courtesy Simone Gossner. 52: Dr Harold E. Edgerton. 53: Gjon Mili. 54: L.M. Beidler, courtesy Florida State University. 55: © Phillip A. Harrington, 56, 57: Lennart Nilsson from Behold Man, Little, Brown and Company, 1974; Dan McCoy from Rainbow. 58: NASA.

Chapter 2: 61: Andreas Feininger. 62, 63: Drawing by Nicholas Fasciano, 64: Fil Hunter-drawings by John Svezia; Ken Kay (2). 65: Fil Hunter-drawing by John Svezia; Ken Kay (2). 66: Fil Hunter; drawing by John Svezia; Ken Kay (2). 67: Harold Zipkowitz; drawing by John Svezia; Ken Kay (2). 72: Ken Kay. 73: Fil Hunter, drawings by John Svezia. 74: Drawings by John Svezia; Ken Kay (5); Linda Bartlett (5). 75: Linda Bartlett, drawing by John Svezia. 76: Ken Kay. 77: Ken Kay, drawing by John Svezia. 78: Drawing by John Svezia. 79: Drawing by Jean Held - Ken Kay (7) - Harold Zipkowitz. 80: Drawing by Nicholas Fasciano - Duane Michals (2) - Harold Zipkowitz. 81: Drawing by Nicholas Fasciano-Duane Michals (2) - Harold Zipkowitz. 82: Drawing by John Svezia; George Krause - drawings by Nicholas Fasciano. 83: George Krause, drawings by Nicholas Fasciano. 84, 85: John Neubauer, drawings by Nicholas Fasciano, 86, 87: Richard Avedon, History of Photography Collection, Smithsonian Institution. 88, 89: Farrell Grehan; Mark Kauffman.

90, 91: Wynn Bullock; Andreas Feininger. 92: Frederic Weiss. 93: [®] Herbert List. 94: Ralph Crane from Black Star. 95: Susan Felter [®] 1978, courtesy Robert Samuel Gallery, New York. 96, 97: [®] Joe DiMaggio/JoAnne Kalish. 98: Francisco Hidalgo, Paris.

Chapter 3: 101: Leonard Soned. 104: Ansel Adams. 105: Drawing by Walter Johnson. 106-108: Ansel Adams, drawings by Nicholas Fasciano. 109: Ken Kay. 110: Ben Rose. 111: Ben Rose, drawing by Nicholas Fasciano. 112: Ken Kay. 113: Drawings by Nicholas Fasciano. 114. 115: William Gedney. 116. 117: Willorn Tifft, drawings by Jean Held. 118, 119: John Senzer, drawings by Jean Held. 120, 121: Maitland A. Edey, drawings by Jean Held. 123: John Senzer. 124, 125: Harold Zipkowitz, drawings by Jean Held. 123: John Senzer. 124. 125: Harold Zipkowitz. 126, 127: Henri Cartier-Bresson from Magnum, drawing by John Svezia. 129: Art Kane. 130, 131: John Dominis, drawing by John Svezia. 129: Art Kane. 130, 131: John Dominis, drawing by John Svezia. 132: Manny Rubio.

Chapter 4: 135: Courtesy Oregon Historical Society. 138: David Lees, courtesy Museo Correr, Venice. 140: Henry Beville, courtesy John Byerly; courtesy Maine Historical Society from American Heritage. 141: Harold Zipkowitz (2) - drawing by Otto van Eersel; Lee Boltin. 142: Yves de Braine, courtesv Deutsches Museum, Munich. 143: Yves de Braine, courtesy Deutsches Museum, Munich, drawing by Otto van Eersel. 144, 145: Derek Bayes, courtesy Science Museum, London; Lee Boltin. 146, 147: Lee Boltin, courtesy George Eastman House. 148: Harold Zipkowitz. 149: Eddy van der Veen, courtesy Photo Bibliotèque Nationale, Paris. 150: Gernsheim Collection, Humanities Research Center, The University of Texas, Austin; Harold Zipkowitz. 151: Derek Bayes, courtesy Science Museum, London, drawing by Otto van Eersel. 152, 153: Eddy van der Veen, courtesy Mr. Jean Vian; drawing by Otto van Eersel - courtesy George Eastman House. 154: Yves de Braine, courtesy Deutsches Museum, Munich; Eric Schaal, courtesy Deutsches Museum, Munich-Harold Zipkowitz. 155: Harold Zipkowitz (2) - Gernsheim Collection, Humanities Research Center, The University of Texas, Austin (2). 156: Ben Rose, courtesy George Eastman House (2)-Fototeca Storica Nazionale, Milan. 157: Harold Zipkowitz. 158: Eddy van der Veen, courtesy Musée des Beaux Arts de Beaune. 159: Eddy van der Veen, courtesy Conservatoire National des Arts et Métiers, Société de Photographie, Paris-Eddy van der Veen, courtesy Musée des Beaux Arts de Beaune. 160, 161: George M. Quay-drawing by Otto van Eersel: Eadweard Muybridge, courtesy George

Eastman House. 162, 163: Deutsches Museum, Munich. 164, 165: Eddy van der Veen, courtesy Conservatoire National des Arts et Métiers, Société de Photographie, Paris; Jacques-Henri Lartigue from Rapho Guillumette, Paris. 166: Courtesy Zeiss, Stuttgart; Peter Hunter from Magnum—Dr. Erich Solomon from Magnum ® Peter Hunter Press Features.

Chapter 5: 169, 170: Gernsheim Collection, Humanities Research Center, The University of Texas, Austin, 172: Société Française de Photographie, Paris, from Gernsheim Collection, Humanities Research Center, The University of Texas, Austin. 173: Landesbildstelle, Berlin. 174: Gernsheim Collection, Humanities Research Center, The University of Texas, Austin. 175: Staatliche Landesbildstelle, Hamburg-David O. Hill photograph Scottish National Portrait Gallery, Edinburgh, copied by Larry Burrows; Derek Bayes, courtesy Victoria and Albert Museum, London. 177: Courtesy George Eastman House. 178-183: Gernsheim Collection, Humanities Research Center. The University of Texas, Austin. 184: Giraudon, Paris. 185: Lee Boltin, courtesy George Eastman House. 186, 187: Photo Bibliotèque Nationale, Paris. 188, 189: Derek Bayes, courtesy Victoria and Albert Museum, London. 190: Gernsheim Collection, Humanities Research Center, The University of Texas, Austin-Staatsbibliothek Bildarchiv, Berlin, Handke. 191: Gernsheim Collection, Humanities Research Center, The University of Texas, Austin. 192, 193; Courtesy The Royal Photographic Society of Great Britain, drawing by Herb Quarmby. 194, 195: Gernsheim Collection, Humanities Research Center, The University of Texas, Austin. 196, 197: National Gallery, London; The Metropolitan Museum of Art. 198: Photo Bibliotèque Nationale, Paris; Stavros Niarchos Collection, Aaron Scharf, London. 199: Photo Bibliotèque Nationale, Paris, 200: Aaron Scharf-Yves de Braine, courtesy Musée Courbet, Ornans, France.

Chapter 6: 203: Henri Cartier-Bresson from Magnum. 204, 205: George Silk. 206: Alfred Eisenstaedt. 211: John Dominis. 212, 213: Ansel Adams. 214, 215: Gjon Mili. 216, 217: Henri Cartier-Bresson from Magnum. 218: Irving Penn from Vogue magazine, © 1953, The Condé Nast Publications Inc. 219: Irving Penn from Look magazine, © 1967, Cowles Communications Inc. 220, 221: © W. Eugene Smith. 222, 223: Lee Friedlander. 224, 225: Balph Gibson. 226, 227: William A. Garnett. 228, 229: Horst © 1939 (renewed 1967) by The Condé Nast Publications Inc.; Horst-Vogue France, Paris. 230: © Arnold Newman, courtesy Polaroid Corporation.

Index Numerals in italics indicate a photograph, painting or drawing.

Aberrations, lens, 124-125 Action photography, 32, 53, 70, 92-97, 132, 164-165, 204-205, 209-210; blurred and sharp picture elements juxtaposed, 94, 95; freezing of action, 76, 77, 83, 84-85, 92, 95, 164-165, 209, 214; hints for, 209-210; multiple exposure to suggest movement, 96-97, 214; panning, 94, 164-165, 210; and shutter speed, 75, 76, 84, 209-210. See also Motion Adams, Ansel, 13, 106-107, 213 photographs by, 104, 106-108, 212-213; quoted, 213 Adams, Edward T., 30; photograph bv. 30-31 Adamson, Robert, 174, 176; portrait photographs by, with Hill, 174-175 Aerial photography: history of, 162; landscape, 162, 163, 226-227; war reconnaissance, 16 Aeronautical exhibition, Paris, 42, 43 Agee, James, quoted, 213 Albarello, Anthony, 129; photograph by, 128 Alice in Wonderland (Carroll), 177 Allegorical photography, 19th Century, 170, 180, 181-182, 184, 192-193 Amateur photography: beginnings of, 138-139, 156-157, 170; choice of camera for, 71; color, early, 42; hints for, 204-211; statistics on, 12 Angle of view: of long lens, 123, 131, 207; of normal lens, 126-127; of short (wide-angle) lens, 123, 128; of zoom lens, 102, 132 Animal photographs, 208-209, 211, 229; equipment for, 66, 131, 208-209; motion in, 159, 160, 208, 209; practicing, 209. See also Wildlife photography Aperture, 62, 63, 68, 74, 78-81, control of depth of field by, 80-81 82, 84-85, 122, 123; control of light by, 78-79, 82, 84; defined, 62, 78; dependent on focal length, 122; evolution of use of, 136; f-stops, 78, 79, 80, 81; use for special effects. 88-89; use of, in combination with shutter speed, 82-83, 84-85 Aperture-priority automation, 84, 85 Aperture scale, 80-81, 125 Arago, François, 170 Arca-Swiss camera, 213 Architectural photography, 97, 98, 172, 186, 210; cameras for, 70-71, 213. See also Cityscapes Art: photography as, 13, 14, 16, 32, 33-41, 71, 183, 212-230; photography as an aid to, 174, 176, 181, 193, 198-200; photography in imitation of, Victorian era, 32, 33, 169, 170-171, 172, 173, 180-182, 184, 185-197. See also Painting; Sculpture Astronomy, use of photography in, 50, 51, 170 Autochrome color process, 42, 43

Automatic controls, 12, 68, 72, 84-85

139, 163, 204; in aperture priority vs. shutter-priority cameras, 84-85; for exposure time, 69-70, 84-85; on single-lens reflex camera, 69-70 Avedon, Richard, photograph by, 86-87; quoted, 87 Baby photographs, 66. See also Children Background: error of overemphasis on, 207; intentional blurring, in action photography, 94, 210; reduction of emphasis by long lens, 130-131, 207, 208. See also Depth of field Ballet studies, 93 Barbaro, Daniel, 108 Barnack, Oskar, 138-139 Bausch, Edward, 138 Beidler, Lloyd, photomicrographs by. Berlioz, Hector, 176 Bird photography, 14, 82-83, 159, Bischof, Werner, photograph by, 26 Black-and-white photography: vs. color, 42: vs. color, in photographing people, 207; contrasted with color, 44, 45, 46-47 Blurring: aperture setting and, 80-85. 86; circles of confusion as cause of, 107, 118; due to chromatic aberration, 124-125; due to motion, 76-77, 84, 85; foreground, 80, 119, 209; intentional, for emphasis of movement, 76, 86-87, 92, 93, 94-95; intentional, for special effects, 48, 49, 86-89, 92, 205; intentional, of background, 88-89, 94; juxtaposed with sharp picture elements, 48, 49, 94, 95; in long-lens photographs, 119, 123, 130-131; short camera-to-object distance as cause of, 120; in zoomlens photographs, 132 Books on photography, early, 181, 182; first book of photographs, 172 Bourke-White, Margaret, photograph by, 20 Box camera, 68-69, 213; introduction of. 156-157 Brain tumors, photograph of, 56 Braun, Adolphe, Le Château de Chillon, 200 Briand, Aristide, quoted, 166 Britt, Peter, 135 Brownie camera, 62, 68, 213 Bullock, Wynn, photograph by, 90-91 Burty, Philippe, quoted, 188 Byerly, Jacob, 140 Calotype process, 174; prints, 174-

175, 186-187

Cameras: automatic-exposure, types

of, 62, 63; basic parts of, 62, 63;

basic types of, 64-67; choice of, considerations in, 68-71, 204;

compared to eye, 50, 78, 105;

controls of, 72-85 (see also

of, 68-69, 84-85; basic functioning

Controls, camera); evolution of, cover, 4, 136, 137-139, 140-166; hand-held, evolution of, cover, 4, 138-139, 154-155, 156-157, 164-166; invention of, 136; ownership statistics, 12; sizes of, 144-147, 154-157, 166; specialized, 62, 138, 146-155, 158-163 Camera obscura, 106, 108, 136, 142, 144; portable, 136, 138, 140; uses of, 136, 138, 172 Cameron, Julia Margaret, 177-180. 194; illustrative photographs by, 177, 180, 194-195; portrait photographs by, 177, 178-179; quoted, 179 Candid photography, 12, 70; beginnings of, 62, 65, 154, 166; cameras for, 166. See also Action photographs Carbro-Color printmaking process, 44
Car racing, 164-165
Carroll, Lewis (Charles Dodgson), 177; photograph by, 177
Cartes-de-visite, 148, 149
Cartier-Bresson, Henri, 15, 127, 216, 200 222; photographs by, 126-127, 203, 216-217; quoted, 15, 92, 216 CAT (computerized axial tomography) scanner, 56 Centaurs, 214 Chaplin, Charlie, 16 Chevalier, Maurice, 16-17 Children, photographing, 62, 170, 177, 207-208, 218; with twin-lens reflex camera at floor level, 66 Chromatic aberration: defined, 124: lens design for correction of, 124, Chronophotographic camera, 158 Circles of confusion, 107, 118-119, 121; defined, 107 Cityscapes, 24, 34-35, 98, 152-153. See also Architectural photography Close-ups, 88, 208; from close range vs. distance, arguments, 204, 206-207; introduction of, 178; and perspective, 112, 113, 116-117; simple viewfinder camera unsatisfactory for, 64, 68; taken with long lens from a distance, 111, 112, 113, 131, 204, 206, 207; taken with normal lens, 204, 206, 207 taken from short range, 111, 112, 113, 116-117, 204, 206; taken with wide-angle lens, distortion of, 129; taken with zoom lens. 132 Color photography, 42, 43-49, 56, 57, 58, 226-230; Autochrome process. 42, 43; vs. black-and-white, 42; vs. black-and-white, in photographing people, 207; carbro printing process, 44; contrasted with blackand-white, 44, 45, 46-47; edge distortions in, 124-125; evolution of, 42, 44; of fashion, 42, 44-45, 228-229; filters used in, 44, 58; of landscapes, 48-49, 226-227 Composites, 180, 181; Rejlander's, 192-193; Robinson's, 180-181, 190 Composition, 32, 34-35, 216, 230; general hints, 204, 208;

"pictorialism" replaced by natural realism, 182 Compound lens. 124-125 Computers, used in photography, 56, 58.84 Concave lens, 109, 110, 111; use in viewfinder, 110 Controls, camera, 62, 63, 72-85; aperture, 62, 63, 68, 69, 78-85; automatic, 12, 68, 69, 72, 84-85, 139, 163, 204; for depth of field, 80-85; focusing systems, 62, 63, 68, 72-73; for light, 62, 63, 69, 74-75. 78-79, 82; for motion of object photographed, 76-77, 82-85; shutter, 62, 63, 69, 74-77, 82-85; used for special effects, 86-98 Convex lens, 108, 109, 110, 111, 118-119; compound, 124-125; focal length of, 112-113; focusing of light rays by, 108-109 Corot, Jean Baptiste Camille, 177 Courbet, Gustave, Le Château de Chillon, 200
Crane, Ralph: quoted, 211;
photograph by, 94
Crystal Palace exhibition, London, Cubism, 200 Cunningham, Imogen, 36; photograph by, 36 Daguerre, Louis Jacques Mandé, 137, 140, 144, 170; photograph by, 171, 172 Daguerreotypes, 42, 137, 140, 152, 153, 170, 172, 173, 174, 190; earliest known to exist, 171, 172; exposure times, 137, 140, 173; reproduction impossible, 171-172 Dance studies, 53, 93, 214 Dancer, John B., 150, 151 Daumier, Honoré, 176 Da Vinci, Leonardo, 136 Delacroix, Eugène, 199; Odalisque, Delaroche, Paul, quoted, 171 Della Porta, Giovanni Battista, 136 Depth distortion, 131. See also Distance distortion Depth of field: aperture settings for. 80-83, 84; effect of aperture on, 80-81, 82, 84; effect of camera-toobject distance on, 120-121; effect of focal length on, 118-119, 120, 122, 123, of long lens, 118, 119, 122, 123, 131, 207; of normal lens, 126-127; shallow, for emphasis of essentials, 88-89; of short (wideangle) lens, 118, 119, 120, 122, 128, 129 Depth of field scale, on lens, 125; use of, 80-81 Desportes, Alexandre-François, painting by, 184 Detective cameras, 154-155 Development of prints, manipulation in. 40-41, 86-87, 224 Diamond, Hugh, 184; photograph by,

Diaphragm, 62, 63, 78, 80, 103, 122

Diffusion of light, 87 DiMaggio, Joe, 97; photograph by, 96-97 Disdéri, André Adolphe Eugene, 148, Distance, camera-to-object, 73; effect on depth of field, 120-121; effect on perspective, 114-117 129; in photographing people, opinions on, 204, 206-207 Distance distortion, 116-117, 123 128-131 Distance scale, on lens, 125; calculating depth of field from, 80-Distance setting, 72, 73
Distortions: distance, 116-117, 123; of fast-moving objects, caused by focal-plane shutter, 75, 164-165; perspective, 116-117, 128, 129; relative image size, 116-117, 129 Dodgson, Charles. See Carroll, Lewis Dominis, John: photographs by, 130-131, 211; quoted, 208 Drop shutter, 138 Duckworth, Mrs. Herbert, 178 Duncan, David Douglas: photograph by, 46-47; quoted, 46 Durieu, Eugène, 199; photographs by, 198-199 Eakins, Thomas, 196; photograph by, 196-197 Eastman, George, 138, 139, 156; quoted, 156 Edgerton, Harold E., 52; photograph bv. 52 Eisenstaedt, Alfred, 13, 29, 204, 206-207; photographs by, 29, 206; quoted, 206, 207 Electron microscope, 54 Electronic flash, 14, 48, 52, 69, 70, 75, 230; use with long exposure, 48, 49, 94, 95 Elisofon, Eliot, 204, 205; quoted, 204, 206, 207 Emerson, Peter Henry, 182-183; photograph by, 182-183; quoted, England, William, 138
Enlargements: impractical in early photography, 138, 139, 144, 147; simple viewfinder camera pictures unsuited for, 68 Eppridge, Bill, 204; quoted, 204, 206 Ermanox camera, 139, 166 Ettingshausen, Andreas von, 137; photograph by, 24 Exacta camera, 139 Exposure time: Autochromes, early, Ag: automatic controls for, 69-70, 84-85; daguerreotypes, 137, 140, 173; early photography, 142, 136-137, 138, 139, 140-141, 142, 144, 156, 158, 173, 174, 176, 179; overexposure, intentional, 87, 224; underexposure, 87, 94, 205, 209 See also Shutter speed; Time exposures Eye and vision, human, 50, 119, 150:

camera compared to, 50, 78, 105; normal lens compared to, 116, 127 Eye-level cameras, 64-65, 66, 70

Fading Away (Robinson), 180, 190 Fallopian tube, photograph of, 56-57 Fashion photography, 17, 218, 228; color in, 42, 44-45, 228-229 "Fast" lenses, 102, 103, 166 Feininger, Andreas: photographs by, 61, 91; quoted, 91 Felter, Susan, photograph by, 95 Field cameras, 71 Fighting Lady, The (film), 17 Figure studies, by Durieu, 198-199 Fillans, James, and daughters, 175 Film, 62, 63; black-and-white vs. init, 62, 63, black-alid-wille vs. color, in photographing people, 207; color, history of, 42; color, modern, 44, 228; instant-developing, 230; instant-loading cartridges, 12, 68, 139; large-size, in view camera, 67, 71; roll, introduction of, 138, 156; for single introduction of, 138, 156; for singleintroduction of, 138, 156; for single-lens reflex camera, 70; size of, and focal length of lens, 127, 128, 131, 144; 35mm, 70, 103, 138; for twin-lens reflex camera, 66, 70, 127 Film advance, 62, 63, 70 Filters, use of, 87, 90, 98, 211; in color photography, 44, 58 Fisher, Florence, 179 Fitz, Henry, 141 Floodlighting, 228-229 Flower close-ups, simple viewfinder camera unsatisfactory for, 64 Focal length, 78, 112-113, 144, 148; defined, 113; and distance distortion, 116-117, 123; effect on depth of field, 118-119, 120, 122 123; effect on image size, 64, 112-115, 123, 132; of long lens, 112-113, 131; markings on lens barrel, 113, 125; of normal lens, 127; relationship to film size, 127, 128, 131, 144; relationship to f-stop, 122; and relative image size, 116-117, 127; and relative perspective, 113, 114-117, 123; of short (wide-angle) lens, 112-113, 128, 144; of zoom lens, 132 Focal plane, 118; defined, 108 Focal-plane shutter, 70, 74, 75, 138,

139, 153; and distortion of fast-

moving objects, 164-165 Focal point, 108, 109, 113; defined,

Focusing, 72-73, 108-109, 182-183; and depth of field, 80-85, 86-87, 118-123; in dim light, 64, 65, 72; effect of aperture on, 80-81, 82, 84-

85, 122-123; in single-lens reflex camera, 65, 72; soft focus, 87; for

special effect, 86-89; in twin-lens reflex camera, 66, 70, 72; in view

151; rangefinder, 64, 65, 68, 69, 72,

camera, 67, 72; in viewfinder camera, 64, 72, 73 Focusing systems, 62, 63, 72-73; automatic, 72; ground-glass focusing screen, 70, 72, 80, 137

quoted, 14 Grehan, Farrell, photograph by, 88 Groskinsky, Henry, quoted, 210 Ground-glass focusing system, 70, 72, 80, 137, 151 Guillotine shutter, 138 Guizot, François, 176-177 Gun camera, Marey's, 158, 159 Hand-held cameras, cover, 4; first, for amateurs, 138, 154-157; first professional, 138-139, 166 Harrington, Phillip, photomicrograph by, 55 Hasselblad camera, 14, 71, 213 Hell's Angels, group of, 218, 219 Herschel, Sir John, 179; quoted, 12 Hidalgo, Francisco, photograph by, 98 Hill, David O., 174, 176; photograph of, 174; portrait photographs by, with Adamson, 174-175 Hindenburg, the, explosion of, 28, 29 Hockney, David, 230 Holmes, Martha, 207-208; quoted, 208 Horst, Horst P., 228; photographs by, 228-229 Hot rodders, 94 Houses, photographing, 210-211 ICA camera, 164 "Ideas in Houses" Life series, 211 Idylls of the King, The (series of photographs), Cameron, 180, 194-

Illustrative photography, 19th

73, 81, 92, 139 Fontana, Franco: quoted, 48; photograph by, 48

Friedlander, Lee, 222, 224;

Fuzziness. See Blurring

Foreground blurring, 80, 119; with long lens, 119, 209

French Photographic Society, 184

photographs by, 25, 222-223; guoted, 222

Fruit fly, eye of, photomicrographs, 54
F-stops, 78, 79, 80, 81; "fast" lenses,
166; as ratio of focal length to

aperture, 122. See also Aperture

Garbo, Greta, 16 Gardner, Alexander, photograph by,

Garnett, William, 226; photographs

Genre photography, Victorian era,

Gibson, Ralph, 224; photographs by, 224-225

Gimpel, Léon, 42; photograph by, 43 Goebbels, Joseph, 206

Goro, Fritz, quoted, 211 Graff, Phillip, group portrait by, 173 Graflex_camera, 164

Grand Prix car race, 164-165 Greenewalt, Crawford, 13-14;

by, 226-227; quoted, 226

190-191

Football, 132

Century, 177, 180, 190-195 Image: creation of, 105, 106-109; reversal, 63, 67, 106 Image size: distortions, 116-117, 129 207; effect of distance on, 114-115, effect of focal length on, 64, 112-115, 123, 132; relative, effect of focal length on, 116-117, 127, 128-131. See also Close-ups Impressionism, 200 Incandela, Gerald, 40; photograph by, 40 Ingres, Jean Auguste, quoted, 171 Instamatic cameras, Kodak, 139 Instant-developing film, 230 Instant-loading film cartridges, 12, 68, 139 Interiors, photographing, 103, 210-211

James, William, photograph by, 11 Jerusalem, 126-127 Joel, Yale, quoted, 204 Jupiter and four moons, photograph from Voyager I, 58

Kane, Art, photograph by, 129 Käsebier, Gertrude, 32; photograph by, 33 Kauffman, Mark, 204; photograph by, 88; quoted, 204, 206, 210-211 Keats, John, quoted, 50 Kessel, Dmitri, 211; quoted, 211 Kodak cameras, 138, 156-157; early film processing arrangements, 156; Instamatic, 139; No. 1, 156

Lady of Shalott, The (Robinson), 180-181 Land, Edwin H., 139 Landry, Bob, photograph by, 21 Landscape photography, 35, 90-91, 104, 137, 182-183, 200, 211, 212-213; aerial, 162, 163, 226-227; cameras for, 70-71, 213, 226; color in, 48-49, 226-227; practical hints for, 211; Victorian, 170, 172, 184, 188-189, 190, 191 Lartigue, Jacques-Henri, 13, 164; photographs by, 20, 164-165; quoted, 13 Leaf shutter, 70, 74, 138 Lee, C. Robert, photograph by, 27 Leen, Nina, quoted, 209 Leica camera, 15, 64, 71, 166, 216, 220, 222, 224; introduction of, 138-139 Leitz, E., 138, 139 Lenses, 12, 62, 63, 64, 101, 102-103, 104-132; aberrations and their correction, 124-125; basic purpose of, 103; basic types for cameras, 102-103, 124-131 (see also Long lens; Normal lens; Short lens; Zoom

lens); basic types, results compared, 114-119, 120, 122, 123,

126-131; choice of, considerations in, 102-103; compound, 124-125;

concave, 109, 110, 111; convex,

80, 103, 122; early uses of, in camera obscura, 106, 108, 136. camera obscura, 106, 108, 136, 140, 142; evolution in photography, 136, 137, 138-139, 140, 141, 142, 143, 144, 156; f-stops, 78, 79, 80, 81; image reversal, 63, 67, 106; importance of, 102; markings on, 125; microscope, 144; negative, 110, 111; prices of, 102, 103; scales on, use for focusing, 80-81; "speed" of, 102, 103, 125, 137, 139, 142, 144, 164, 166; swiveling, in panoramic 166; swiveling, in panoramic camera, 152, 153; test for faults, 103, 125; use of filters, 87, 90, 98, 211; Voigtländer ("the German lens"), 137, 142, 143. See also Aperture; Focal length Leopards, 130-131, 211 Le Secq, Henri, 186; photographs by, 186-187 Liddell, Alice P., 177
Life in Photography, A, Steichen, 15
Life (magazine), 14, 204;
photographers, 13, 29, 46, 204-Light: chromatic aberration of, 124-125; diffusion, 87; reflection of, 105, 109, 141; refraction, 108, 109, 112, 124-125 Light, control of amount of: by aperture, 62, 63, 78-79, 82, 84, by aperture and shutter in combination, 82-83, 84-85; by shutter, 62, 63, 74-75, 82, 85 Light meter, built-in, 69, 84 Light rays, control of: basic need for to obtain image, 105, 118; by lens, 63, 103, 108-109; by pinhole, 106-107; result of absence of control, 105. See also Focusing Lighting: dim, automatic exposure control for, 84; dim, and focusing 64, 65, 72; dim, how to handle, 144, 211; landscape photographs, 211, 213; photographs of interiors, 211, strobe, 52, 214 Limón, José, and dance partners, 214 Lincoln and McClellan at Antietam, 20 List, Herbert, photograph by, 93 Liszt, Franz, 176 Loewy, M., photograph by, 51 Long, Avon, 214, 215 Long lens, 102, 103, 131; advantages and characteristics of, 131; angle of view of, 123, 131, 207; and background blurring, 119, 123, 130-131, 207; close-ups taken with, 111, 112, 113, 131, 179, 204, 206, 207; depth of field of, 118, 119. 122, 123, 131, 207; distance distortion of, 116, 117, 130-131. focal length, 112-113, 131; and image size, 112-113, 114; and

108, 109, 110, 111, 112-113, 118-119, 124; diaphragm, 62, 63, 78.

perspective, 114, 115, 116, 117, 130-131; photographing people, 204, 206, 207; and relative image size, 116, 117, 130-131; results compared with those of other lenses, 114-119, 122, 123, 127, 129, 131; used with viewfinder camera, 64; uses of, 102, 103, 131, 204, 208-209; for various film sizes, 131; wildlife shots with, 130-131, 208-209, 211 Louis, Joe, 129 Lumière, Auguste, 42 Lumière, Louis, 42 Lyon, Danny, photograph by, 23 McCarthy, Joseph, on television, 21 McCoy, Dan, photograph by, 57 Madwoman of Chaillot, The, Avedon, 86-87 Magnifying glass, 110
"Mammoth" (camera), 146-147
Manchester Art Treasures Exhibition, 1857, 181, 193 Marey, Etienne Jules, 158, 159, 160; Margaret, Princess, 89
Mardens, Friedrich von, 152, 153; photograph by, 152-153; photograph by, 152-153
Massachusetts Institute of Technology, 52 Medicine, use of photography in, 15, 50, 56-57 Meter, light. See Light meter
Microscope, use of. See
Photomicrography
Mili, Gjon, 52, 214; photographs by, 53, 214-215 Miller, Hugh, 174, 175, 176 Miniature cameras, 144, 154-155, 166 Miniatures (paintings), 172, 173 Mirror camera, Wolcott's, 141 Misrach, Richard, 48; photograph by, Mitchell, General Billy, 16 Monro III, Alexander, 174, 175 Moon, photograph of, 50, 51 Moonrise at Hernandez, New Mexico, 212-213 Morgan, J. P., Steichen photograph of, 16 Motion: and blur, 76-77, 82-83, 84, 85; of camera, intentional, 48, 49, 94, 97, 98, 164-165, 210; control by shutter speed, 70, 76-77, 82-83, 84-85, 92-95, 97; emphasized by 84-85, 92-95, 97; emphasized by long exposure and electronic flash, 94, 95; emphasizing, 76, 92, 93-97, 164-165; "frozen;" 76, 77, 83, 84-85, 92, 95, 164-165, 209, 214; how to deal with, with slow shutter speed, 204, 205, 209-210; intentional blur, 76, 86-87, 92, 93, 209; intentional blur, 76, 86-87, 92, 93, 209; intentional blur, 76, 86-87, 92, 93, 209; intentional blurring of background, 94, 210; multiple exposure to suggest, 96-97, 214; time exposure of, for movement pattern, 91. See also Action

photographs

Motion studies, 158, 159, 160-161

Motor drive, used for multiple also Portrait painting exposures, 96-98 Panning: for action photographs, 94, 164-165, 210; for panoramic Movie cameras, 139; prototype of, photographs, 152 Multilens cameras, 138; for miniature portraits, 148; for motion studies, Panoramic camera, 138, 152, 153 Panoramic photograph, 152-153 Parallax error, 65, 67; in twin-lens Multiple exposures, 52, 96-98; to suggest motion, 96-97, 214 reflex camera, 66; in viewfinder camera, 64
Paris, 20, 21; Exposition
Aeronautique, 42, 43; panoramic photograph of, 152-153 Museum of Modern Art, New York City, 17 Mussolini, Benito, 29 Muybridge, Eadweard, 138, 160; Parks, Gordon, 13 motion study of a girl, 160-161 Pencil of Nature, The, Talbot, 172 Penn, Irving, 218; photographs by, 38, 218-219; quoted, 38, 218 Nadar (Gaspard Félix Tournachon), 176-177 Pentax camera, 226 People, photographing, 32, 205-208; color vs. black-and-white, 207; NASA, photograph of Jupiter and four from distance vs. close range, arguments, 204, 206-207. See also moons, 58 Naturalistic Photography, Emerson, 182 Portrait photography Pepper No. 30, Weston, 36, 37 Nature photographs. See Animal photographs; Flower close-ups; Perspective: effect of camera-to-Landscape photography Necktie camera, 154, 155 object distance on, 114-117, effect of focal length on, 116-117 Negative lenses, 110, 111. See also 123; with long lens, 114, 115, 116, 117, 130-131; with normal lens, 114, 115, 116, 126-127; with short Concave lens Newman, Arnold, 230; photograph by, 230 (wide-angle) lens, 114, 116-117, News photography. See Press photography Newton, Helmut, 44; photograph by, 128-129 Pet photographs, 66, 209 Petzval, Josef Max, 137, 142, 144 Photographers, esthetic concerns of, 32, 33-41, 87, 212-230
Photographic chemicals, 136, 137, Niepce, Joseph-Nicéphore, 136-137 Nikon camera, 65, 71 Nilsson, Lennart, 14, 56; photograph 140, 142, 147 Photographic News, The (of London), quoted (1859), 174 by, 56-57; quoted, 56 Normal lens, 102, 103, 125, 127, 216; advantages and characteristics, 127; angle of view of, 126-127; in close-ups, 204, 206, 207; Photographs: oldest known to exist, 171, 172; world's first, 137 Photography: early role and impact of, 170-183, 184; invention of, 136-137, 170, 184; statistics on, 12; compared to human eye and vision, 116, 127; and depth of field, 126-127; focal length of, 127; and image size, 114, 115, 116, 126technological development of, 136-137, 138-139, 140-166 Photojournalism, 30-31, 61, 139, 164-127; vs. long lens, in photographing people, 204, 206-207; and perspective, 114, 115, 116, 126-127; results compared 166, 206; use of color in, 42; zoom lens for, 132. See also Press photography with those of other lenses, 114-117, Photomicrography, 50, 54-55 Photomontage, cover, 4, 40, 41. See _also Composites 127, 129, 131 Nuclear physics, use of photography Picasso, Pablo, 38 in, 50 Nudes, 36, 170, 181, 192, 193, 196-Pictorial Effect in Photography, 199; view camera for photographing, 70-71 Robinson, 181, 182 "Pictorial" school of photography, 32, 33, 180-182, 183, 184-197 John Lorenter 105, 164-107, 108, photographs taken with, 106-107 Polaroid Land Camera, 139 Porgy and Bess, Avon Long in, 214, 215 Olson, John, photograph by, 21 Outerbridge, Paul, 44; photograph Overexposure, intentional, 87, 224

Painting: effect of invention of photography on, 170-171, 172-173; photography as an aid to, 174, 176,

stimulus to, 171; photography in imitation of, 32, 33, 170, 171, 172,

173, 180-182, 184, 185-197. See

181, 193, 198-200; photography as

Portrait painting: imitation by photography, 32, 33, 173; miniature, 172, 173; 19th Century proliferation, 172; silhouette, 172,

173; sudden replacement by photography, 172-173
Portrait photography, 16, 17, 38-39, 62, 215, 218-219, 230; beginnings

of, Victorian era, 170, 172-174, 184;